Richard Hollis
is a freelance graphic designer, and
has worked as a printer, art editor, production manager,
teacher and lecturer. He studied art and typography at the
Chelsea, Wimbledon and Central Schools of Art, London.
From 1958 he taught lithography and design at the London
College of Printing and Chelsea School of Art, before work-
ing in Paris in the early 1960s. From 1964 to 1967 he was
Head of the Graphic Design Department at the West of
England College of Art, Bristol, and was for six years
Senior Lecturer at the Central School of
Art and Design.

WORLD OF ART

This famous series
provides the widest available
range of illustrated books on art in all its aspects.
If you would like to receive a complete list
of titles in print please write to:
THAMES AND HUDSON
30 Bloomsbury Street, London WC1B 3QP
In the United States please write to:
THAMES AND HUDSON INC.
500 Fifth Avenue, New York, New York 10110

Printed in Slovenia

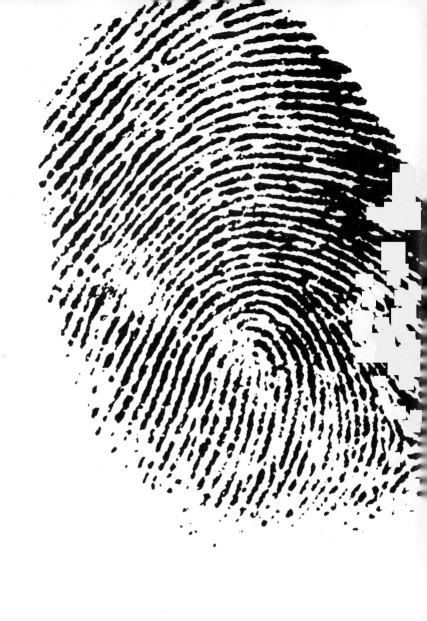

Graphics are marks,
first as identification:
finger print, same size
from *The Medium is the Massage*
by Marshall McLuhan 1967
[Quentin Fiore]

Richard Hollis

Graphic Design

A Concise History

With over 800 illustrations, 29 in colour

Thames and Hudson

In memoriam
E.J.H. R.A.C.S.

Reprinted 1997

© 1994 Thames and Hudson Ltd, London

Designed by Richard Hollis

British Library Cataloguing-in-Publication Data
A catalogue record for this book is available
from the British Library

ISBN 0-500-20270-2

Typeset in Monotype Ehrhardt and ITC Franklin Gothic
Quark™ed by Adam Hay Design, London
Printed and bound in Slovenia
by Mladinska Knjiga

Contents

Acknowledgments

The idea for this book originated during the 1960s at the West of England College of Art (particularly stimulated by discussions with the late Paul Schuitema) and at the Central School of Art in London; much of its visual material was assembled at the same time. The author's work would have been impossible without the help of many designer colleagues. Their names would make a list of unmanageable length, but among them particular thanks are due to Lutz Becker, Nicholas Biddulph, Sheila Bull, the late Mel Calman, Jon Corpe, Robin Fior, the late F.H.K. Henrion, David King, Robin Kinross, Guillaume Lefébure, Giovanni Lussu, Ruedi Rüegg, Philip Thompson and Marion Wesel.

The library staff at Central St Martins College of Art and Design, St Bride's Printing Institute in London and the Museum für Gestaltung in Zurich were especially helpful. Ann Creed Books, the David King Collection and the Department of Typography and Graphic Communication, University of Reading have generously lent material for illustration; Julian Hawkins was unfailingly co-operative in its photography, and the text has benefited from the editorial attention of Debbie Radcliffe and the typographical expertise of Adam Hay.

The author is grateful to his clients for their patience during the book's long incubation and also particularly to his wife, Posy Simmonds.

Author's note

The illustrations are intended to function in the same way as projected images at a lecture, and are for reference only, or for the reader's own further research. The scale of the original work is indicated by its description ('poster' or 'leaflet'); the size at which it is reproduced is sufficient only to convey the way in which words and images have been employed. Rather than giving individual credits, each image has been identified only by designer and title or description. The format of the captions has been devised to avoid distraction. They serve as references, and translations are given only where necessary.

Introduction

Visual communication in its widest sense has a long history. When early man hunted for food, and spotted the imprint of an animal in the mud, he was looking at a graphic sign.

His mind's eye saw the animal itself.

Graphics can be signs, like the letters of the alphabet, or form part of another system of signs, like road markings. Put together, graphic marks – the lines of a drawing or dots of a photograph – form images. Graphic design is the business of making or choosing marks and arranging them on a surface to convey an idea.

A sign is not a picture. Graphic images are more than descriptive illustrations of things seen or imagined. They are signs whose context gives them a unique meaning, and whose positioning can lend them a new significance.

Beware wild animals
British road sign

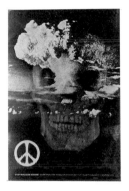

Campaign for
Nuclear Disarmament
poster 1960
[F.H.K. Henrion]

Most usually words and images are used together; either text or image may dominate, or each have its meaning determined by the other. Some of the most sophisticated examples of graphic design have relied on the precision of words to give an exact meaning to an ambiguous image.

When printed, the word, as a form of recorded speech, loses a whole range of expression and inflection. Contemporary graphic designers (and particularly their precursors, the Futurists) have tried to break this limitation. Their work gives sound to typographic expression through the size, weight and position of the letters. Indeed the urge to do more than merely convey a message, to give it a unique character, is instinctive.

Context also determines the sense of the design and how it is read. One of the best-known modern graphic designs – 'I love New York' – a mixture of pictogram and alphabetic signs, depends for its message on an agreed understanding of meaning and convention. We recognize

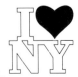

New York State
Department of Commerce
promotional logo
[Charles Moss /
Wells, Rich, Greene]

7

the image as a heart because that is how hearts are represented. When it is a textbook diagram the heart is no longer a metaphor for love.

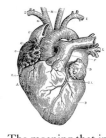 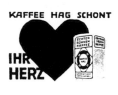

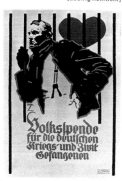

'Charity
for German prisoners of war
and civilian internees'
poster 1918
[Ludwig Hohlwein]

above, left
19th century medical illustration

'Kaffee Hag
looks after your heart'
advertisement 1920s
(pack design 1906)
[Eduard Scotland]

National Blood Transfusion Service
symbol 1948
[F.H.K.Henrion]

The meaning that images and alphabetic signs convey has little to do with who made or chose them: they do not express their designers' ideas. The designer's message serves the expressed needs of the client who is paying for it. Although its form may be determined or modified by the designer's aesthetic preferences or prejudice, the message has to be put in a language recognized and understood by its intended audience. This is the first way in which graphic design is significantly different from art (even though a large number of the early pioneers of graphic design were themselves artists). Secondly, unlike the artist, the designer plans for mechanical production. After commissioning, designs begin as rough layouts on paper or on a computer screen. The designer often acts as an art director, supervising commissioned photography or other illustrative material. Proposals discussed with the client are often revised in several stages, before the final form of the design is prepared with instructions for production.

rough sketch for logotype
and completed design 1960s
[Herb Lubalin]

As a profession, graphic design has existed only since the middle of the twentieth century; until then, advertisers and their agents used the services provided by 'commercial artists'. These specialists were visualizers (layout artists); typographers who did the detailed planning of the headline and text, and gave instructions for typesetting; illustrators of all kinds, producing anything from mechanical diagrams to fashion sketches; retouchers; lettering artists and others who prepared finished designs for reproduction. Many commercial artists – such as poster designers – combined several of these skills.

Graphic design has overlapped the work of the agencies and studios and now embraces not only advertisements, but also the design of the magazines and newspapers they appear in. The lone designer has become part of a team in the communications industry – the world of advertising, magazine and newspaper publishing, marketing and public relations.

Until the late nineteenth century, graphics were essentially black and white, print on paper. The relationship of the image and background, the inked and the non-inked, positive and negative space, became crucial to the aesthetics of the whole. The non-inked area can be just as important visually as the inked, and thus the background, its proportions and dimensions, its colour and texture, is an integral part of graphic design. At the same time, the background provides the physical support for the images and signs. The most common support is paper. The single sheet, printed on one side, may be a poster or a letter. As the sheet is folded once, it becomes a leaflet; folded again and fastened, it becomes a booklet; multiples of folded sheets, when trimmed, make a magazine or book. These – the poster, leaflet, booklet, magazine and book – are the physical structures on which graphic designers must organize their information. The content of the individual page, the double-page spread and subsequent pages must be arranged and structured to be viewed in sequence, as the narrative literally unfolds.

Graphic designers in the West inherited the Roman alphabet, whose forms had changed little for centuries. Initially imitating the letters made by the pen of the scribes, the letterforms evolved as variations of those in Roman inscriptions. Different versions of this historic prototype developed between the fifteenth and the twentieth centuries; the geometry of letters, their symmetry and proportions, attracted almost obsessive debate. Such preoccupations exemplify the changing pressures on designers from aesthetic fashion and technical progress in each period.

Physical supports and structures for graphics:

the single sheet printed one side

the single sheet printed both sides and folded

a number of sheets folded and fastened with or without a cover

construction of the letter 'R'
Venice 1509

construction of the letter 'I'
Paris 1692

right
'42-line Bible' 1445
left-hand page
fitting a grid of rectangles 9x9
based on the page proportion

The principle of letterpress printing from the raised surface of individual letters of moveable type
from Diderot's *Encyclopedia* 1745-72

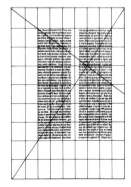

Over several centuries, the three basic functions of graphics have changed as little as the Roman alphabet, and any one design may be

used in all three ways. The primary role of graphic design is that of **identification**: to say what something is, or where it came from (inn signs, banners and shields, masons' marks, publishers' and printers' symbols, company logos, labels on packaging). Its second function, known in the profession as Information Design, is for **information and instruction**, indicating the relationship of one thing to another in direction, position and scale (maps, diagrams, directional signs). Most distinct from this is its third use, **presentation and promotion** (posters, advertisements), where it aims to catch the eye and make its message memorable.

Graphic design is now part of the culture and economy of the industrialized countries. However, despite progress in technology since the 1960s, allowing messages to be bounced off orbiting satellites and giving shared access to images, developments are still surprisingly localized and, though most designers work as part of a team, change is still associated with individual pioneers. New forms are nurtured in response to commercial pressures and changing technology, yet at the same time graphic design continues to feed off its own traditions. Although many images are created by designers themselves, many more are ready-made, like the old woodblocks re-used by medieval printers from earlier jobs, old engravings or stock photographs from a picture agency. The electronic revolution has given us the possibility of storing images from earlier periods and recycling them, manipulating and assembling them in contemporary design.

These factors have led to a chronological organization of this book, by developments in countries that have influenced graphic design internationally. The book uses the example of those designers who have most obviously contributed to the development of graphic design or are the most typical practitioners of their period. It charts the transformation of printed communication, and the role of new techniques and technology – photography and the computer – which have given the designer increasing control over the means by which graphics are produced and reproduced.

Graphic design constitutes a kind of language with an uncertain grammar and a continuously expanding vocabulary; the imprecise nature of its rules means that it can only be studied, not learnt. We cannot properly understand a piece of graphic design unless we can read the words. This book tries to make clear why alphabet and image look as they do. Its primary concern is not with what they look like, but what, together, they can be made to mean. It begins with the poster. As a single sheet, unfolded and printed only on one side, it is the simplest medium for graphic design. It exemplifies its essential elements – alphabet and image – and its means of reproduction.

identification:
tabard, shield and plumed helmet of Bertrand du Guesclin, constable of France
woodcut book illustration 1487

information and instruction:
How to trap birds
woodcut illustration, Paris 1660

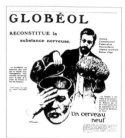

presentation and promotion:
'Globéol' tonic
advertisement 1912
photomontage
[R.Ehrmann]

1

The Art Poster

As graphic design, posters belong to the category of presentation and promotion, where image and word need to be economical, connected in a single meaning, and memorable. In the streets of the expanding cities at the end of the nineteenth century, posters were an expression of economic, social and cultural life, competing to attract buyers for goods and audiences for entertainments. The attention of the passers-by was grabbed by the posters' colour, made possible by the development of lithographic printing. Their illustrations, given a precise context by the text, reflected the artistic fashion of the day, and introduced a new aesthetic of simplified, economical images which derived from their means of reproduction.

Before lithography, posters were printed by letterpress, like books, in black ink from type with occasional woodblock illustrations. It was the printer who chose the type and arranged it, usually to fill the printed sheet. Although photography had existed for some decades, its images could not be reproduced in a large size, nor in large numbers. Artists now painted poster designs, which were transferred by hand to the flat surface of lithographic printing stones – one for each colour, sometimes using as many as fifteen – a technique which survived until well after the Second World War. This 'chromolithography' allowed the reproduction of the complete range of tone and colour of oil paintings like *Bubbles* (1886), the famous painting of a child by Sir John Millais, bought by Pears and used to advertise their soap.

The integration of artistic and industrial production is exemplified in the career of Jules Chéret. Son of a type compositor and apprenticed to a lithographer in Paris, he went to London to study the latest techniques. Back in Paris in the 1860s, Chéret gradually developed a system of three- or four-colour printing: a black drawing on a graduated, pale background colour, usually blue at the top, with the addition of strong red and delicate yellow. Chéret and those artists who followed his example in the 1890s could themselves draw with ink or chalk or paint freely on the printing stone to give large areas of solid colour, or they could spatter the surface to achieve a broken texture. The stone on which they drew gave a dense or open texture to the marks they chalked on it, providing a photographic range of tone. In this way, the artist had direct access to the process of reproduction, without the technical demands and graphic limitations of engraving in metal and wood.

From 1866, Chéret's studio and printing factory carried out the reproduction and printing of his own designs, sometimes on a scale of up to 2.5 metres (8ft) high, which required more than one sheet of paper. Almost without variation, they consisted of the single life-size figure of

Bubbles
chromolithograph
advertisement 1886
[J.E.Millais]

'Madrid International Exhibition'
advertisement 1893
[Théophile Alexandre Steinlen]

lithographic
printing stones

a young woman and one or two words of drawn lettering, occasionally with a slogan. The figures are detached from any usual perspective, their feet not on the ground but floating on the surface of the poster. The single figure and minimal text has persisted as the most frequently used combination of word and image. This formula was the basis of posters produced in Europe and America at the turn of the century. Images either as objective presentation of a product or as a symbolic representation of an idea were rare: aesthetic appeal was the artists' chief concern.

Chéret's mature style was achieved by the late 1880s, and was soon adopted and developed by other artists, particularly Pierre Bonnard and, more famously, Henri de Toulouse-Lautrec. Chéret's 'keyline' drawing – which he had changed from printing in black, to blue – established the design of the poster and was transferred to the printing stones as a guide for each colour. In these posters there is no light and shade, no depth. The subject is refined to flat colour and contour, and unprinted white paper, something like a map. The keyline serves as the boundary between one colour and another. Instead of the painstaking imitation of an artist's original, the design can be made on the stone with gradations of tone and built up with subsequent proofs from further stones (see p. 17).

The firm outlines and flat colour reflect the artists' enthusiasm for the woodblock prints of the Japanese, whose artefacts, shown at world fairs in Paris in 1867 and again in 1878, were the dominant aesthetic influence of the period. Even typefaces (like Auriol) imitated Japanese characters. Japanese prints and the influence of photography stimulated an unconventional use of space in the upright rectangle. Downward views, as in the *Bécane* poster by Edouard Vuillard, and cut-off figures, notably Lautrec's *Aristide Bruant dans son cabaret*, emphasize the decorative flatness of the pattern, and echo the spontaneous glimpses of photography. The fact that the lettering of such posters, though crudely amateurish, is hand-painted by the artist integrates it into the design.

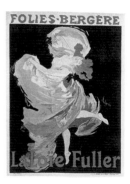

'La Loïe Fuller'
poster 1893
[Jules Chéret]

Auriol
typeface designs 1902
[George Auriol]

ABCDEFGHI
JKLMNOPQR
STUVXYZ
abcdefghijklmn
opqrstuvxyz

'Aristide Bruant in his cabaret'
poster 1893
[H. de Toulouse-Lautrec]

La revue blanche
magazine poster 1894
[Pierre Bonnard]

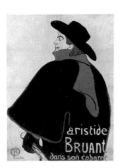
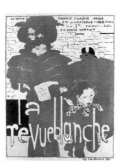

With the growth of the decorative style of Art Nouveau, the whole area of the poster became part of a textured surface. The single figures of women in the work of Alphonse Mucha, a Czech artist working in Paris, were given a suave contour drawing of face and body; the hair was developed into a stylized area of flat colour, fantastic in its formalized

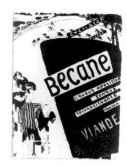

'Bécane : Reviving tonic,
beef extract aperitif'
poster 1890
[Edouard Vuillard]

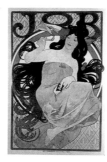
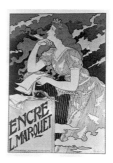

'Job'
poster for cigarette papers
poster 1898
[Alphonse Mucha]

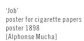

'L.Marquet ink'
poster 1892
[Eugène Grasset]

tendrils. His posters are animated with inventive lettering: in advertisements for *Job* cigarette papers the letters are designed into a geometrical monogram which appears as a repeat background pattern.

Artists outside France who saw Paris as the art capital of the world looked admiringly at its posters. Nevertheless, Amsterdam, Brussels, Berlin, Munich, Budapest, Vienna and Prague, Barcelona and Madrid, Milan and New York all nurtured schools of poster artists and brilliant individual designers. Milan produced the largest number of outstanding posters whose originality challenged Paris. The best-known and most influential was Leonetto Cappiello, whose long career in Paris resulted in a prodigious output of more than three thousand posters, which included several key works at different periods. At first he used various styles, particularly influenced by Lautrec and Chéret, from whom he adopted the use of the solid colour background. Cappiello had begun his career making caricatures, which led him to using cartoon-like ideas, an important technique developed by later poster designers in France, such as Raymond Savignac, in the 1960s. Cappiello's *Thermogène* pointed in this direction.

'Albert Robin brandy'
poster 1906
[Leonetto Cappiello]

'Thermogene warms you up'
poster for medicinal wadding 1909
[Leonetto Cappiello]

'Red throat: Solutricine pastilles'
poster 1957
[Raymond Savignac]

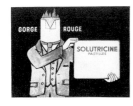

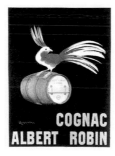
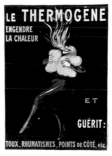

Italian poster design was led by Adolfo Hohenstein, born in St Petersburg in 1854, who began his career in Milan in 1890, and retired to Germany as a painter in 1906. Hohenstein and his colleagues, particularly Leopoldo Metlicovitz and Marcello Dudovich, placed realistic, fully three-dimensional figures, male and female, often nude, against stylized backgrounds in the late 1890s manner, but with a solidity of drawing and richness of colour – quite the opposite of the gauzy primary colouring

of Chéret – supported by great technical skills in their reproduction. Whereas their opera posters were decorative illustrations, in advertising consumer goods their images introduced a direct link of cause and effect, which connected a realistic representation of the product to a symbolization of its properties.

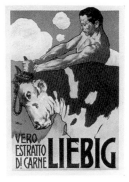

'Federazione Italiana inks'
poster 1899-1900
[Marcello Dudovich]

'Liebig meat extract'
poster 1894
[Leopoldo Metlicovitz]

Metlicovitz's Liebig beef extract poster shows a man 'taking the bull by the horns'. The idea of strength, shared by the bull and the man, is conveyed by the draughtsmanship, which exaggerates the virility of man and animal, contrasting them with the cotton-wool clouds. This contrast is expressed by a graphic technique typical of Italian design, which sets the realistic three-dimensions of the drawing against its flat colour: the man and the animal, the blue sky and the animal markings.

The visual use of metaphor, where an object is identified with an idea, had long been common in political cartoons. It was less usual in posters, but was employed to great effect in one of the strongest and most influential designs. This was the two-colour poster for the German satirical weekly *Simplicissimus*, by one of the magazine's illustrators, Thomas Theodor Heine. A red dog on a black background faces the viewer. Part of the chain it has broken dangles from its collar; the other is held under its left paw. The whites of the eyes, the teeth protruding from the lower jaw and the halves of the chain stand out in white, and so does the only word, '*Simplicissimus*'. The use of white, the unprinted paper, the reversed light out of dark, is a device which has become a traditional means for extending the designer's graphic range.

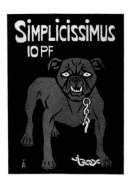

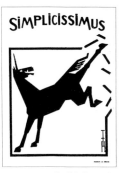

Americans considered Paris as the world's capital of fashion as well as of art. With the publication of a history, *Les Affiches illustrées*, in 1886, posters acquired cultural respectability and collecting them became fashionable. The Franco-Swiss Eugène Grasset, whose work in a range of decorative arts developed a restrained, academic version of Art Nouveau, was commissioned by the New York publishing firm of Harper Brothers in 1892 to design posters for the Christmas issue of their *Harper's* magazine. Such small indoor posters were an established means of advertising special seasonal issues in the 1890s. Several American artists successfully integrated illustrations with drawn lettering in their designs,

Simplicissimus weekly
posters 1896, 1898
[Th.Th. Heine]

the most accomplished being the Lautrec-like Edward Penfield and the Grasset-like Louis J. Rhead, and for *Lippincott's* magazine, William Carqueville and J.J. Gould.

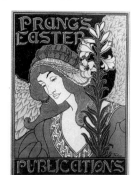

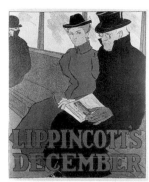

'Prang's Easter publications'
poster 1895
[Louis Rhead]

Lippincott's
indoor poster for magazine 1896
[J.J.Gould]

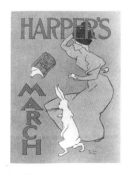

Harper's magazine
indoor poster 1895
[Edward Penfield]

'Arabella and Araminta Stories'
poster 1895
[Ethel Reed]

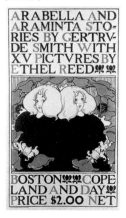

The Chap-Book
poster for magazine 1895
[Will H. Bradley]

The Modern Poster
poster 1895
[Will H. Bradley]

Penfield, who designed all the posters for *Harper's* from 1893 to 1899, was straightforward in his graphic techniques. His thinking is almost audible in the design for March 1896: March wind, March hare. The wind is indicated by the woman holding on to her hat, a copy of the magazine (the product) flies above the preoccupied white hare at her feet. The title lettering of 'Harper's' is almost standardized – a logotype or masthead. Lettering in designs by Ethel Reed was more original, given a decorative weight that matched her drawing.

The American poster artist whose career as a designer extended well into the twentieth century was Will Bradley. In 1894–5 Bradley's style matured in a series of posters for the *Chap-Book* magazine and covers for the *Inland Printer*, which brilliantly re-worked Art Nouveau mannerisms with medieval and Renaissance-inspired lettering. Bradley absorbed the influence not only of France but also of Japan and England, where a monthly journal, *The Poster*, had been launched in 1898 to satisfy public curiosity in and enthusiasm for this new art.

In an effort to rethink the role of art in an industrialized society such as Britain, William Morris and others, by emphasizing the role of handworkmanship, had looked back to Renaissance models, and at earlier more vigorous type designs. Bradley adopted their decorative borders

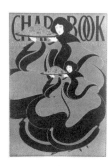

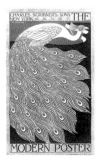

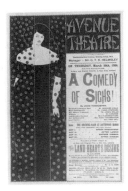

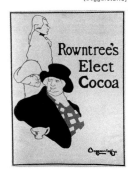

Avenue Theatre
poster 1894
[Aubrey Beardsley]

'Rowntree's Elect Cocoa'
poster 1895
[Beggarstaffs]

'Hamlet'
poster design 1894
[Beggarstaffs]

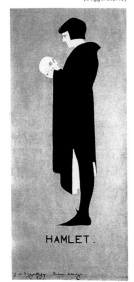

and large areas of black and white contrasted with fine line, as developed by the black-and-white illustrator Aubrey Beardsley. Beardsley orchestrated figures in a perspectiveless space by means of patches of black hair or costume and white areas defined by thin black lines of geometrical severity or lines packed together to make textured greys. The *Avenue Theatre* poster (1894) demonstrates his extreme economy and finesse. Out of blue and acid green he has produced veiled curtains with large green spots, their transparency indicated by the vertical dashes of line on the white areas of the woman's arms and shoulders. The mass of hair and the dress are defined by the delicate white line reversed out of the flat blue background, and the features of the face by line and stipple.

In Beardsley's design the image and the text, printed from type, were separated on the sheet. The integration of lettering with a similar, more robust use of flat colour was pioneered by two painters in the 1890s, William Nicholson and James Pryde, working in partnership as the Beggarstaffs. They employed a silhouette treatment as it was 'a very economical way of producing a poster for reproduction because the tones were all flat. To get this flat effect we cut out the designs from brown paper.' Their designs were generally asymmetrical, with heavy lettering used to counterbalance the main weight of the image, and restricted to two or three colours.

Poster artists of this period demonstrated the aesthetic freedom and creative daring that accompanies the first confrontation with new technical innovation in graphic production and reproduction. When artists, instead of adding text with printer's type, drew the lettering themselves, and when they were responsible for each element in a design which was intended for reproduction by machine, they were practising what was later to become recognized as graphic design. By inviting their colleagues to exhibit and reproduce their work abroad they established a professional international community so that Bradley's work, with Beardsley's and the Beggarstaffs', was seen in Paris, Munich and Vienna, as was that of Toulouse-Lautrec in New York and London.

Two-Dimensional Design and Graphic Reproduction

Outline is the simplest representation of an object in two dimensions. A solid outline (a silhouette) or its negative (the flat background shape) are the primary elements of graphic design. The Japanese woodblock print best demonstrates the effect of outline, background and silhouette, and is an obvious influence on Bonnard's poster (below). Reversing lines or letters out of a dark area or overprinting dark on light are two main sources of graphic variety.

Lithography at the end of the nineteenth century allowed artists to print large solid areas and to use colour, and gave them the freedom to draw their own lettering, which had previously been limited to a restricted range of ready-made type designs.

This control over print was the beginning of graphic design. Later, photography and computer technology became fundamental in the production and reproduction of both images and text.

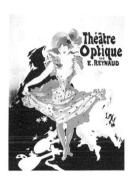

'Light-Show Pantomimes' poster 1892 [Jules Chéret]

far left
red and yellow printing, before the addition of dark-blue, mid-blue and pale blue green

centre
blue printing including keyline

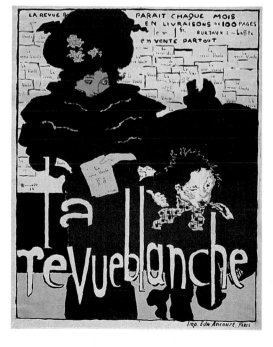

Marie in Furs
theatre poster, Japan 1968 [Tadanori Yokoo]

La Revue blanche
poster 1894 [Pierre Bonnard]

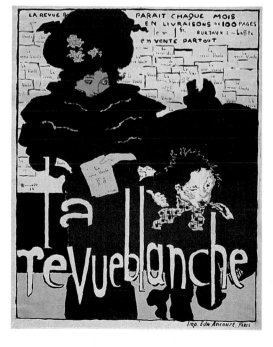

Imp. Edw. Ancourt, PARIS

Information Design

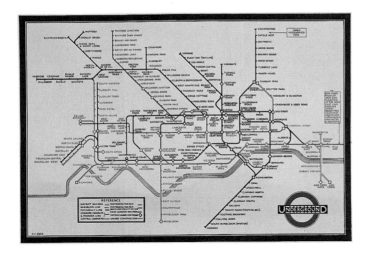

London Underground map
1933
[Henry C. Beck]

London Undergound Railways
map 1920s

The lines of a diagram do not describe a three-dimensional object but, together with other lines, they aim to convey relationships and show connections in a system. The London Underground map (discussed on pp.94-95) is one of the best known. It uses colour symbolically, as a kind of identifying label.

In the 1920s and 1930s, the Viennese Method, or Isotype, was pioneered by Otto Neurath. Isotype (International System of Typographic Pictorial Education) is a convention of signs and their use. In Vienna he presented the underlying social and economic structures in visual form as a basis for social provision, particularly in housing and public health. The two basic rules of Isotype are that a greater number should be represented by a greater number of signs – not by a single larger sign – and, second, that the presentation is free of perspective, where distance would require signs to be smaller and thus confuse their value.

Group practice in design was prefigured in the Isotype studio. Teams were responsible for collecting data; organizing it; designing the symbols and choosing their final size and position; and executing the final drawings ready for the printer or for exhibition.

'Casualties in the Great War 1914-18'
Isotype chart c.1933
[Otto Neurath, Gerd Arntz and
Marie Reidemeister-Neurath]

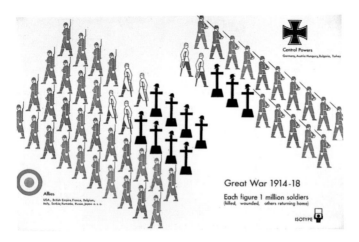

Bauhaus Typography

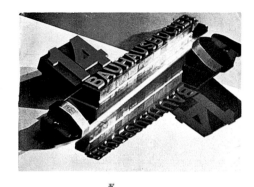

Bauhaus Books
prospectus,
cover and two double-pages 1927
[Laszlo Moholy-Nagy]

cover designs to Bauhaus Books:
No.1 [Farkas Molnar]
Nos.2, 10, 11 [Laszlo Moholy-Nagy]
No.3 [Adolf Meyer]
No.4 [Oskar Schlemmer]
No.9 [Herbert Bayer]

The Bauhaus books, mostly designed by Laszlo Moholy-Nagy, show a variety of typographic design. All of them employ the typical elements of what is called 'Bauhaus Typography' – sans-serif type and over-size numerals, and horizontal and vertical 'bars' (whose function is sometimes to emphasize, to help organize the information, but sometimes, as above, to decorate).

Bauhaus rationalism – exemplified in the school's letterhead of the period (see p.64) which demanded the use of lower-case letters only – was only adopted by Moholy-Nagy in 1930 for the text of the twelfth book. His cover photograph for the prospectus, as a mirror image of the inked metal type, exposes the printing process: it reproduces the reversal which takes place in printing.

Photography and Sequence

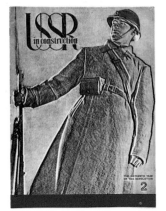

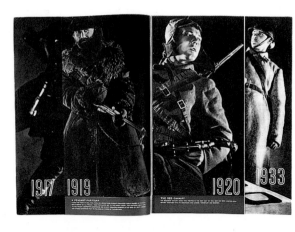

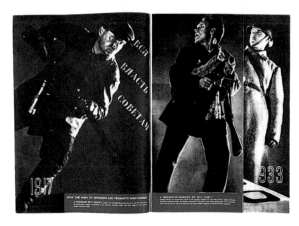

USSR in Construction
magazine layout 1933 [El Lissitzky]
See p. 50

During the 1920s and 1930s
designers met the challenge of
the new medium of film by
exploiting photography –
cropping and juxtaposing
photographs, reorganizing them
in photomontages and arranging
them on pages in a dramatic
narrative.

Pages were often cut
or given flaps, as here, or
had elaborate cut-outs and
fold-outs like the outfitter's
brochure (opposite).
As in the Bauhaus example
on p.19, Max Bill exposes
his graphic procedure,
'operating' on
the photograph of
the building's facade.

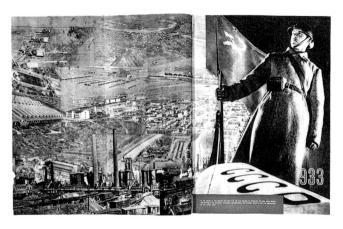

'Bespoke
tailoring'
booklet
Berlin, 1932
[Laszlo
Moholy-Nagy]

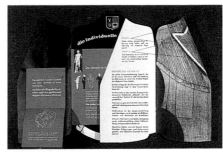

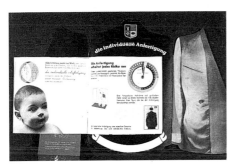

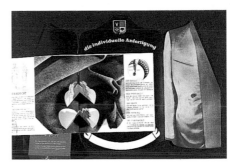

Clinical,
medical and
pharmaceutical
supplies booklet
Zurich, c.1938
[Max Bill]

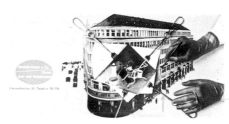

Printing Technique and Design

The most common way of printing, until the 1960s, was by letterpress (relief printing from type and photo-engraved metal blocks). Type and blocks were rectangular, wedged together for printing in a frame – columns of text type separated by a vertical bar. Tschichold's poster (below) has the structure of letterpress.

Herbert Matter's leaflet, however, conceals the rectilinear framework by using half-tone blocks with rounded and feathered edges , overprinted in colour. Its structure derives from the folds of the conventional format of tourist brochures.

'The Professional Photographer: his work – his tools' exhibition poster, Basle 1938 [Jan Tschichold]

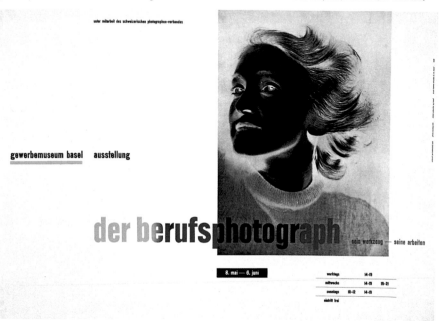

tourist brochure, Zurich 1935 [Herbert Matter]

'Europa 1907' exhibition catalogue cover
Amsterdam 1957 [Willem Sandberg]

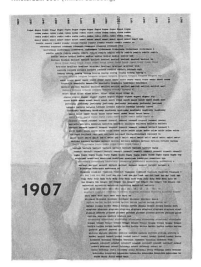

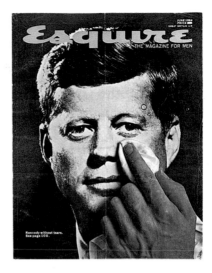

Esquire
magazine cover
New York 1964
[George Lois]

Sandberg has used the year 1907, literally
and typographically, as the vertical axis
around which the exhibition is centred.
Dates run along the top of the page.
The life span of each artist is indicated
by the repetition of their surname from
year of birth to death.

Colour and Visual Clues

The way we read this *Esquire* cover depends
on colour. The photograph of Kennedy, in
sepia, distances it in time, reminding us of
older images, perhaps even family snapshots.
The hand might be ours, the reader's.
Its full-colour realism wipes away the
sentiment expressed by the 'tears'.

The designer George Lois has used the
techniques of the 'New Advertising' of the
1960s, where words (here, 'Kennedy without
tears') and image were integrated into
a single idea (see p.113).

The role of the red ears in Grapus's
complex, almost monochrome theatre
poster are discussed on p.197.

A Heart under a Cassock
theatre poster, Paris 1977
[Grapus]

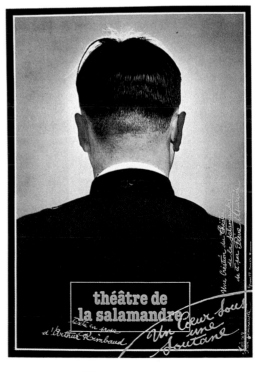

Printing Technique and Colour

23

Production and New Technology

In the 1970s and 1980s, a new generation of designers began to exploit the possibilities of the computer. The single most important influence on this 'New Wave' was Wolfgang Weingart, a typographic designer teaching in Basle. Weingart, trained as a typesetter, distorted and extended phototypesetting and used the reproduction process to merge type and image. In this poster, he overlaid half-tone films with a dot screen: as with Moholy-Nagy, the graphic result expresses the technical means by which it is achieved. Weingart's references here are to clichés of Swiss tourist posters – the winding mountain road and profile of Mont Blanc.

April Greiman, an American who had studied with Weingart, replaced photographic montage with 'hybrid imagery' assembled by computer (see p.212).

One hundred years after artists appropriated the new medium of lithography, graphic designers exploited new technologies to take control of the production of text and image.

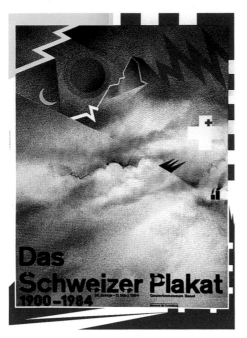

'The Swiss Poster' exhibition poster Basle 1984 [Wolfgang Weingart]

Design Quarterly magazine fold-out poster 1986
[April Greiman]

2

The Beginnings of Design
in Europe

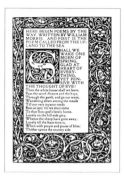

In late Victorian Britain, one of William Morris's and the Arts and Crafts Movement's interests was book production. In 1891 the first book was printed at Morris's Kelmscott Press. Between then and 1896 when Morris died, more than fifty titles were produced in a variety of formats, often with woodcut decorations and borders, set in typefaces made to his own specifications from photographs of fifteenth-century printed letters. These and books from other private presses were among British graphic work much admired in Continental Europe.

The cafés of Vienna, in which members of all professions associated and new ideas were discussed and disseminated, kept journals for their customers to read there. An advertisement for the Café Piccola, in its list of journals, places *The Studio* second. Reckoned to have a German readership of twenty thousand by the mid-Nineties, *The Studio* was published in London. Its inaugural issue in 1893 had been the first to publish the drawings of Aubrey Beardsley. The magazine included reports on the Arts and Crafts Movement, the Beggarstaffs' posters and on the Glasgow School of designers – Charles Rennie Mackintosh, Margaret and Frances Macdonald and George Walton. All aroused intense interest in Germany and Austria.

Poems by the Way
book page 1897
[William Morris / Kelmscott Press]

'The Glasgow Institute of Fine Arts'
poster 1894/5
[Herbert McNair, Mary Macdonald,
Frances Macdonald]

The Scottish Musical Review
poster 1896
[Charles Rennie Mackintosh]

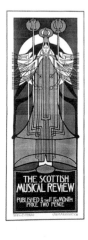

Vienna, the capital of the Austro-Hungarian Empire, had been replanned in the 1860s, and was being rebuilt as a modern city, but in Renaissance style. For the artists and architects, a more creative attitude to history was evident in the British craft workshops and in the example of Henry van de Velde, a Belgian follower of Morris. Both

Morris and Van de Velde used domestic visual taste as an index of moral health, and for both, design was the chief element in their utopias.

As with Morris and Van de Velde, many of the Viennese artist-designers worked in several fields. Gustav Klimt, a painter widely commissioned to decorate the buildings of the new Vienna, led the move away from historical styles, forming an association of artists that became known as the Secession. Klimt's design for the cover of the first Secessionist exhibition catalogue of 1898 employs the same extreme vertical format as some of Beardsley's posters, the same empty wall-like space with its implication of a theatrical setting, extreme asymmetry and single weight of line. This even line unifies the drawing and lettering in a way which is essentially graphic: it is two-dimensional, drawn for graphic reproduction.

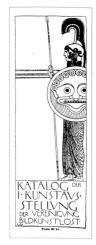

'First Secessionist exhibition'
catalogue cover 1898
[Gustav Klimt]

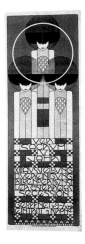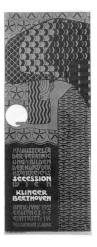

'13th Secession exhibition'
poster 1902
[Koloman Moser]

'14th Vienna Secession Exhibition'
poster 1902
[Alfred Roller]

The Procession of the Months
book and calendar c.1900
[Walter Crane]

The posters for the Secessionist exhibitions developed a graphic language with a rich variety of expression, which fused illustration, decoration and text, synthesizing the Japanese influence, Beardsley and the theoretical book of the English illustrator Walter Crane, *Line and Form*, published in 1902. The same year, Alfred Roller's poster for the fourteenth Secessionist exhibition demonstrated this Viennese manner. Its illustration is extravagantly formalized: elements such as dress, wings and hair have become decoration, as with Mucha. The sinuous, insistent contour of Art Nouveau has all but disappeared and the line, printed in the same four colours as the flat areas of the poster, makes pattern rather than describes depth. The surface is further emphasized by using unprinted paper for the brightest parts of the lettering carrying the salient information, so retaining the even size of letters and the overall texture and patterning.

In Vienna, the conventionalized forms of the letters of the alphabet were subject to stylizations and distortions unsurpassed in their decorative invention – and unreadability. These were both advertised and crit-

lettering 1901
[C.R. Mackintosh]

26

ÜBER·ZIER:
SCHRIFTEN
IM·DIENSTE
DER·KUNST:

lettering on book cover 1899
[Rudolf von Larisch]

PROJEKT·FÜR·DEN·NEV=
BAV·DER·FERDINANDS=
BRVCKE·IN·WIEN
ANSICHT·DES·STIEGEN

architectural drawing lettering
1909
[Otto Wagner]

Die Zeit telegraph office
1902
[Otto Wagner]

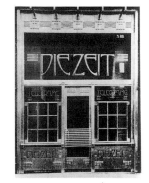

proposed trademark for
the Wiener Werkstätte
1903
[C.R.Mackintosh]

monograms of
the Wiener
Werkstätte: The Wiener Josef Hoffmann
 Werkstätte Koloman Moser
 red rose

Letterhead
1903
[Josef Hoffmann]

icized in *Decorative Type in the Service of Art* (1899), a book by a lettering teacher of an older generation, Rudolf von Larisch. He berated the designers for their ill-drawn letters, the way they failed to fit together and the excess of their ornament. At the same time Larisch approved the lettering of the principal architect of the Viennese Renaissance style, Otto Wagner, who had himself joined the Secessionist artists in 1899.

The lettering of Wagner's architectural perspective drawings had been remarkable, but his 1902 facade of the Die Zeit telegram office is astonishing in its resemblance to Viennese graphic work. Notably, it incorporated the small square as an ornamental motif. The square (to play a recurring and important role in graphic work of the 1920s) was to become almost an obsession with the designers of the Wiener Werkstätte (Vienna Workshops). This was a manufacturing and marketing enterprise for the crafts, established in 1903 by a former assistant of Otto Wagner's, Josef Hoffmann, and the designer Koloman Moser, both teachers at the Vienna Kunstgewerbeschule (School of Arts and Crafts), with the backing of Fritz Wärndorfer, an industrialist and patron of Charles Rennie Mackintosh, and collector of Beardsley drawings.

Mackintosh himself suggested a trademark, but a complete visual identity for the firm was designed by Hoffmann. Each article was produced with four identifying marks: the Werkstätte's red rose symbol, and the monogram marks of the Werkstätte, the designer and the maker. Hoffmann designed letterheads, cards, invoices and wrapping paper. The square motif is repeated throughout. On the writing paper the squares seem to follow Wagner's principle that 'something unpractical cannot be beautiful' and are employed to show where the paper folds, twice horizontally, so that the squares appear in the corner of each area of the folded sheet. As part of the programme to produce a totally designed environment, even the key to an office cupboard had its handle in the form of the rose trademark.

The square was the format adopted for the Secession's monthly review, *Ver Sacrum* (*Sacred Spring*). Launched in 1898, it discussed exhibitions and published contributions of the literary avant-garde, carrying

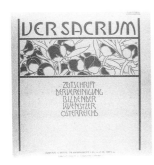

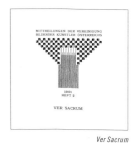

Ver Sacrum
above
title page 1901
[Koloman Moser]
far left
cover 1899
[Adolf Böhm]
centre
advertisements in *Ver Sacrum*
1899
[Maximilian Lenz, centre
Josef Hoffmann, far left, far right
Koloman Moser, left and right]

State Printing House
centenary book 1904
[C.O.Czeschka / Koloman Moser]

illustrations and decorations by Secessionist artists reproduced by the photomechanical techniques of much cheaper periodicals, often using two colours with extreme economy and to great effect. *Ver Sacrum* was more in the exclusive tradition of the private-press book than the magazine – when it closed after six years its subscription list numbered only six hundred. Equally important in its influence, and economical with its means, was *Die Fläche* (*The Plane Surface*), a series of portfolios of design.

The Viennese designers' enthusiasm for the new techniques of reproduction is hinted at in Carl Otto Czeschka's drawing of the State Printing House's process studio, set within a border designed by Moser. The typography is by Larisch. Unlike their posters, the pages of most Viennese books were less successful in making a consistent unit. German had been traditionally printed in black-letter 'Gothic' type known as Fraktur. This was gradually ousted in favour of versions of fifteenth-century Venetian type. Such a historicizing design was adopted by the radical architect Adolf Loos for the masthead of his journal *Das Andere* (*The Other*), subtitled 'Towards the Introduction of Western Culture into Austria'. 'The type', he said, 'looks as modern as if it were made yesterday. More modern than the Otto Eckmann [Art Nouveau] letters of the day before yesterday.'

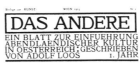

Eckmannschrift
typeface 1900
[Otto Eckmann]

Das Andere
magazine masthead
Ver Sacrum Antiqua typeface 1903
[Adolf Loos]

Vienna's turn-of-the-century designers absorbed the lessons of the Arts and Crafts and, in their eclecticism and internationalism, in their enthusiasm for new techniques, heralded the avant-garde movements in design that followed the First World War. In their drawing and lettering, Egon Schiele's and Oskar Kokoschka's graphic works are masterpieces of early Expressionism; the interchangeability of figure and ground in Larisch's teaching on lettering, demonstrated by Koloman Moser in his decorations, was to become a principle of basic design education. Viennese designers were mostly their own clients, but their commissions went beyond fashionable society to the State itself. In 1902 Koloman Moser began designs for bank notes, and for postage stamps,

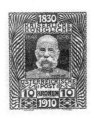

framing the image with his typical patterned border. (Those for Bosnia-Herzegovina in 1906 were the earliest stamps to use photographs.) Yet Viennese designers remained essentially artists: it was many years before the profession of graphic design was to be established.

A move in this direction was taking place in Germany through the work of Peter Behrens and Van de Velde. As painters-turned-architects, they saw design as part of a programme to integrate all the arts into daily life, like the Futurists in Italy and the Constructivists in Russia were to do after the First World War.

Influenced by William Morris, Van de Velde also designed private-press books, but rather than ignore the machine, he was inclined to master it and to persuade industry to let the artist determine the shape of its products. He had some success. His poster design for Tropon concentrated food is typically Art Nouveau. Although published as a print in the Berlin art and literary magazine *Pan*, it was a thoroughly commercial undertaking as part of a range of advertising and packaging.

'Tropon Egg-White Concentrate'
showcard 1898
[Henry van de Velde]

'Tropon Children's Food'
package 1898
[Henry van de Velde]

'A Document of German Art:
exhibition of the Darmstadt Artists'
Colony'
poster 1901
[Peter Behrens]

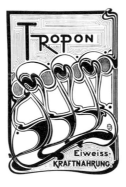

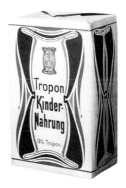

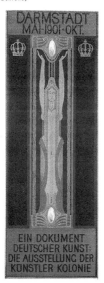

Such patronage began a tradition of enlightened interest in design shown by the leaders of some large companies in Germany in the early years of the century: Bahlsen biscuits, Kaffee Hag and Günther Wagner 'Pelikan' inks were the forerunners in corporate image-making. The most comprehensive effort in this area was made by Peter Behrens. His early graphic work, such as the 1901 poster for the inaugural exhibition of the art colony in Darmstadt, clearly echoes the elongated format of the Glasgow School posters, but is entirely twentieth-century in its restrained drawing and almost mechanical lettering. A letterform that absorbed traditional elements was Behrens's own typeface, Behrens-Schrift. 'For the precise form of my type,' he wrote, 'I took the technical principle of gothic script, the stroke of the quill pen. Also, in order to achieve an even more German character, gothic letters were a decisive influence on me for the proportions, the height and width of the letters and the thickness of the strokes.' It was not until 1916 that Behrens arrived at a form that shed historical references. This was designed for the electrical combine Allgemeine Elektricitäts Gesellschaft (AEG), to which Behrens was appointed in 1907 as architect and designer. His

publicity material for AEG, austere and geometrical, is recognized to be the first application of comprehensive design as part of company policy. First known as 'house style' – which was a series of rules that gave consistent treatments to all elements within an organization – this was developed in the 1930s by Olivetti in Italy and the Container Corporation of America as Corporate Identity. The central feature was the trademark, a kind of emblem with or without the company or brand name, which was always in the same style of lettering. (In letterpress, this was often printed from letters joined together or cast in metal as one piece and known as a logotype.)

ABCDEFGHI
JKLMNOPQR
STUVWXY3
abcdefghijkl
mnopqrſßstuv

Behrens-Schrift
typeface design 1902
[Peter Behrens]

PETER BEHRENS
NEUBABELSBERG
Allgemeine Elektrizitäts
Geſellſchaft

sans-serif lettering 1916
[Peter Behrens]

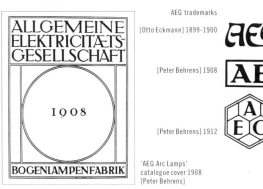

AEG trademarks

[Otto Eckmann] 1899-1900

[Peter Behrens] 1908

[Peter Behrens] 1912

'AEG Arc Lamps'
catalogue cover 1908
[Peter Behrens]

'AEG Incandescent Lamps'
showcard 1899-1900
[Otto Eckmann]

If the main thrust of the development of graphic design after the First World War centred on the avant-garde and its aspirations, a less hectic and no less brilliant evolution was taking place in the commercial poster. Since the 1900s, poster designs had been reproduced not only as postcards and enamel signs, but also as perforated adhesive labels, like postage stamps, and adapted for packaging. This encouraged economy in design and colour. In Germany the period from the start of the century to the First World War saw designs that developed the refined, vigorous aestheticism of the Beggarstaffs to advertise consumer products. In Berlin a group of designers associated with the printing firm of Hollerbaum und Schmidt broke new ground: their posters restricted the image to the object being advertised, and the words to the brand name. This style became known as the *Sachplakat* ('object poster'). Its chief master was Lucian Bernhard. His most famous designs, for Priester matches

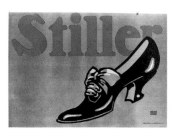

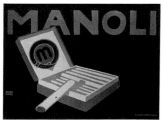

'Stiller'
poster c.1908
[Lucian Bernhard]

'Manoli'
poster c.1912
[Lucian Bernhard]

(1906), for Stiller shoes and Manoli cigarettes, needed no verbal elaboration. The object is presented with the same unambiguous graphic simplicity as the lettering.

Also working for the same printer were two other masters of the *Sachplakat*, Hans Rudi Erdt and Julius Gipkens. Erdt's Opel automobile poster, in a restricted range of flat colours (black, blue, grey and two browns), is exceptional in its graphic invention: the 'O' of Opel is a completely regular circle describing a tyre with the same visual conventions as the drawing of the driver's head. (The 'O' would normally have the same alphabet forms as 'pel'; it would be thicker at the sides, like the 'O' of the typeface in which the text of this book is printed.)

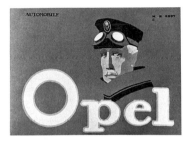

The fourth significant German designer of the *Sachplakat*, Ludwig Hohlwein, worked in Munich. His style, similar to the Beggarstaffs', used heavy lettering forced into rectangles, and large rough-edged areas of colour, their flatness broken by the texture of wet, curdled paint, accented by photographic shadows and highlights, the whole design framed by a border.

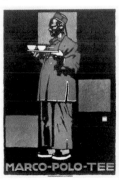
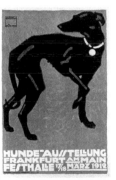

The *Sachplakat* co-existed with the more conventional commercial posters. Like advertisements, they deployed slogans, using words in the way they were used in newspapers and magazines, as headlines and captions to pictures. However effective, such work belongs to a history of advertising. Only when advertising has a single visual concept, as it developed in the United States in the 1950s (see Chapter 13), does it have a significant place in the history of graphic design.

3
War and Propaganda
1914 to the 1920s

The First World War established the importance of visual design. The diagram, illustration and caption helped to inform and instruct. Signs and symbols for military identification of rank and unity were a code of status that was instantly understood. The regimental badge, with its heraldic device and its motto, had much in common with the equally economical design and the lean, powerful images and slogans of the new posters. These were called into service by governments – where today radio or television would be used – for public announcements and propaganda and to exhort citizens to share in the war effort.

The posters produced by the warring nations, France, Great Britain, Italy, Austria-Hungary, Germany, Russia, and later the United States, reflected the character and stage of development of graphic design in each country. Germany's commanding designers – Bernhard, H.R. Erdt, Gipkens, Hohlwein – were joined by others, notably Louis Oppenheim.

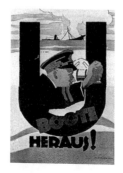

The virtues of the *Sachplakat* – simple, concentrated images, flat colour, solid shadows, with consistently well-drawn lettering in a dense texture – gave their works a graphic unity missing in the posters of other countries. In Britain and the United States an enlarged painted illustration, to which the printer added lettering, undistinguished in layout and feeble in design, was the most familiar form of war-time poster. French posters were typically well-drawn, by such artists as Jean Louis Forain and Steinlen, often accompanied by long, sometimes poetic, texts.

Two followers of this French manner, and exceptions to the conventions in their own countries, were the American artist Joseph Pennell and, in England, Frank Brangwyn. The heavy contrasts, dramatic chiaroscuro and strong drawing of Brangwyn's designs depict the war with unusual realism, to which he added the grave authority of hand-drawn lettering in bold roman capitals.

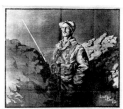

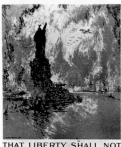

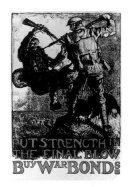

DEBOUT DANS LA TRANCHÉE
QUE L'AURORE ÉCLAIRE, LE SOLDAT
RÊVE À LA VICTOIRE ET À SON FOYER.
POUR QU'IL PUISSE ASSURER L'UNE
ET RETROUVER L'AUTRE,
SOUSCRIVEZ
AU 3ᵉ EMPRUNT DE LA DÉFENSE NATIONALE

THAT LIBERTY SHALL NOT
PERISH FROM THE EARTH
BUY LIBERTY BONDS
FOURTH LIBERTY LOAN

PUT STRENGTH IN
THE FINAL BLOW
BUY WAR BONDS

'Standing in the trench lit by the dawn,
The soldier dreams of victory and home.
So that he can achieve the one, and
return to the other,
Subscribe to the 3rd National War Loan.'
poster 1917
[Lieutenant Jean Droit]

'Buy Liberty Bonds'
poster 1918
[Joseph Pennell]

'Buy War Bonds'
poster c.1917
[Frank Brangwyn]

In each country, the categories of war-time poster were the same. Those for recruiting troops appealed to patriotism, and induced guilt at letting others face danger on their behalf. In Britain, this produced a forerunner of 'art-directed' advertisements, where objects, people and their relationships are arranged to convey precise meanings. The famous slogan 'Daddy, what did YOU do in the Great War?' accompanies the kind of illustration that was common in magazines, banal in its execution but telling in its ingredients. The style of sitting-room and the carefully dressed children suggest post-war affluence; the boy playing with toy soldiers displays the 'correct' male attitude of romantic militarism.

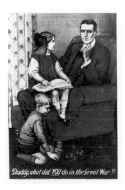

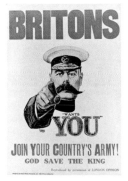

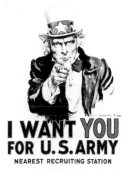

'Daddy, what did YOU do in
the Great War?'
poster c.1915
[Savile Lumley]

'Britons [Kitchener] Wants You'
poster 1914
[Alfred Leete]

'I Want You for US Army'
poster 1917
[James Montgomery Flagg]

There were also British posters that used a straightforward image without rhetoric to accompany a bald assertion, like 'Be honest with yourself. Be certain that your so-called reason is not a selfish excuse.' Image and sans-serif text, given equal weight, were an objective, factual tendency which emerged most clearly in Swiss advertising twenty-five years later (see Chapters 10 and 14).

The best-known recruiting poster was the 1914 British 'Your Country Needs You'. It had an illustration of Lord Kitchener, the Minister of War, enlarged from a magazine cover, who was easily recognized by the shape of his massive moustache and Field-Marshal's cap and badge. It was much imitated, inspiring the 'I want you for U.S. Army', a self-

portrait of the artist, James Montgomery Flagg, as Uncle Sam. The elements of this design are simply arranged, its patriotic colouring emphasized by the red, white and blue border. Later, the public figure directly addressing the viewer became a significant device. Oppenheim gave a monumental graphic treatment to Field Marshal von Hindenburg's head in the manner of a three-colour woodcut, with the commander's autograph message. This simple technique and the economy of handwriting reinforces the personal, direct appeal. The graphic form carries part of the meaning. It is not the literal, pictorial manner of Kitchener's or Uncle Sam's accusing finger.

German designers were aware of Allied posters. They were reproduced in the magazine *Das Plakat* which was published throughout the war. In Berlin there was even an exhibition of British recruiting posters in 1915. With a conscript army, the Germans had no need of this type of poster. Yet for other purposes they needed posters urgently. The war was not only taking lives in huge numbers, it was consuming vast resources in munitions and supplies. Posters were the means used by the state to persuade its citizens to lend it money by subscribing to war loans. These campaigns emphasized and reflected national differences in their graphic character. The woodcut style of the mailed fist and heavy Fraktur lettering in black and red of Bernhard's 1917 war loan poster would have been reassuring in its association with Teutonic history (the dense texture of religious script and the armoured fist). For the ninth and final war loan of 1918, Bernhard used heavy lettering alone, impeccably drawn and laid out to produce a powerful and unquestionably Germanic style.

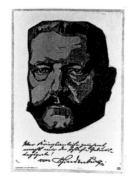

'Whoever subscribes to the [7th] War Loan is giving [me] the best birthday present! – von Hindenburg'
poster 1917
[Louis Oppenheim]

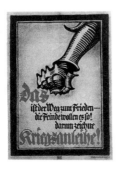
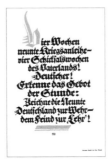

far left
'This is the way to peace – the enemy has asked for it! So subscribe to the [7th] War Loan.'
poster 1917
[Lucian Bernhard]

'Four weeks Ninth War Loan – four weeks of fate for the Fatherland'
poster 1918
[Lucian Bernhard]

'The Hun – his Mark'
poster 1917
[J.Allen St John]

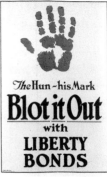

Attempts in the Allied countries at using a visual metaphor were rare. *The Hun – His Mark. Blot it Out with Liberty Bonds* is a crude visual translation of 'blood on his hands', but effective propaganda.

Apart from illustrating its own soldiers as heroes of chivalry and the enemy as rapacious beasts, the stereotypes that were already familiar in magazine caricatures became, in varying degrees, graphically simplified. The soldier at the front was less commonly represented by Brangwyn's realism than by a knight in armour, and national fighting spirit by the German and American eagles, the French cockerel, the British lion and the Russian bear.

In 1918 the Austrian designer Julius Klinger used the red figure '8' of the eighth war loan as a trap for the Allies, represented as a black and green dragon, its writhing head and neck transfixed by a succession of arrows, one for each of the seven preceding loans.

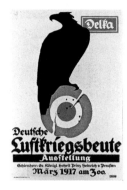

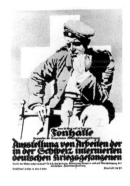

The German designers' similar mastery in combining various types of representation in a single clear idea is exemplified in a design by Gipkens. This is his poster for an exhibition of captured trophies from the war in the air. With a silhouetted black eagle perched on the bullet-holed roundel marking of an Allied plane, Gipkens extends an economical graphic language in an astonishingly natural but complex manner. Because the circle of white in the red-white-and-blue roundel, pierced by bullet holes, is the unprinted white of the paper, the poster seems to be part of the actual surface of the aircraft. The bullet holes are illustrations; the eagle, while its outline is realistic, is a symbol, and the identification mark which it grasps is a hybrid – both a drawing of the mark and the mark itself.

The familiar graphic mark of the Red Cross was used internationally, handled with dramatic skill by German poster designers. In one instance it appeared with its colours reversed, as the Swiss flag, to advertise an exhibition of work by German internees in Switzerland. This was a design by Hohlwein, whose work lost none of its elegance during the war. It demonstrated a spare, affecting power in a series of posters to raise funds for prisoners and the disabled. He used the red heart, a trite symbol common in postcards, as a sign of compassion, behind a lone, half-length figure and vertical prison bars (see p.8).

Many elements and characteristics of graphic design appeared in the war, not only in posters. The military needed systems of signs for organizing and identifying its personnel and supplies, and clear manuals of instruction for their deployment and use. The hierarchy of command and authority was marked by badges of rank, a system of signs that had to be learnt. Apart from the regimental badge for troops, the use of motorized transport brought the need to identify units by corps and division. So that they could be less easily identified by the enemy, formations of the British army were given coloured stripes and rectangular

patches. Staff officers in corps or divisions designed symbols for their organizations. Some were simple monograms, like the Highland Division's 'HD'; more elaborately, the 32nd Division's symbol was composed of four figure '8's.

The war posters produced stereotypes that were the basis of the political propaganda of the turbulent years that followed in Italy, Russia and Germany. National aspirations that had focused on wartime leaders now turned Marx, Lenin and the Fascist dictators into icons; caricatures of the enemy as barbarians or ravenous beasts now served to represent the horrors of Bolshevism and the evils of capitalism.

The posters of 1914 to 1918 mark a turning point. Drawn and painted illustration was to lose its place as the dominant pictorial technique in printed graphics. Black-and-white photography was now easily reproduced mechanically. Flashbulbs, faster film emulsions and lenses helped photography develop as a means of recording events and appearances. Studio lighting and retouching gave the photographic image a drama, glamour and excitement that it shared with the cinema.

In Europe commercial designers like Bernhard were joined by avant-garde artists who saw graphic design as a means of extending art into modern life. They used and abused traditional typesetting. They exploited photography as an objective form of illustration and juxtaposed images to expose new meanings. At the same time they subverted it, destroying and re-assembling its images by montage, which was to become a new expressive and critical device.

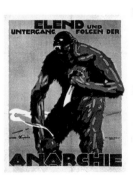 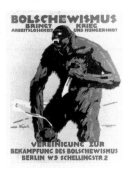

'Misery and destruction are what follows anarchy'
poster 1918
[Julius Engelhard]

'Bolshevism brings war'
poster 1918
[Julius Engelhard]

4

Futurism and Italy

In the decade 1910 to 1920 the old Europe was shaken by the First World War and convulsed by political unrest. The foundations of modern art were laid by the avant-garde, which at the same time introduced new ways of looking at words and of using the alphabet to make images. The practice of reading words arranged in horizontal lines, page by page, had long been established before printing was invented. In posters and on the title pages of books, words were symmetrically arranged in a hierarchy of importance through different sizes of type. Apart from making shapes with type, this seemed an unassailable convention. Little attempt had been made to arrange words in a way that would enhance their individual or collective meaning.

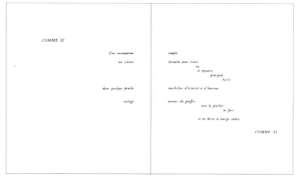

Un coup de dés
double page of poem 1897
[Stéphane Mallarmé]

'Il pleut'
poem from *Calligrammes* 1914
[Guillaume Apollinaire]

In 1897 the French poet Mallarmé had produced a twenty-page poem, *Un coup de dés* (*A Throw of the Dice*), which not only broke typographic conventions but also gave reasons for doing so. Mallarmé saw the two open pages of a book as a single space. Across the double-page spread he treated his *vers libre* (verse free of rhyme and metre) as 'a musical score for those who wish to read it aloud. Differences in type used for the major motif, for the second and subsidiary ones, dictate their importance when spoken.' The white space was 'like silence'. In it he placed the words, sometimes each on successive lines, like the treads of a staircase. The advantage of 'this distance, whereby groups of words or individual words are mentally separated, is that it seems now to accelerate, now to slow down the movement'. He confessed that the poem 'does not everywhere break with tradition; in its presentation I have in many ways not pushed it far enough forward to shock, yet far enough to open people's eyes'.

Futurism and Italy

37

Shock, in addition to opening people's eyes, was part of the Futurist programme. Their battles on the typographic front began before the First World War. The movement was led by the poet Filippo Tommaso Marinetti, an exponent of 'free verse', who published the first and most famous Futurist manifesto in Paris in 1909. Marinetti took its message – glorifying aspects of the modern world such as speed, motor cars, aeroplanes, war – on noisy tours of European capitals.

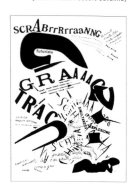

far left
Zang Tumb Tumb
book cover 1914
[F.T.Marinetti / Cesare Cavanna]

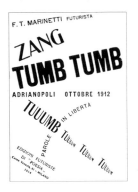

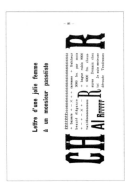

In 1914 Marinetti published his first book of what he called '*parole in libertà*'. Entitled *Zang Tumb Tumb*, it was a kind of verbal painting to celebrate the recent Battle of Tripoli, which tried to find visual equivalents of sounds in the shapes and relative size of the words. It exemplified Marinetti's programme for a Futurist literature, which anticipated many ways in which words came to be used in graphic design: 'One must destroy syntax and scatter nouns at random . . . One should use infinitives . . . One must abolish the adjective . . . abolish the adverb . . . one should deliberately confound the object with the image that it evokes . . . abolish even punctuation.' Most importantly, Marinetti realized that the letters that made up words were not mere alphabetic signs. Different weights and shapes, not only their position on the page, gave words a distinct expressive character. Words and letters could be used as visual images almost in their own right.

Words Set Free
above, left
poem (typeset vertically)
'Letter from a pretty woman
to an old-fashioned gentleman'
(CHAIR = 'FLESH')
above
'In the evening in bed, she re-read
the letter from her gunner at the front'
(unfolding page)
1919
[F.T.Marinetti]

Marinetti joined forces with the like-minded writer Giovanni Papini and the painter Ardengo Soffici in the magazine *Lacerba* published in Florence from 1913. It had a radical avant-garde standpoint and its fortnightly circulation of 20,000 copies was predominantly among workers. *Lacerba*'s typographic experiments mapped out the ground that was to be fought over for the next thirty years by the avant-garde and its enemies. In several cities of Italy, pages of pamphlets and reviews appeared, animated with words set free. Some artists and writers covered pages with crazy abandon; others restricted themselves to a few words.

The words replaced images in the same way that the pictures of silent movies were interrupted and exchanged for words on the screen that continue the narrative – 'Our hero arrives' – or substituted for the sound as the heroine screams 'Help!'.

Lacerba
magazine page 1914
[Francesco Cangiullo]

38

The sounds of battle were the loudest in *Zang Tumb Tumb*: single words were placed at oblique angles on the page – technically difficult and time-consuming for a printer using rectangular pieces of metal type, but a printing problem to which Marinetti had a solution: in Rome he lived above a printer whose wooden type he cut up and stuck together. More conventionally, ready-printed letters could be stuck down from which a photo-engraved relief line block would be made for printing.

For the cover of his own poems, *BIF & ZF+18*, Soffici used an assemblage of ready-made typesetting, wooden type material which he cut up, with poster letters and existing photo-engravings in a technique that the German Dadaists used a few years later. In the same revolutionary book, Soffici introduced in conventional columns of text sudden changes of style and size in the typeface: sometimes large, often sans-serif type, sometimes lines of a much smaller size – almost a whisper on the page. Even more extraordinarily, Soffici punctuated his text with fragments of advertising blocks.

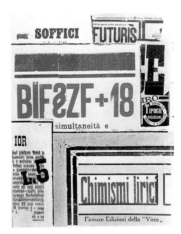

As self-publicists, the Futurists welcomed advertising as a manifestation of modern life and as the antithesis of the museum culture they despised. Marinetti said, for example, that the illuminated signs facing Milan Cathedral could 'express the splendour of a poetic imagination radiating to eternity'. It was a way of continuing poetry by other means. For the most important figure in graphic design, Fortunato Depero, advertising was a medium for extending Futurist ideas.

Depero was an associate of the Futurist painter Giacomo Balla, and with him signed *The Futurist Reconstruction of the Universe* manifesto in 1915. Among its provocative suggestions were 'sound and kinetic three-dimensional advertisements'. In 1927 Depero came close to this aim in a stand he designed for the publishers Treves at the International Decorative Art Fair in Monza. Nine metres (nearly 30ft) high, it was a building partly constructed of huge solid letters whose elements were repeated on a smaller scale in the shelving and decoration inside.

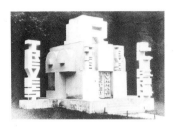

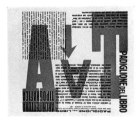

exhibition pavilion for Bestetti,
Tumminelli and Treves Brothers,
publishers
Third Monza International Decorative
Arts Biennale 1927
[Fortunato Depero]

'Pavilion of the Book: Typographic
Architecture' in *Depero Futurista* 1927
[Fortunato Depero]

The same year saw the publication of his book *Depero Futurista*, one of the key works of Futurist self-promotion and of graphic design. Published by the aviator-artist Fedele Azari, a little larger than A4, with a stiff cover and eighty pages fastened with two large nuts and bolts, it is a catalogue of advertising designs. The following year, 1928, Depero set off for New York. Here he continued to paint and exhibit, design for the theatre and work as a freelance advertising designer. He also designed covers for magazines, including *Vanity Fair*, but inevitably much of his work was advertising both Futurism and himself.

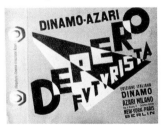

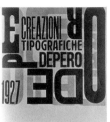

Depero Futurista
metal book cover 1927
[Fortunato Depero]

'Depero Typographic Works'
in *Depero Futurista* 1927
[Fortunato Depero]

There was a child-like element in Futurism. 'Futurist Reconstruction' had included 'The Futurist Toy', for which the first criterion was that it should make the child laugh loudly, and be stimulating to adults. All Depero's advertising images look as though they were made for the nursery, as paper cut-outs with simple reversals of white on black. This heraldic simplicity is their strength. They were easily reproduced by line block in newspapers and in flat colour by lithography for posters. Depero's association with the firm that made the Campari aperitif resulted in a series of advertisements collected in a book, *Numero unico futurista Campari 1931*.

Depero rejoiced in Futurist success. 'The influence of the Futurist style in every medium and creative area of publicity is evident, decisively and categorically – I see it on every street corner, on every space reserved for advertising, more or less plagiarized or stolen, with more or less intelligence, more or less taste – my dynamic colours, my crystalline and mechanical style, my flora, fauna and metallic, geometric and imaginative human beings are widely imitated and exploited – I am delighted.'

The Futurists had incorporated elements of advertising into their literature. Conversely, they had extended Futurism into advertising. Now, fascinated by technology, or at least by the image of modernity which it

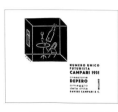

Numero unico futurista Campari
booklet cover 1931
[Fortunato Depero]

supplied, they appropriated elements of industrial production. The nuts and bolts of *Depero Futurista* were the first example. Three copies of this book had been bound in tin plate, a material used again in 1932 by the poet Tullio D'Albisola for a version of Marinetti's *Parole in Libertà Futuriste*, designed to appeal to the senses of touch, heat and smell.

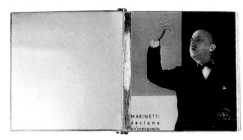
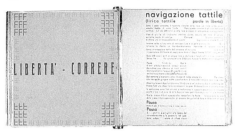

The book has facing pages using flat colours on one half and black-and-white on the other. The layout moved away from the frenzy of Marinetti's earlier edition. It was controlled in a square format by an austere geometry and the use of a geometrical sans-serif typeface.

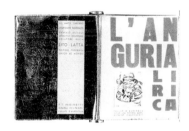

In 1934, D'Albisola's own book, *L'Anguria lirica*, appeared. It was designed by the precocious Milanese Bruno Munari, who was to remain a prominent designer in Italy for more than fifty years. The portrait of D'Albisola on the title page was drawn by Nicolay Diulgheroff, the son of a Bulgarian typesetter, who had followed the foundation course at the Bauhaus school in Germany (see Chapter 6). As a painter and commercial designer, he worked in Depero's popular Futurist manner most obvious in geometricized lettering: for example, capital 'A' becomes a triangle. Indeed, Futurism had become a style rather than a principle.

Depero's most successful commercial poster, for S. Pellegrino magnesia, uses traditional poster techniques: the single figure linked to the product by a visual idea. Futurism was influential, but the great Italian poster designers – Cappiello, Dudovich, Mazza, Sepo and Seneca – continued the tradition with few modernist traces.

CENTRALE FUTURISTA
VIA CRISTOFORO COLOMBO 37 - TORINO - TEL. 329154
MOVIMENTO FUTURISTA
DIRETTO DA F. T. MARINETTI
VICE-SEGRETERIA GENERALE
VIA CABOTO 32 - TORINO 110

Futurism and Italy

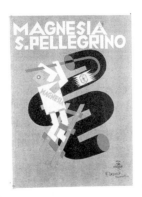

Magnesia S.Pellegrino
poster 1930
[Fortunato Depero]

'Modiano'
poster for cigarette papers 1930
[Federico Seneca]

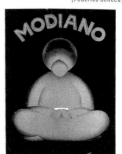

When he was in New York in 1929, Depero had written the outline to his *Il Futurismo e l'arte pubblicitaria* (*Futurism and the Art of Advertising*) which was published after he returned to Italy in 1931. 'The art of the future will inevitably be advertising art', it claimed, and called for advertising to reflect a new enthusiasm for 'our glories, our men, our products.' Such rhetoric helped to involve Futurism in promoting the ideas of Mussolini as leader of an imperialist, Fascist Italy.

There were conflicting tendencies in Futurism: on the one hand an aggressive modernism; on the other a monumental neo-classicism which made references to the ancient Roman Empire, with very low viewpoints lending a heroic aspect to everything it represented. They joined forces at the enormous exhibition held in Rome in 1933 to celebrate the tenth anniversary of the Fascist movement. In Leandri's muddled typographic poster urging support for the celebrations, the diagonals and asymmetry of '*parole in libertà*' produce a dynamic effect, but one that obscures the message. No principle organizes the words to focus the reader's eye; there is no hierarchy of relative importance – a feature of Marinetti's work. At this time the New Typography in Germany (see Chapter 6) had learnt to emphasize the meaning of words by the use of white space within the design. It was this kind of functionalism that was the most important influence on many of the younger designers who had been associated with Futurism. Their reaction to growing nationalism and the printing industry's neo-classical and neo-Renaissance conservatism was presented in the magazine *Campo Grafico*, first published in 1933. It looked outside Italy, to Paris as well as to Germany, and introduced the

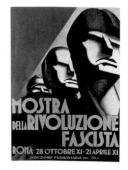

'Exhibition of the Fascist Revolution'
poster 1933
[C.V.Testi]

'Futurism: Futurists – all come to Rome
on 15 April'
poster issued as magazine insert 1933
[Leandri]

'The March on Rome'
Fascist Revolution Exhibition, Hall P
1933
[Mario Sironi]

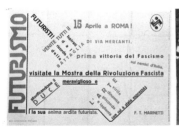

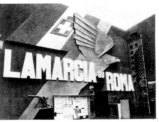

Casabella
magazine cover 1937
[Edoardo Persico]

work of a new generation of Italian designers. The most important of these, Edoardo Persico, also became editor of another new magazine, *Casabella*. Marinetti remained a talisman of progress for younger designers: *Campo Grafico* devoted an issue to him as late as 1939.

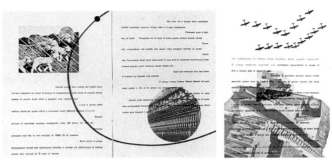

Poem of the Milk Suit
booklet 1937
[Bruno Munari]

It was with a poem of Marinetti's that Munari produced one of the most impressive works of early Italian graphic design. This was *Il poema del vestito di latte* (*Poem of the Milk Suit*), to promote a synthetic textile. Munari presented it in entirely modern techniques – cut-out photographs printed in black and coloured overprinting with the typesetting in Bodoni and a slab-serif type, justified across the column in a square area of text. This post-Futurist work retained the confidence and energy that Marinetti had introduced more than twenty years earlier, but its typographic anarchy had been discarded: the brilliance and discipline of Munari's pages reflect the shape of a new kind of modern design in Italy (see Chapter 15).

Futurism is important because it broke with the traditional, symmetrical layout of the printed page. It created the precedent for the Dadaists' typographical innovations in Germany and lent its name of Futurism to the experimentalism in Russia which immediately preceded the revolution of 1917.

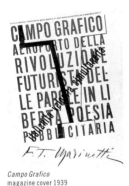

Campo Grafico
magazine cover 1939
[Enrico Bona]

5
Soviet Russia

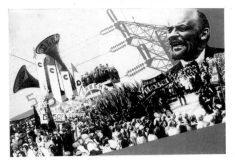

The years following the revolution of 1917 in Russia saw graphic design develop, with film, as a mass medium. This new language was exported to become an important influence in Germany and Holland between the wars. Russia had a powerful visual tradition expressed in the *lubok* – narrative woodcut broadsheets – icons, and illustrated political magazines; it also had an artistic intelligentsia moved by Futurism to turn its back on the past. In a hectic atmosphere of optimism and debate, of physical privation and at a time of civil war and political upheaval, in a semi-literate society, images and words became the agents of the revolution. Before electrification and the widespread use of radio it was only the individual speaker at a meeting who could explain political developments and report progress on the fronts of the civil war (1918-21).

In the first few years of the revolution, posters became the public speakers, shouting visual slogans and illustrating political allegories. As the revolution developed it harnessed the new resources of photography and with them the skills of designers in the graphic presentation of statistics and cartography; these combined to produce images that transcended objectivity in the poetic presentation of a romance of progress.

Three distinct types of poster design are evident. The first, practised most notably by Viktor Deni and D.S. Moor, was the development of the political illustration. Moor's allegories gained power in enlargement, with haunting contrasts of then and now, enemies versus heroic allies, imperialism against workers' struggles, to which he added a simple slogan: *Smert' Mirovomu Imperializmu* (*Death to World Imperialism*). Industry, squeezed by the reactionary dragon, is on the point of rescue by the armed forces of revolution. Less typical of Moor's work is the lone figure of his poster appealing for the victims of the 1920 famine, with the single word *Pomogi* (*Help*). The drawings of the skeletal old man and the two wretched stalks of barley are no longer illustrations but have become a single graphic idea, an ideogram of hunger.

Many of Moor's and Deni's posters were restricted to black and red. Red could be used to identify revolutionary elements, particularly flags,

'Death to World Imperialism'
poster 1919
[Dmitri Moor]

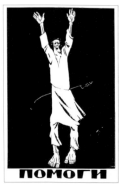

'Help'
poster 1920
[Dmitri Moor]

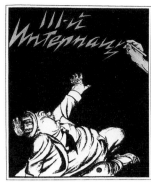

'The 3rd [Communist] International'
poster 1921
[Viktor Deni]

Edict on the wearing of beards
lubok print
17th century

workers' shirts and peasant blouses. Black was used for the main drawing and as a solid colour for the clothes of capitalists and priests. The restriction of colour was used to powerful effect. In Deni's most graphically concise poster, a red hand produces the red writing 'Third International' on a black rectangle, forcing the stereotyped capitalist in top hat to cower below it, thereby integrating slogan and illustration.

Woodblock posters, a tradition that had been revived and adapted in the First World War for patriotic propaganda, now found a new form as 'Rosta Windows', produced from 1919 to 1922. Rosta was the state agency for transmitting news and information by telegraph, and it controlled press reporting. The Rosta Windows were single-sided bulletins, often illustrated comic narratives, hung mostly in shop windows, in railway stations, and at the front in the civil war .

They were large, from one metre to as much as four metres (12ft) high, produced in more than a hundred copies by stencil. Their initiator was a political cartoonist, Mikhail Cheremnykh, who produced five hundred posters for Rosta and is said to have designed fifty in a single night.

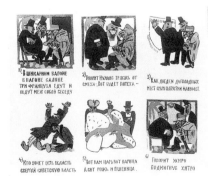

'In the Luxury Wagon'
poster 1921
[Mikhail Cheremnykh]

The most celebrated and equally prolific creator of the Rosta poster was the poet Vladimir Mayakovsky. Apart from writing most of the texts, Mayakovsky drew one third of the total output of the workshops, which over the two years of their production totalled about sixteen hundred.

45

'Let us make the squares our palettes, the streets our brushes!', he said. Posters were designed and printed overnight in communal workshops. The stencil technique required flat colour and simple shapes; fine lines or delicate lettering were impossible. To begin with, copies of stencils were distributed by train, so that the actual production of the same poster could be carried out in remote parts of the Soviet Union. Later, regional Rosta studios were established.

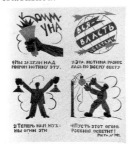

'We lit this truth above the world...'
Rosta poster (on electrification)
Moscow 1920
[Vladimir Mayakovsky]

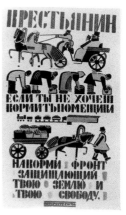

Artists in Petrograd used linocut to produce their posters, adding colour to the black print by hand. Vladimir Lebedev and Vladimir Kozlinsky were the best-known for this technique, which was simple but not cartoon-like as with Mayakovsky. Figures were drawn as in children's stencils, in solid blacks and heavy line, matched by equally heavy lettering relieved by splashes of painted colour.

One Rosta sheet shows two designs. The top is in the conventional comic-book style. The bottom, to which was added the slogan '*Cht ty sdelal dlya fronta?*' ('What have you done for the front?'), was geometrical and abstract. It was the work of a Constructivist.

'Peasant, if you don't want to feed the landlord, feed the front...'
Rosta poster
Petrograd 1920
[Vladimir Lebedev]

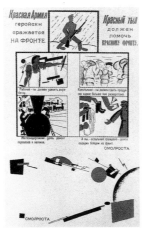

left
'The Red Army is fighting heroically at the front.'
Rosta poster
Smolensk 1920
[Kasimir Malevitch]

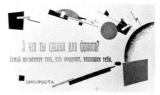

'What have you done for the front?'

The Constructivists rejected the idea of the unique work of art as belonging to the old bourgeois society. Armed with the forms of the new abstract painting, they set out to demolish the division between art and labour. The mechanical production of images through photography

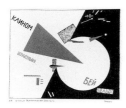

fitted their ideology. Industrial reproduction by the printing press also suited their aim to be co-workers in the establishment of Communism.

The famous *Klinom Krasnym bei Belykh* (*Beat the Whites* [counter-revolutionaries] *with the Red Wedge*) exhibits a more coherent link between what the image suggests and what the words say, their meaning emphasized by their relationship to the elements in the design. This small poster was designed and its text devised by El Lissitzky, typical of many Constructivists in having a wide range of design activities. Trained as an architect in Germany, Lissitzky's most significant achievements were in the design of books and exhibitions. He was one of the pioneers of photomontage, the assembly of different elements that gave life to the essentially static photograph by juxtaposition or superimposition, combining different viewpoints, cropping, cutting out and exploiting violent contrasts and changes of angle. In his self-portrait *The Constructor*, Lissitzky employed collage (sticking together) and montage (superimposing), by drawing and lettering on the image, as well as by multiple printing from several negatives of the hand, the self-portrait and the gridded paper. The designer becomes a self-explanatory icon: the eye and hand linked by a tool — the compasses drawing a circle on paper, implying precision, and including a vestige of text – the last three letters of the alphabet and his name printed from his letterhead. It could well have been made to illustrate a slogan of the time: 'Down with guarding the traditions of art! Long live the Constructivist technician!'

Lissitzky's designs for books united geometrical abstraction with functionalism. They expressed his belief that 'Printed words are seen and not heard' and that 'A sequence of pages makes the book like cinema.' In the *Suprematist Story of Two Squares*, published in 1922, the narrative is developed by captioning the square-format geometrical compositions with a dynamic typography in the margins. The following year Lissitzky designed a book of poems by Mayakovsky, *Dlya Golossa* (*To be Read Out Loud* – literally, 'For the Voice'), which had a thumb index with a symbol code for each poem. The illustrations were constructed from printers' material, mainly 'rules' (pieces of metal or wood that printed as lines of varying thickness).

Soviet Russia

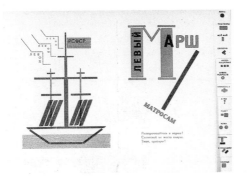

To Be Read Out Loud
book double page 1923
[El Lissitzky]

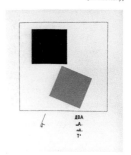

Suprematist Story of Two Squares
in Six Constructions
book page 1922
[El Lissitzky]

Mayakovsky played a leading role, not only in Rosta posters but also in the promotional material and packaging for state consumer enterprises. In this he worked closely with the painter, designer and photographer Alexander Rodchenko as a self-styled 'Reklam-Konstructor' ('Advertisement Constructor'). Typical of their style is a newspaper advertisement for the Gum department store in Moscow. Childishly drawn silhouettes, like dressmakers' patterns, of four spread-eagled figures have their hands on a flat circle with the lettering 'Grab the lifebelt! Everything for everyone. High quality as well as cheap! Take it from us on the highest authority.' Huge exclamation marks each side of the design give an urgency to the crude symmetry typical of Rodchenko's early graphic work. This relied on heavy stripes of colour and reversing colour on a central axis, a technique that achieved a powerful impact in covers for the magazines *Lef* and *Novy Lef* from 1923 until 1928. By this time they were exhibiting some of the characteristics of the International style. What became the common language of graphic design thirty years later included the emphasis on rectangularity and on white space as part of the design, an exclusive use of sans-serif typefaces and photography rather than drawn illustration.

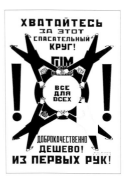

'Grab the lifebelt'
Gum store advertisement 1923
[Alexander Rodchenko]

Novy Lef
magazine cover 1927
[Alexander Rodchenko]

Rodchenko was one of the first to experiment with photomontage. In 1923 he illustrated Mayakovsky's *Pro Eto* (*About This*) by combining parts of specially taken photographs with images cut from magazines, and he used the same technique in a series of two-colour covers for crime novels in 1924. Although surprising in their juxtapositions, these collages are crude when compared either to the subtle depth Lissitzky achieved or to the works by the most powerful master of photomontage, Gustav Klutsis. Describing the new medium as 'the art of socialism's construction', Klutsis employed photomontage to create heroic images of Soviet achievement, often combined with explanatory statistics. His *Development of Transport: The Five Year Plan* poster of 1929 is a construction that combines photographic and graphic elements. Scale is used to show both numbers and importance. The meaning of the images can be understood without reading slogans or captions. Progress is being surveyed from a camel, a metaphor for the Old; it is being borne down on by the New, the dominant locomotive, marked with its identifying

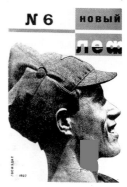

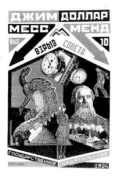

Miss Mend
book cover 1924
[Alexander Rodchenko]

red star – the State. The words and figures make the meaning of the graphics more specific but their role is secondary to the larger metaphorical images.

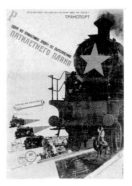

'Development of Transport;
The Five-Year Plan'
poster 1929
[Gustav Klutsis]

Such posters heralded the mature achievement of Soviet graphic design. The geometry and primary colours of Constructivist abstract art remained, but the most complex work derived its graphic form and arrangement not from an imposed style but through the effort to make its meaning clear. This is particularly evident in Klutsis's book design and in the typography of Alexei Gan and Solomon Telingater.

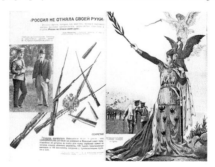

The Year 1914
book double page 1934
[Solomon Telingater]

Designed by Telingater in 1934, Ilya Feinberg's book *1914-i* (*The Year 1914*) exemplifies this new use of word and image. It is an anti-military, anti-imperialist account of the outbreak of the First World War and Lenin's response to it, presented as a catalogue of extracts from contemporary newspapers, the columns of text interrupted by phrases in different sizes of bold type. But it is the images that carry the argument. The text and images are inseparable; they are entirely documentary, mostly news photographs, but including badges and medals, postage stamps, and pictures of guns and bullets, their meaning clear through their relationship to each other and to the text.

Constructivism
book page design by author 1922
[Alexei Gan]

This kind of montage originated partly in the films of the early 1920s by pioneering directors such as Sergei Eisenstein and Dziga Vertov, where contrasting fragments are juxtaposed. The technique was

49

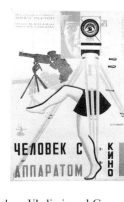

Man with a Movie Camera
film poster 1929
[Vladimir and Gyorgy Stenberg]

Cinema Eye by Tziga Vertov
title designs in *Kino-fot* magazine 1922
[Alexander Rodchenko]

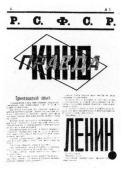

employed by the brothers Vladimir and Gyorgy Stenberg in posters to advertise the films. They employ no single dominant figure (the most common form of poster arrangement) but assemble details of stills from the film. Such fragments appear in one of two posters that the brothers designed for Vertov's demonstration of the cinema's possibilities, *Man with a Movie Camera*. It substitutes an eye for the lens of the camera next to part of a laughing face, as though the camera eye is an alternative way of seeing. The legs of the camera tripod make a space through which a pair of disembodied legs and a skirt cavort, and the tripod of the camera is echoed by the repeated silhouette of a tripod carrying a machine-gun rather than a camera. The viewer completes the images and makes the connections as though they are continuous narrative sequences in a film. The Stenbergs and other designers, notably Nikolai Prusakov, made many such posters in full colour, less tautly designed, but exciting, decorative and imaginative.

Dynamic, filmic effects also appeared in the monthly magazine *USSR in Construction*, which became the most highly developed and consistent achievement of Soviet graphic design. Published in separate editions in Russian, German, French and English from 1930 to 1941 as a showcase of Soviet achievements, it employed the leading photographers, designers and journalists of the day.

Cement
film poster 1928
[Mikhail Dlugach]

Using and inventing a range of printing and reproduction techniques, the pages demanded the reader's co-operation, imaginatively and physically, to participate in the heroic advance of the Revolution. An aircraft's plan view, repeated in silhouette over an aerial photograph, takes the reader on a flight (see p. 20). The story of the Red Army is told in photographs with dates in large white outline numerals: militiaman 1917; sailor, civil war partisan 1919; cavalryman 1920; Asiatic infantryman on the Chinese front 1929; Red Army soldier 1933. The soldier is protecting what is revealed when the last vertical half-page is unfolded – the industrial development and civil engineering achievements of the Five Year Plan, with an aeroplane wing in the foreground making sense of the distant aerial view of housing. Different kinds of folding, semi-transparent paste-ins and cut-outs were included, even a paper parachute;

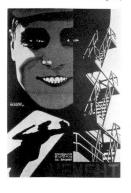

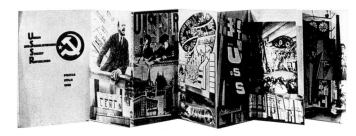

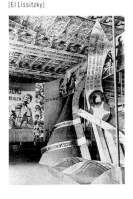

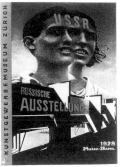

every kind of graphic technique from engineering drawing to airbrush spraying was employed to explain and dramatize a message.

As well as printed propaganda, Soviet designers were involved in the decorations and banners for street parades where they used three-dimensional structures to carry revolutionary messages. During the 1920s international trade fairs and exhibitions were important means of promoting trade and of publicizing socialist culture. Lissitzky was the most widely employed and original of the exhibition designers. His designs for the *Pressa* press exhibition in Cologne in 1928 used large-scale photomontage. Huge belts, like paper on a rotary printing press, carried examples of Soviet posters and leaflets; curved vertical banners like newspaper printing plates were stencilled with the repeated image of a massive soldier to represent the Red Army press. Likewise, at the International Hygiene exhibition in Dresden in 1930 the visitor was bombarded with slogans at every angle and with posters covering the ceiling.

Lissitzky had considerable influence outside Russia. He spent long working visits in Germany, launching a magazine in Berlin and another in Switzerland, and his *Story of Two Squares* was translated into Dutch. Films such as *Battleship Potemkin* focused the Western intelligentsia's attention on Soviet cultural achievements. But the traffic of ideas was not one-way. Russia welcomed foreign designers. In 1931 the German John Heartfield visited Moscow, where he demonstrated how to make photomontages. He designed an issue of *USSR in Construction*, whose pictorial presentation of statistics had been inspired by the Viennese originator of Isotype, Otto Neurath (see p. 18). Until Stalin suppressed its avant-garde energy, the Soviet Union appeared in many Western eyes to reconcile social demands with revolutionary aesthetics, and graphic design was seen as the expression of a mass society in the machine age.

Soviet Russia

6
Germany

Unemployment, inflation and political chaos followed the First World War in Germany. Yet it was then that graphic design emerged as part of a modern industrial society in the cities of central Northern Europe – not just on posters in the streets, but in letterheads, advertising leaflets, catalogues for industrial components, and trade fairs. Germany, situated between two powerful avant-gardes, was open to their influence. To the east was Communism and Constructivism in Soviet Russia; to the west, the doctrinaire enthusiasms of the Dutch De Stijl artists, described in the next chapter. What was called Commercial Art survived in advertising, notably in the work of the outstanding poster artists such as Hohlwein and Bernhard. But visual communication in the 1920s was shaped by the avant-garde artists.

The most prominent artistic movements at the end of the war were Expressionism and Dada. Posters, books and journals produced by Expressionist artists were marked by aggressive illustration, whose violent contrasts were matched by freely drawn lettering or by heavy typefaces originally designed for advertising.

There was an over-emphasis in these techniques, which left a few remarkable film posters but no lasting mark on design. It was the poets and artists of the Dada movement – anti-establishment, anti-military, anti-art – with their Futurist disdain for tradition, who continued the revolution in the use of words and images. They particularly employed montage, the assembly of ready-made images, and they mixed all kinds of letterforms and printers' ornaments in typographic compositions.

The advertisement designed by John Heartfield in 1917 to advertise a portfolio of lithographs by his fellow Dadaist George Grosz combined old engraved blocks, found at the printer, with slogans in sans-serif type. The need to lock the type into the printing press demanded rectangular units and thus imposed a strict vertical-horizontal arrangement. To Heartfield this was no restriction: he poured wet plaster around the angled type and blocks to hold them in position for printing.

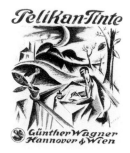

Pelikan Inks
poster 1921
César Klein

Pelikan Artists Colours
poster c.1925
[Ludwig Hohlwein]

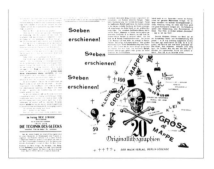

'Small Grosz Portfolio - just published'
advertisement 1917
[John Heartfield]

Bauhaus symbols
used 1919-22

used from 1922
[Oskar Schlemmer]

Utopia: Documents of Reality
book page 1921
[Johannes Itten]

New Art Salon
poster 1914
[Oskar Schlemmer]

Bauhaus Exhibition
poster 1923
[Fritz Schleifer]

Yko Office Supplies
catalogue cover 1925
[Joost Schmidt]

The Dadaists' propaganda skills, first exercised in self-promotion, were diverted to publicizing design itself as part of a social revolution in which freedom would be achieved through increased mechanization. In typography they followed a disciplined version of Constructivism. It was limited to a narrow range of typefaces and paper sizes, and each design had to have a structure derived from its verbal content, not arranged according to established precedent. For images, the hand-drawn was replaced by the machine-made illustration, the photograph. The designer worked at a drawing board like an architect, producing a layout that provided instructions. In this way decisions were taken out of the hands of the printer and made in the studio, remote from the industrial process.

These developments, from Expressionism towards functionalism and from handcraft towards design for machine production, can be traced in the changing graphic design at the Bauhaus, the famous school of arts and crafts, established in Weimar in 1919. Its first letterhead used the typeface designed by Behrens, Mediäval. The school's first emblem was like a mason's mark, a spread-eagled figure carrying aloft a pyramid. By 1924 this had been replaced by the geometricized profile of a head (adapted from a much earlier design by Oskar Schlemmer, one of the staff), which could be simply reproduced from printer's 'rules' – strips of wood or metal that printed as solid lines.

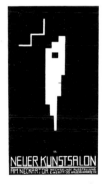
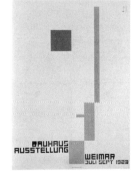

Rules became the stereotype of what was popularly identified as 'Bauhaus typography'. In fact, rules and sans-serif types were typical, but they were part of a much more radical reform which examined the elements of graphic design and the role each of them played in transmitting information. Already, in his Utopia Press almanac of 1921, the Bauhaus master Johannes Itten had soberly extended Futurist efforts to make printer's type more articulate, and to give it some of the emphasis and inflections of speech. This he did with a mixture of black letter (Fraktur) and heavy Victorian types and printer's ornaments, dots and squares, balanced on a central axis. The pages were governed by the inherently rectangular geometry of the printer's material, and white space helped to establish relationships of meaning in the text.

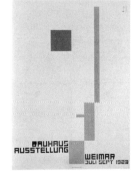

Germany

53

At the Bauhaus, a thorough analysis of visual communication began with an examination of the alphabet. In German, there were special problems: the prevailing style for text was black letter, whose archaic form clearly did not belong to the machine age. A more radical approach was taken to the use of capitals for the initial letters of nouns. A footnote which appeared on the Bauhaus letterhead designed by Herbert Bayer in 1925 stated the school's attitude uncompromisingly:

typewriter ribbon tin 1925
[Joost Schmidt]

towards a simplified way of writing
1. this is the way recommended by reformers of lettering as our future letterform. cf. the book '*sprache und schrift*' [speech and letterform] by dr. porstmann, union of german engineers publishers, berlin 1920.
2. in restricting ourselves to lower-case letters our type loses nothing, but becomes more easily read, more easily learned, substantially more economic.
3. why is there for one sound, for example a, two signs, A and a? one sound, one sign. why two alphabets for one word, why double the number of signs, when half would achieve the same?

ABCDEFGHIJ KLMNOPQR STUVWXYZ
Neuland type 1923
[Rudolph Koch]

ABCDEFGHIJK
abcdefghijklm
Erbar type 1923
[Jakob Erbar]

ABCDEFGHIJK
abcdefghijklmn
Futura type 1927
[Paul Renner]

ABCDEFGHIJ
abcdefghijklmn
Kabel / Cable type 1927
[Rudolf Koch]

The attempts made at the Bauhaus and elsewhere to devise new letterforms all had a strict geometric base. Geometry was the basis to a functionalist shunning of Renaissance designs, Fraktur and the Germanic craft tradition of heavy calligraphic typefaces, like Rudolf Koch's Neuland of 1924, where the mark made by a craft tool, rather than an imposed formal idea, determined the design. Koch followed Erbar, a geometrical typeface of the early 1920s, in his Kabel (Cable) which appeared at the same time as the most popular of the new sans-serif types, Futura, in 1927. The Bauhaus teachers Josef Albers and Joost Schmidt worked on a number of alphabets, but Bayer applied himself most consistently. Like the others, his Universal (1926) is constructed from circles and straight lines of a constant thickness on a grid of squares.

below
1 alphabet design 1924
[Max Burchartz]

2 'Universal' typeface design 1926
[Herbert Bayer]

1234567890 abcdefg
abcdefghijk hijklmno
lmnopqrstu pqrstu
vwxyzäöüß vwxyz?

1

2

aaabCDGO
ghoqp EFH
m ijrrl TXMN
xzwvZ8BJ
1234SMAV

3

abcdefg
qrfstuu
ABCDEFG
PQRSTUU

4

3 geometrical sans-serif letter 1926
[Joost Schmidt]

4 'Geometrical basic forms' and 'Combination of simple elements' stencil letter design 1926
[Josef Albers]

The first declaration of the aims of this 'New Typography' (as it was soon called) stated no preferred style of type. 'We use all typefaces, type sizes, geometric forms, colours, etc,' wrote Laszlo Moholy-Nagy, in 1923. Moholy-Nagy, a Hungarian painter, had arrived to teach at the Bauhaus only months before it opened its doors to the public during the

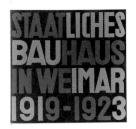

State Bauhaus in Weimar 1919-1923
book cover 1923
[Herbert Bayer]
title page
[Laszlo Moholy-Nagy]

ABCDEFGHIJK
abcdefghijklm
ABCDEFGHIJ
abcdefghijkl

City type
1930
[Georg Trump]

Book and Graphic Design Record
magazine cover 1931
[Georg Trump]

summer of that year with an exhibition explaining its aims and achievements. These were also set out in a book, *Staatliches Bauhaus in Weimar 1919–1923*, where Moholy-Nagy's statement appeared, and whose design demonstrated the new approach. The cover was filled with the title, drawn in sans-serif capital letters by Bayer. The inside pages, designed by Moholy-Nagy, made free use of white space and black rules which, in the contents pages, were used as huge Roman numerals.

One of the visitors to the Bauhaus exhibition was a young calligrapher and book designer who taught in the Academy in his home town of Leipzig, centre of the German book-printing industry. Jan Tschichold was to become the chief propagandist for the New Typography, beginning in 1925 with *elementare typographie*, a special issue of the trade journal *Typographische Mitteilungen*. This was planned as a Bauhaus issue but included the work of non-Bauhaus designers, particularly Lissitzky. Tschichold elaborated ten 'elementary' (meaning 'basic') principles, beginning with:

1. Typography is shaped by functional requirements.
2. The aim of typographic layout is communication (for which it is the graphic medium). Communication must appear in the shortest, simplest, most penetrating form.
3. For typography to serve social ends, its ingredients need *internal organization* – (ordered content) as well as *external organization* (the typographic material properly related).

He went on to stress the importance of the photograph; of sans-serif types as the most correctly 'basic' – although he admitted the legibility of Renaissance *Mediäval-Antiqua* typefaces; the importance of the *un*printed areas of paper; the possibility of lines of type set obliquely or vertically; the adoption of standardized DIN (Deutsche Industrie Normen) paper sizes, such as A4 for writing paper; and the rejection of all ornament other than squares, circles and triangles, and then only if these were rooted in the overall construction. Tschichold developed and refined his theme in the most important single document of the Modern Movement – his book *Die neue Typographie*, published in 1928.

At this time Tschichold was teaching in Munich at the printing school under Paul Renner, designer of the Futura typeface, where he was joined in 1929 by Georg Trump, designer of the odd City type (1930). This triumvirate perfected a functional modernism in jobbing printing, particularly in ranges of stationery designed like forms to be completed by the typewriter. Tschichold's cinema posters, lithographed in two colours, were mainly abstract compositions with hand-drawn lettering, often arranged diagonally, with a single small photograph, often circular. The most interesting of these is *Laster der Menschheit* (*Man's Depravity*), showing the star Asta Nielsen filling almost a third of the poster in the top right-hand corner. Her photograph appears as though on a cinema screen, which is suggested by lines radiating from the bottom left of the design; these lines define the corner of the screen, and the film title and

Germany

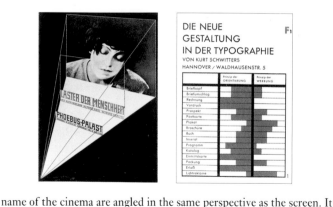

Man's Depravity
poster 1927
[Jan Tschichold]

'New Design in Typography'
chart showing
'information' (left column)
'advertising' (right column)
as proportions of their function in:
'letterheads / envelopes /
invoices and bills / forms /
prospectuses and leaflets / books /
advertisements / programmes /
catalogues / tickets / packages /
official announcements /
illuminated advertising signs'
booklet cover 1930
[Kurt Schwitters]

name of the cinema are angled in the same perspective as the screen. It
exemplifies, almost caricatures, Tschichold's aim to derive the graphic
elements from the content, not only advertising the star and the indi-
vidual film, but also exposing the general nature of film as an enlarged,
projected image.

With Tschichold, one of the chief activists in the New Typography
was the Dadaist Kurt Schwitters. From his house in Hanover he
launched a one-man movement with its own journal, *Merz*, whose first
issue appeared in January 1923. The fourth, in July that year, before the
Bauhaus exhibition, printed Lissitzky's 'Topography of Typography',
a set of seven principles which began 'Words on the printed sheet are
seen, not heard.' Schwitters produced a stream of advertisements and a
prospectus with a contribution by Lissitzky for his own advertising
agency, which opened in 1924. *Merz* no. 11 was devoted to publicity for
Günther Wagner, the Hanover firm making stationery supplies and
artists' materials under the Pelikan trade name. The pages of *Merz* were
laid out according to the precepts of the New Typography, with sans-
serif type and the page broken by heavy rules, and contained Schwitters's
own typographic programme, the important principle being 'Do it in a
way no one has ever done it before.' He used this approach in attempts
to reform the alphabet, where his was the most radical contribution to

'Merz Lecture Evening'
invitation card 1926
[Kurt Schwitters]

Merz symbols
[Kurt Schwitters]
1923 c.1926

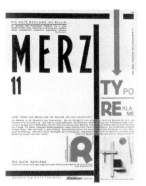

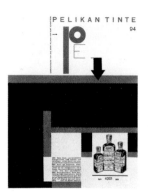

Merz no.11
double page / advertising demonstration
1924
[Kurt Schwitters]

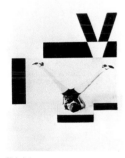

the new movement: his *Systemschrift* made the letters 'optophonetic', with a separate sign for each sound. It remained undeveloped but elements appeared in Schwitters's hand-drawn posters of that year.

Despite his idiosyncratic approach, Schwitters was an organizer and propagandist, visiting and corresponding with artists and designers and lecturing in Germany and abroad (collaborating with his Dutch counterpart, Theo van Doesburg: see Chapter 7). This activity resulted in the formation of a small group, the Ring neuer Werbegestalter (Circle of New Advertising Designers). By 1930 it consisted of twelve members, including two Dutch designers, Paul Schuitema and Piet Zwart.

Schwitters organized many exhibitions for the Ring, inviting guest contributors. Among these were also the leading figures of the avant-garde in central Europe. Ladislav Sutnar was a graphics specialist as well as an industrial designer. He was propagandist for Družstevní práce (Cooperative Work), an organization whose publications promoted a Modernist outlook, and was director of the State School for Graphic Arts in Prague from 1932 to 1939. Karel Teige, also based in Prague, was first a painter and then moved to photomontage and typography. He was theorist of the Devětsil group, whose magazines and almanacs he designed using the resources of the printer's type case. (Similar magazines represented the avant-garde in Yugoslavia, *Zenit* from Belgrade and *Tank* from Zagreb.) The third Eastern European designer exhibited by Schwitters was the Hungarian Lajos Kassák, designer of the magazine *MA*. The first Ring exhibition took place at the Cologne Kunstgewerbemuseum in March 1928, one of a number of exhibitions and public statements by its members that set out the aims of the new techniques of visual design.

In 1927 the conventional columns of the *Frankfurter Zeitung*, set in Fraktur type, were interrupted by blocks of sans serif. These were illustrations to an article on the front page, 'What is new Typography?' by Walter Dexel. It was a simple explanation along the Bauhaus lines of Moholy-Nagy, but took exception to some of the Bauhaus mannerisms, particularly the use of rules – 'modern gestures' which interfered with legibility – and even geometrical ornament, which Dexel thought no better than Victorian vignettes. He also deplored Moholy-Nagy's lines of

Germany

type set at an angle. By profession Dexel was an art historian. He was both exhibition organizer and designer at the Jena Kunstverein, the municipal art gallery, for whose invitation cards (sometimes cut up and collaged as posters) he devised an increasingly standardized application of sans-serif type and an occasional horizontal rule. Unlike his contemporaries, he solved the problem of upper- and lower-case by using capital letters exclusively. His publicity for a photographic exhibition of contemporary photography in Magdeburg in 1929 was one of the purest expressions of the New Typography. Nonetheless, it was unusual in allowing the hand-drawn lettering to form the image, its black-and-white, positive-negative reversal signifying the photographic process.

'Worship and Form'
exhibition folder 1929
[Walter Dexel]

Dexel's most significant contribution was in the design of illuminated street signs and kiosks in Jena and also in Frankfurt, where design was an important civic issue. The city had its own magazine devoted to planning and design, *Das neue Frankfurt*, with covers designed by Hans and Grete Leistikow and later by Willi Baumeister; it had a supplement designed by Johannes Canis, *Das Frankfurter Register*, a catalogue of products selected for their quality and appearance. Baumeister's design work for the Werkbund exhibition *Die Wohnung* (*The Home*) in 1927 was remarkable in several ways. It was an early example of the overall graphic design of a large enterprise being the responsibility of a single designer. Baumeister designed the stationery, a variety of leaflets, guides and a catalogue, and made huge cut-out letters for the display area. Like Dexel, he used only capital, sans-serif letters. Baumeister was also commissioned to design a postage stamp, which he did using printer's type material, including the drawing of a modern house. His red and black poster was produced in different sizes and with two differing images of old-fashioned interiors. These were photographs, half-obscured by a painted diagonal cross and the written question '*Wie wohnen?*' (*How to Live?*). It perfectly exemplifies Baumeister's belief that typography is inherently to do with movement of the eye and, for this reason, the essentially static, symmetrical arrangement is inappropriate. It demonstrates, too, Moholy-Nagy's dictum that the new typography must be 'Communication in its most intense form' and his insistence on 'absolute clarity'. Nothing could be clearer than the didactic crossing out of the cosy

'Contemporary Photography'
poster 1929
[Walter Dexel]

The New Frankfurt
magazine cover 1929
[Hans Leistikow]

Illuminated tram stops
Frankfurt 1928
[Walter Dexel]

The Frankfurt Register
catalogue cover 1929
[Johannes Canis]

'Werkbund Exhibition: The Home'
poster, advertising stickers
and postage stamp proof (not issued)
1927
[Willi Baumeister]

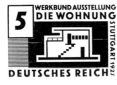

living-rooms, nothing simpler than Baumeister's principle of ranking the words in sizes according to their importance in the message.

Statements of principle went hand-in-hand with practical work. Max Burchartz, as a painter in Weimar, had had close contacts with the Bauhaus and Van Doesburg. In 1924 he established the advertising studio Werbebau in the Ruhr, with Canis. In 1926 he had expressed his attitude to advertising in the Werkbund magazine *Form*. In a long article Burchartz analyses the function of publicity, what makes it effective, and how the viewer is involved. The concept of message and receiver, which became a common way of looking at communication in the 1950s, was introduced. But the larger part of Burchartz's essay is devoted to 'The aesthetic organization of the means of the advertising medium.' 'Functional expression', he said, must derive from organization of the 'raw material' and balancing of 'contrasts: oppositions, tension, conflict.' These principles Burchartz worked out in designs that established the style of International Modernism, which survived Nazism to re-emerge in the 1960s as the 'Swiss style'.

Wehag door furniture
catalogue double page
1931
[Max Burchartz]

In Burchartz's brochures for building products, the 'raw material', cut-out photographs of the product, lit and positioned so as to give maximum information about its form and finish, was integrated on the page (always a standard DIN size) according to his idea of contrast: 'Light and dark, empty space and solid object, stationary and moving, large and small, vertical and horizontal'. In 1931 Burchartz helped organize an international exhibition in Essen, 'Kunst der Werbung' (Art of Advertising). He designed its poster, repeated as the catalogue cover, which offers a synthesis of the elements of modern graphics: a photographic image with sans-serif lettering combined as metaphor and information. In their dramatic arrangement, words and image make a single unit of meaning against a dark background. The hands are a metaphor for the

'The Art of Advertising'
exhibition catalogue cover 1931
[Max Burchartz]

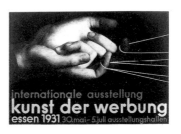

Germany

attraction of the public, but the image is only given meaning by the word 'Werbung' (publicity) which it illustrates.

Designers taught themselves photography, the medium approved by all the manifestos. Published at the Bauhaus, Moholy-Nagy's *Malerei, Fotografie, Film* (*Painting, Photography, Film*) discussed the role of photography in graphics, which he described as 'Typophoto':

> Typography is communication composed in type.
> Photography is the visual presentation of what can be optically apprehended.
> *Typophoto is the visually most exact rendering of communication...*
> Photography is highly effective when used as typographical material. It may appear as illustration beside the words, or in the form of 'phototext' in place of words, as a precise form of representation so objective as to permit no individual interpretation.

The year 1929 saw several events that endorsed the interest in photography. Tschichold, with Franz Roh, published a selection of international photography, *foto-auge* (*photo-eye*). Here designers were strongly represented among the pioneers, as they were in exhibitions such as the Werkbund's 'Film und Foto' (1929) in Stuttgart. Among the organizers was Werner Graeff, who used the idea of 'phototext' in a book published for the exhibition, *Es kommt der neue Fotograf* (*Here comes the New Photographer!*), where images broke the text, even mid-sentence, to make a continuous argument.

One room in 'Film und Foto' was arranged by John Heartfield. Over the door was the slogan 'Use Photography as a Weapon'. Heartfield's weapons had developed from the playful, chance typographic combinations of his Dadaist work at the end of the First World War to photographic collages made by joining images or parts of images together and rephotographing them, hiding the joins with careful retouching. Their unexpected contrasts and their ironic humour shocked the viewer into acknowledging Heartfield's Communist view of political reality.

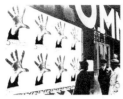

Heartfield's best-known poster, also a cover to the Communist party magazine *Die Rote Fahne* (*The Red Flag*) in 1928, began with the problem of how to get across the idea, and make people remember, that to vote Communist you had to 'vote list five' in the ballot. 'What can you say that's new about it?' Someone reminded him that a hand had five fingers; and that became the slogan and the image.

Most of Heartfield's work in the 1920s was on book jackets. Some used a single photograph, carefully cropped. For the satirical book by Kurt Tucholsky *Deutschland, Deutschland über alles*, Heartfield employed photographs as straightforward illustration as well as in simple, witty montages – attaching ears to a trousered backside, captioned 'Berlin idiom'. The title on the jacket is spoken by a head, half ruling-class and half military, blindfolded by the national flag. On the back are cutouts of a fist holding a police truncheon aloft and another resting on the handle of a sword, with the ironic legend '*Brüderlich zusammen hält*' ('As brothers, standing together').

Germany, Germany Above Everything
above
'Berlin Idiom'
photomontage illustration
right
book jacket 1929
[John Heartfield]

below
How to Coin Dollars
(*Mountain City* by Upton Sinclair)
book jacket (front)
and John Heartfield's friends posing
for the photograph 1931
[John Heartfield]

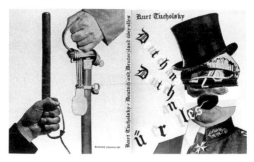

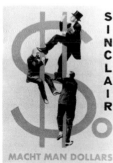

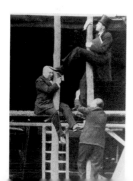

The cover is printed in the patriotic colours of red, yellow and white and all the type is as Teutonic as it could be. Such a use of symbols and signs of nationalism, militarism and capitalism, of law and order, replaced caricature with an economy and effectiveness that was new and brilliant.

Heartfield planned and used his own photographs. For example, his friends, dressed for the part, climbed the scaffolding of a building site, so that they could later be transformed into 'capitalists' climbing a dollar sign, the initial 'S' of the title of the book, *So Macht man Dollars*. Combined with captions and slogans, they could carry a weight of meaning that took them beyond the dynamic combinations of images of the Russians' photomontages.

Heartfield scanned newspapers and weekly magazines, where photography was now commonly used to record events, to find pictures as well as political speeches: the images he could distort and recombine with the words in grotesque relationships. His ideas appeared in hundreds of sepia-printed covers to the weekly *Arbeiter-Illustrierte-Zeitung* (*Workers Illustrated*), from 1929 to 1936. Heartfield used a photograph of Hitler giving his customary acknowledgment to followers – an arm raised behind him with the palm upwards, into which a corpulent oversized

Germany

figure puts money. Immediately above this transaction is the headline 'The meaning of the Hitler greeting', which is explained at the bottom, 'Little man begs for large gifts', with a much smaller motto, 'Millions stand behind me', a pun on Hitler's millions of supporters. Heartfield has used scale to juxtapose two images, dramatically emphasizing Hitler as the small man manipulated by economic interests.

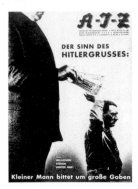

'The meaning of the Hitler greeting'
magazine cover (photomontage) 1932
[John Heartfield]

The work of Heartfield and the young pioneers of the New Typography was publicized in the trade press of the printing industry and in the advertising monthly *Gebrauchsgraphik* (*Commercial Art*). Tschichold reproduced examples in two colours in his second didactic treatise, *Eine Stunde Druckgestaltung* (*One Hour Designing Print*), which appeared in 1930, its A4 format and ribbed silver cover proclaiming its machine-age principles. The most comprehensive presentation of the work and ideas of the young designers was presented in the book *Gefesselter Blick* (*Captured Look*), in 1931. Its editors related text to time, and the image to space, a theme taken up the following year in the 'Fotomontage' exhibition in Berlin, which included not only Heartfield, but also the Russians (among them Klutsis, Lissitzky and Rodchenko) and the Bauhaus pioneers Moholy-Nagy and Bayer.

Bayer had been in charge of the print and publicity workshop after the Bauhaus had moved to Dessau in 1925. Moholy-Nagy, as co-editor, had been responsible for the publicity and layout of the school's journal and for the Bauhaus Books, which were classics of modern art and architectural theory. The first eight had all appeared in 1925. Their typography is often coarse, but they demonstrate Moholy-Nagy's attempt to break the continuity of the text and organize it so that it reflects its content. Heavy black lines are still a distraction. Bold sans-serif type is used not only for headings and sub-headings with single words and phrases but also to interrupt the flow of lines set in Antiqua, to introduce some of the emphasis of the spoken word. This kind of innovation was technically complicated in metal type, and found few followers. His sketch for a film scenario in his *Malerei, Fotografie, Film* (produced in an earlier version in a 1923 issue of the Hungarian journal *MA*), which used bits from the printer's type case and his own woodcuts, had no imitators.

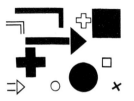

'Some useful typographical signs'
illustration to 'Typography Now:
Aims, practice, critique'
in *Offset* magazine
1926
[Laszlo Moholy-Nagy]

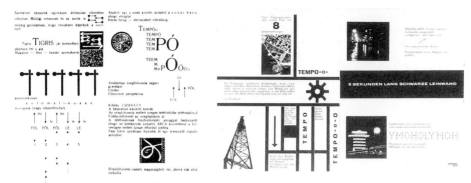

These typographic compositions were more the successors to Joost Schmidt's Expressionistic efforts than a part of the Modern Movement. It was after the transfer of the Bauhaus to Dessau that Moholy-Nagy produced designs of such technical sophistication that they translate him from the improvising craftsman to the industrial designer. Their cleverly disguised ambiguity has the fascination of conjuring but at the same time these works seem to express a desire to expose the process by which such ambiguity is achieved.

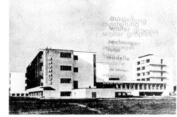

For a brochure advertising the fourteen Bauhaus Books in 1927, Moholy-Nagy photographed the type itself, just as it had been assembled, letter by letter (see colour illustration, p.19). This photograph he reversed left to right, so that it was readable, and added another print, as if to mirror the first. But the type in the second, while upside down, is not reversed left to right.

He repeated this kind of spatial trick in the cover to a Gropius exhibition catalogue in 1930. It shows a photograph of the Bauhaus buildings in bright sunlight. The lettering is printed in pink on the white paper where it has been reversed out of the grey tones of the photograph. Yet the lettering itself throws shadows onto the photograph exactly as if it is in the same space as the scene it depicts, lit by the same sun.

Herbert Bayer, who designed the lettering on the buildings shown in the photograph, had begun his career as a commercial artist before enrolling as a Bauhaus student in 1921. His designs for emergency money for the local government during the inflation of 1923 are famous – including a note for five million marks.

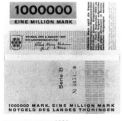

Bayer was responsible for the design of the Bauhaus stationery and

its standardization of paper sizes. He had organized the school's print-ing and publicity department so that it could undertake commissions and print them on its own presses. Because the workshop was limited to its narrow range of sans-serif type, there was an inevitable similarity in all the department's early printed work in 1925. Printed in red and black, with heavy vertical and horizontal 'rules', it is a stereotype of the 'Bauhaus style', although these elements were common to many of the avant-garde, such as Lissitzky, working in Berlin, and Kurt Schwitters, working in Hanover. While it is often crude as a technique, it could be clear and effective. In Bayer's promotional work for industry, particu-larly for the Fagus factory, the lines and dots are used less to appeal to the eye than to direct it, as in his catalogue for Marcel Breuer's 'Stan-dard' furniture, where solid red circles signal each item's code for order-ing. Bayer's designs for letterheads are straightforwardly functional: they have printed guides for folding so that the typed address appears correctly in the window of the envelope. All were in standardized A-sizes, printed in red and black on white paper.

Bauhaus letterhead 1925
[Herbert Bayer]

Besuchsanzeige
postcard front and back 1925
[Herbert Bayer]

Bayer's most ambitious work at this time was a small poster for his old teacher Kandinsky's sixtieth birthday exhibition, printed in red and black on orange poster paper, where the extreme rectangularity of the design is relieved by its skewed angle on the sheet. In 1930 and 1931 Bayer collaborated on two exhibitions with Bauhaus colleagues. First was the Werkbund pavilion at the exhibition of the Société des Artistes Décorateurs in Paris. Second was the Building Trades Exhibition in Berlin, laid out like a theatre set of three-dimensional statistics. In Paris, Bayer's functionalism was expressed in his small, shiny, efficient cata-logue. Through the transparent plastic cover, its title embossed in relief, could be seen an aerial perspective of the building, complete with a pho-tomontaged crowd of visitors. The position of the rooms and their place inside the catalogue was related through a thumb index on the right. One room of the exhibition was arranged with a model of the Dessau Bauhaus buildings on the floor, to give the visitor a view from above; sets of chairs hung from the walls suggested assembly-line production, and pho-tographs were hung at angles in accordance with a theoretical diagram which Bayer prepared of the mechanics of the eye.

For Bayer, the Constructivist method of organizing relationships on the printed sheet through geometry and the use of sans-serif typefaces gave way to less dynamic illustration and the use of serif types, especially

'Kandinsky 60th Birthday Exhibition'
poster 1926
[Herbert Bayer]

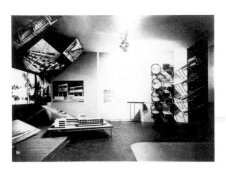
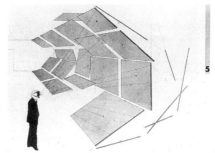

Werkbund exhibition
room 5 and catalogue page
Paris 1930
[Herbert Bayer]

Dorland Studio
brochure page 1931
[Herbert Bayer]

'The Wonder of Life'
exhibition catalogue 1935
[Herbert Bayer]

'The Tooth - an exquisite organism'
Chlorodont toothpaste advertisement
1937
[Herbert Bayer]

the neo-classical Bodoni. This change marked his new concern with 'the laws of psychology and physiology'. This already suggests the language of advertising. In 1928 Bayer had become art director of an international agency in Berlin. The brochure of the Dorland Studio offers its clients 'artists who are masters of all the modern means of presentation'. These means are then illustrated: paint and brush, pencil, set square, a single letter of metal type, camera and airbrush. During the 1930s Bayer used the airbrush not only to create surrealistic dream worlds inhabited by fashion models but also to suggest the objectivity of photography. Explanatory diagrams in encyclopaedias, which can show external appearance and internal working, were refined and developed to become a tool of what is now known as Information Design. Bayer used it to describe the body in terms of a machine in the graphic material for the exhibition 'Das Wunder des Lebens' ('The Wonder of Life').

In a series of advertisements for Chlorodont toothpaste, most of the elements of Bauhaus graphics have disappeared, apart from the use of Futura for the text. The slogans are presented in eighteenth-century script, to give them the character of professorial, time-honoured truths. The conventional elements of the magazine and newspaper advertisement – headline, illustration, text, the slogan and the product – are balanced around a central axis.

What was to become known as Corporate Identity – the application of a consistent style, usually including a symbol, to all aspects of an institution's activity, as Behrens had with AEG – was pioneered in this

Germany

65

period. The city of Magdeburg employed the Swiss-born, Bauhaus-trained Xanti Schawinsky between 1929 and 1931. In Hanover, at the same time, Schwitters designed dozens of pieces of printed material, from postcards and letterheads for administrative departments, to school timetables and hospital bills, to posters for the theatre and opera house. They carried the town symbol which he also designed, and all were type-set in Futura. For the trams, he made a series of cards with rhyming text in Akzidenz Grotesk, known as Standard in English, instructing passengers in such things as how to pay the fare and how to get on and off, illustrated with posed photographs.

'State your destination, length of trip always pay with small change' tramway car poster 1929 [Kurt Schwitters]

school timetable (with Hanover city symbol designed by Schwitters) 1930 [Kurt Schwitters]

Also working as a designer in Hanover was the painter Friedrich Vordemberge-Gildewart, responsible for the publicity of exhibitions at the Kestner-Gesellschaft. All the catalogues used the same geometrical sans-serif typeface, and by 1932 had evolved a standardized layout, with all type in capitals, ranged right.

Junkers water heaters 'Gas und Wasser' exhibition Berlin 1929 [Xanti Schawinsky] the designer preparing a display panel

The new, functional design was by now becoming accepted and introduced in the schools. Baumeister taught in Frankfurt, Burchartz in Essen, Dexel in Magdeburg, Trump in Berlin. When the Nazi party came to power in 1933, many progressive designers, including Renner and Tschichold in Munich, lost their jobs. The Bauhaus was closed. At the same time, Ludwig Hohlwein's posters and many of the new techniques such as photomontage were put at the service of the regime.

In fact, conservative elements had always been hostile to the innovations of the New Typography. Now it was classed as cultural Bolshevism, and parodied to advertise exhibitions of the despised *Entartete Kunst* (Degenerate Art). New nationalistic Fraktur typefaces appeared

Eine deutsche Schrift Deutschland Jochheim Deutsch National!

Fraktur typefaces advertised in *Graphische Nachrichten* Berlin 1935

66

for use in advertising, which became a state monopoly. But Renner's Futura, abused for abandoning the conventional forms of capitals, survived as one of the most practical typefaces for official use.

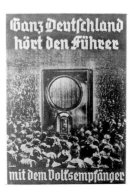

'First National Socialist
(Nazi)
Youth Day'
poster 1936
[Ludwig Hohlwein]

'Degenerate Art'
exhibition poster 1936
[Vierthaler]

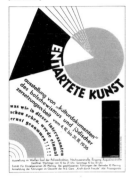

Designers who went into exile took graphic design abroad. In Switzerland it joined an existing tradition. In Italy Schawinsky helped found the profession before he fled Fascism for New York in 1936. A pioneer of the earlier generation, Lucian Bernhard, had opened a New York office in the 1920s, but his simplified poster style did not meet with much success. Bernhard saw Hohlwein as best equipped to bridge the gap between American and European perceptions. 'The American wants an "image", and "idea". For him a purely visual idea is no idea. What he asks for is what he calls "human interest". If he gets it reinforced by a striking use of colour and good composition, so much the better: quite rightly, that's what they admire in Hohlwein. A Hohlwein poster isn't alien to New York, it's only much better than most of the others.' The agency was an American invention which spread to Europe, where many, like Dorland, were subsidiaries of parent companies in the United States. There, according to Bernhard, no drawing board was without its copy of *Gebrauchsgraphik*.

'The whole of Germany
hears the Fuehrer
on the people's radio set'
poster 1936
[Leonid Bermann]

7
The Netherlands

In the development of graphic design the Netherlands was, with Soviet Russia and Germany, at the forefront of the avant-garde. The most original Dutch contribution was the work of Piet Zwart. Zwart's personal symbol was the letter P and a black square (in Dutch, *zwart* means black). The square is a static form which helped to emphasize the flat, rectangular sheet in printed work. Geometry pervaded Dutch design.

designer's personal symbol
1924
[Piet Zwart]

entrance hall tiled floor
1898
[H.P.Berlage]

Zwart's mentor, for whom he worked as an architectural assistant in the early 1920s, was H.P. Berlage, designer of the Amsterdam Stock Exchange and a relentless theorist.

Berlage believed 'that geometry (and thus mathematical science) is not only of the greatest usefulness in the creation of artistic form, but even of absolute necessity. . .' His architectural colleague J.L.M. Lauweriks taught at the School of Arts and Crafts in Dusseldorf where Behrens was principal. Lauweriks encouraged the use of a grid system of design based on sub-divisions and multiplications of the square, an idea that permeated the work of Behrens, and was particularly evident in his work for AEG. Lauweriks's magazine, *Der Ring*, was important in pioneering the use of sans-serif type for text.

Similar theories were developed by De Stijl (The Style), Holland's avant-garde movement in art and architecture. De Stijl was most obviously identified by its rectangularity, exemplified in the abstract paintings of Piet Mondrian, which consist of a grid of black lines on a white canvas with a few rectangles filled with primary colours or grey. De Stijl's energetic spokesman and theorist, Theo van Doesburg was a painter, architect and poet. As well as editing the *De Stijl* magazine, for which he did the layout, he produced graphic design and typography whose strictly geometric manner underlay much of the pioneering work of Schwitters and of the Bauhaus.

Van Doesburg's designs of stationery for the import-export firm of Hagemeier, as well as for the Bond van Revolutionnair-Socialistische Intellectueelen (League of Revolutionary-Socialist Intellectuals), were printed over the letters 'NB' (*Nieuwe Beelding*, New Plasticism), a device common in commercial printing which had been exploited by the Dadaists. In a new design (1920) for the magazine itself, Van Doesburg

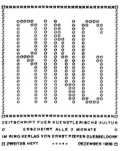

The Circle
cover emblem 1908
[J.L.M.Lauweriks]

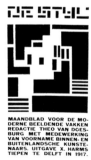

De Stijl
magazine cover emblem 1917
[Vilmos Huszar]

De Stijl
logotype 1921
[Theo van Doesburg]

Hagemeijer & Co
postcard 1919
[Theo van Doesburg]

League of
Revolutionary-Socialist
Intellectuals
letterhead 1919
[Theo van Doesburg]

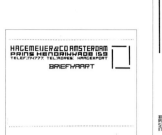

Mécano no.3
magazine cover 1923
[Theo van Doesburg]

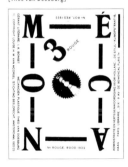

demonstrated a commitment to functionalism, explaining to readers that he had changed from a single-column layout to two columns because the magazine was often folded in the mail, and the crease would now run between the two columns of text.

Other items of stationery for De Stijl had text running vertically and horizontally on the edge of the paper, forcing the reader to turn it round in order to read the words. Van Doesburg also published four issues of a Dadaist magazine called *Mécano* (1922–23). Its third issue required circular reading, induced by a circular saw emblem in the centre of the cover. This technique had been employed in Germany by Schwitters, a contributor to *De Stijl* magazine, who shared Van Doesburg's interest in using typography to make sound pictures. Together in Hanover with Käthe Steinitz, they produced a small book of a fairy story by Schwitters. Emulating Lissitzky's *To Be Read Out Loud*, they made all the illustrations from what they could find in the printer's type case. *Die Scheuche* (*The Scarecrow*) emerged in 1925, the pages printed in red or blue, as the charming, ironic postscript to Dada.

The Scarecrow
double book page 1925
[Kurt Schwitters, Käthe Steinitz,
Theo van Doesburg]

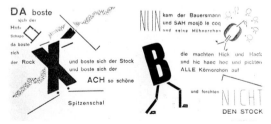

In travels round Europe, Van Doesburg sowed the geometrical ideas of De Stijl, and found the Weimar Bauhaus fertile ground. In 1920 Van Doesburg had met Gropius in Berlin and accepted his invitation to visit the Bauhaus. The following year he rented a studio in Weimar, where he gave free courses and lectures to Bauhaus students. The impact on Bauhaus graphics was powerful and instantaneous. De Stijl's influence is marked in all the publicity for the 1923 Bauhaus exhibition. The poster by Fritz Schleifer (see p.53) shows geometrical lettering typical of Van Doesburg; the prospectus follows Mondrian's grid of black lines; and

printers' rules are used to make up the Bauhaus seal in the manner of the first De Stijl logo.

Printing directly from rules was the technique of Lauweriks's closest follower, the Amsterdam architect Hendrikus Wijdeveld. He edited the magazine *Wendingen* (*Turnings*). Wijdeveld used printers' brass rules to build letters and to construct geometrical ornaments for his pages. In his formalized posters large areas of solid colour are made out of rules stacked together, the slight space between each rule showing as fine lines of un-inked paper. In this way the design and the process of reproduction are interdependent.

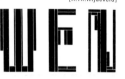

Wendingen
letter construction from printer's rule
and magazine page 1921
[H.Th.Wijdeveld]

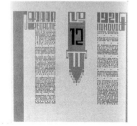

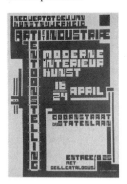

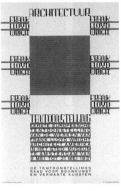

Art and Industry Exhibition
poster c.1923
[J.J.Hellendoorn]

Architecture Exhibition
Frank Lloyd Wright
poster 1931
[H.Th.Wijdeveld]

Stylistically similar works with rectangular lettering, like the 1923 exhibition poster by Jacobus Hellendoorn, were made as drawings to be reproduced by the printer, and so were Piet Zwart's first graphic designs. Trained as an architect – he described himself as a 'typotekt' – Zwart also worked as an interior and furniture designer, and as an architectural critic, throughout a long career which lasted into the 1960s. Before working for Berlage he was assistant to the architect Jan Wils, an original member of the De Stijl group.

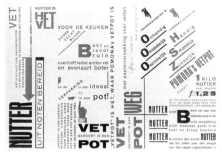

left
Nutter margarine paper
1924
[Piet Zwart]

Ioco rubber flooring
advertisement 1922
[Piet Zwart]

letterhead for Jan Wils 1921
[Piet Zwart]

Zwart began his graphic work with a letterhead for Wils that was a typographical extension of the architect's personal symbol, a square surrounded by five rules of the same thickness. Zwart went on to design advertisements and logotypes drawn in geometrical lettering for a firm producing rubber flooring.

In 1923, Zwart met Schwitters and Lissitzky, both on visits to Holland. Lissitzky presented Zwart with a copy of *To Be Read Out Loud* (his *Story of Two Squares* has already been published in a Dutch version by Van Doesburg the previous year). Zwart became instantly aware of the possibilities of designing directly with typographic material and demonstrated an almost immediate mastery. With the help of a friendly printer, and partly in the spirit of Dada, he used type, ornaments and rules in free, playful compositions with words running up, down, across and diagonally over the page. Berlage had him introduced to the Nederlandse Kabelfabriek (NKF, the Dutch Cable Factory) in 1923.

Suprematist story of Two Squares
in 6 Constructions
book title page, The Hague 1922
[El Lissitzky]

above and right
'Copper cable'
'The safety of our normal cable
is enOrmous'
'50,000 volt cable tested
in 3,000 hours use'
NKF advertisements 1923-26
[Piet Zwart]

Over the next ten years, in nearly three hundred advertisements, Zwart moved from pure typography to combining photographs and photomontages with type. His square and the rectangle gave way to the acute angle and the circle.

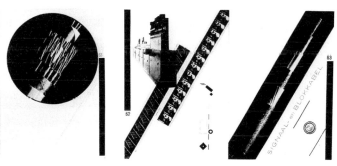

NKF catalogue 1927-28
[Piet Zwart]

NKF
symbols c.1924
[Piet Zwart]

The second technique Zwart learnt from Lissitzky on a later visit in 1926 was how to make photograms, and these became a further source of images for his NKF work.

In the NKF catalogue the lines of text are placed parallel to the salient axis of the image, often diagonally. This diagonal emphasis came naturally to designers trained as architects, like Zwart (and Lissitzky). The tools and techniques of the draughtsman gave them an extensive geometrical vocabulary: they were familiar with the use of the set-square at various angles, with compasses and with perspective projections. A

poster design for a course in graphics at The Hague in 1932 shows a student using an adjustable T-square to position a diagonal headline, while below a larger figure directs his camera downwards at an angle of exactly 30 degrees.

The De Stijl artists Bart van der Leck and Vilmos Huszár made strictly geometrical graphic designs. Another artist, Cesar Domela, worked as a professional designer, and was a member of Schwitters' Ring neuer Werbegestalter, along with Zwart and Paul Schuitema. Like Zwart, Schuitema and colleagues such as Gerard Kiljan and their students and assistants (Wim Brusse, Dick Elffers and Henny Cahn) taught themselves photography, whose images, they said, would convey a message more quickly and clearly. Photomontage enabled them to make the text and the image 'organically one'.

Using diagrams and photographs with a minimum of words, Kiljan's instruction leaflet for state telephones is a particularly good example of their methods. It shows the equipment, indicates what the graphics on the instrument itself mean, and shows it in use. Lines link or separate different categories of meaning, and distant callers are presented in photographs taken obliquely from above, in the same perspective as the aerial photographs on which they are superimposed.

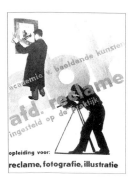

Academy of Fine Art
publicity course
poster design 1932

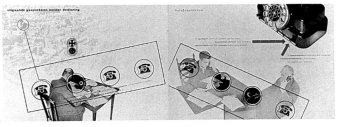

PTT (Post, Telegraph and Telephone)
telephone instruction booklet 1932
[Gerard Kiljan]

Schuitema worked for Berkel, suppliers of weighing machines and bacon slicers. He designed their trademark and stationery and a wide variety of advertisements, brochures and catalogues. They followed his and Kiljan's aim to 'use the minimum means for maximum effect'; yet the speed with which they are read is in inverse proportion to the time spent in their elaborate planning and the skills required of the process engravers who made the blocks and the letterpress printers.

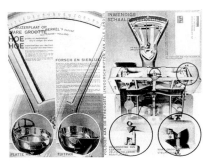

Berkel weighing machines
brochure 1930
[Paul Schuitema]

The precise pressure of the raised inked metal on the paper was critical to the effect of such sophistication as Cahn's folder for electric clocks and internal telephones. Such technical elegance, the 'machine aesthetic', mirrored the advanced communication equipment that it advertised. ('The machine is, *par excellence*, a phenomenon of spiritual discipline', wrote Van Doesburg.)

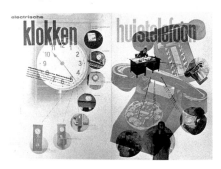

Dutch Home Telephone Co.
electric clocks / internal telephones
brochure double page 1938
[Henny Cahn]

An opposite attitude was demonstrated in the work of H.N.Werkman. His output, consisting mainly of books produced in very limited quantities with a few related pieces of ephemera, deliberately exposed the printing process. The thickness and irregularity of the inking and occasional smudging are a mockery of professional craft standards. Werkman frequently used printing letters abstractly, as shapes, adding areas of colour from torn pieces of paper rolled with wet ink. He often printed without the press, which he called 'hot printing'. Werkman's uninhibited graphic invention has been an inspiration to graphic designers anxious to introduce an obviously 'creative' effect. The self-conscious use of old wood type came to signal 'non-commercial' design well after the Second World War, during which Werkman was executed for clandestine printing.

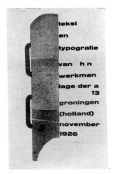
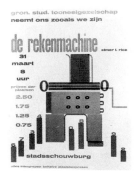

The Next Call no.9
magazine back cover 1926
[H.N.Werkman]

The Adding Machine
theatre poster 1933
[H.N.Werkman]

After Van Doesburg's early death in 1931, and with it the end of *De Stijl* magazine, the clearest manifestation of the Dutch avant-garde was on the covers of *De 8 en Opbouw* (*The 8 and Construction*), the journal

published fortnightly by two groups of architects, launched in 1932. Their technique of improvised assemblages of alphabet and image, in black overprinted with a single colour dominated by the figure '8', typified the manner of Schuitema and Zwart.

The 8 and Construction
magazine cover 1932
[Paul Schuitema?]

'Giso Lamps'
poster 1928
[Willem Gispen]

'Gispen Steel Furniture'
poster 1933
[Willem Gispen]

telephone box lettering 1933
[Willem Gispen]

Zwart's longstanding connection with the firm of Bruynzeel, suppliers of building products, included his design of prefabricated items such as doors and kitchen fitments as well as hundreds of printed promotional items – brochures, catalogues, blotters and calendars. Schuitema's involvement in similar work included photography for the industrial designer W.H. Gispen, who designed publicity material and catalogues which matched the clear, mechanical elegance of his products.

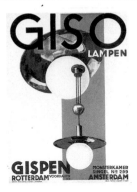 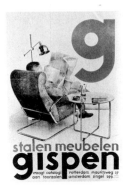

radiators catalogue 1939
[Paul Schuitema]

Among the items made by Gispen's workshops was the telephone box for the PTT (the Dutch Post, Telegraph and Telephone service), with his own lower-case geometrical lettering. This integration of advanced contemporary design with a public company was the responsibility of J.F. van Royen. Van Royen had started work in 1904 as a clerk at the PTT, at the same time running his own private press in the Arts and Crafts tradition. In 1920 he became head of the PTT and, as he was also an official of The Netherlands Association for Craft and Industrial Art (VANK), which acted as an intermediary between designers and clients, he was able to employ established designers such as the Art Nouveau

The PTT Book
colour booklet pages 1938
[Piet Zwart]

artist Jan Toorop, as well as the modernist avant-garde. Van Royen's personal taste and interests became the company's visual identity.

The PTT, above all through its postage stamps, made the latest graphic techniques widely familiar. Zwart's and Kiljan's photographic stamp designs appeared in 1931, Schuitema's a year later.

The Dutch had welcomed ideas from Germany and Russia; indeed, they had absorbed and refined them. Through the energy of Van Doesburg, a Dutch presence in the international evolution of the new medium was forcefully established. In 1928 Zwart was invited to take charge of the graphic department at the Bauhaus (but he gave only an intense short course); as members of the Ring neuer Werbegestalter, Zwart's and Schuitema's work was publicized, and with Kiljan, exhibited in the Stuttgart 'Film und Foto' exhibition of 1929.

It was, however, the enlightened tradition of imaginative design in the public services inherited by the students of Zwart, Schuitema and Kiljan that was to give The Netherlands continuous importance in the history of graphic design.

postage stamps
1931
[Piet Zwart]
[Gerard Kiljan]

75

8

Switzerland

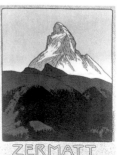

Switzerland's three best-known graphic artists at the end of the nine-teenth century were Grasset, Steinlen and Félix Vallotton. All three had made their careers abroad, in France. The pre-eminent Swiss painter Ferdinand Hodler also made his first important contribution to design outside Switzerland: the poster for the nineteenth Vienna Secession exhibition in 1904. Below a sky of formalized clouds, a figure, lying in a field dotted with white flowers, symbolizes the Secession's motif, 'The Sacred Spring'. It shares not only the visual content (sky and landscape) of the later Swiss travel poster but also the 'Swiss style'. Like the Japan-ese print, this suppresses perspective and emphasizes the two-dimen-sionality of the printed sheet, which Hodler achieves here by making the bands of sky on which the lettering runs of roughly even height, not diminishing in perspective as they would in a naturalistic view.

19th Secession Exhibition
poster 1904
[Ferdinand Hodler]

Safir Automobile Factory
poster 1907
[Burkhard Mangold]

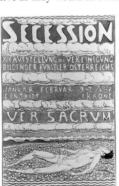

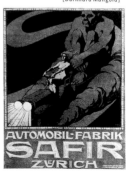

Another painter, Burkhard Mangold, anticipated later developments in his extraordinary automobile poster of 1907. The light brown 'S' of the road, the initial letter of the makers, Safir, breaks the flat black of the background. Swiss designers restricted perspective in their images, typ-ically emphasizing this flatness by using geometricized lettering with an even weight of line. This can be seen in the Zermatt poster of 1908 by Emil Cardinaux. This simplified two-dimensional manner, in image and lettering, was exhibited by Hugo Laubi in 1920: in its geometrical econ-omy, his Odeon café poster is a significant precursor of the abstract posters of the later Swiss graphic designers.

Otto Baumberger produced a poster in 1919 for the hat shop Baumann in Zurich, whose history is a positive demonstration of Swiss designers' early mastery of a lasting technique. The poster was amended twice in 1928 when the firm moved, and reprinted several times later. The top hat, used as a symbol for hats, makes verbal explanation unnecessary.

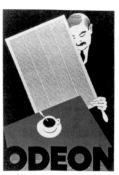

Odeon
hotel poster 1920
[Hugo Laubi]

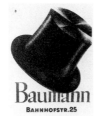
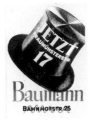
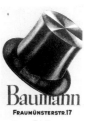

Baumann
hat shop posters
1919 / 1928 / 1928
[Otto Baumberger]

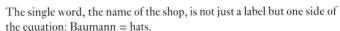

Radio House Scheuchzer
poster 1931
[Niklaus Stoecklin]

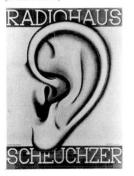

Sunlight
household soap poster 1924
[Niklaus Stoecklin]

PKZ
men's clothes shop poster 1934
[Peter Birkhäuser]

The single word, the name of the shop, is not just a label but one side of the equation: Baumann = hats.

The design by another of Switzerland's best poster artists, Niklaus Stoecklin, for Sunlight soap, asked the viewer to make an obvious connection between the soap and its packet, placed centrally at the bottom of the poster, and the white sheet. The stark message – the cause of the whiteness being the effect of the soap – is tempered by the appearance of nature in the form of a butterfly. It is one of the many posters of this period where the images need no caption: Stoecklin's ear, surreally enlarged for Radiohaus Scheuchzer (1931); Peter Birkhäuser's open mouth in the poster for the Basle Song Festival, and his button, for the outfitter PKZ.

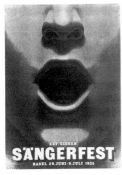

'Song Festival'
poster 1935
[Peter Birkhäuser]

As in the rest of Europe, advertising was influenced by American example, particularly in the use of the slogan or headline. This led to the insistence on a complete advertising concept, which concentrated on one aspect of the product ('the unique selling proposition') and was developed in a campaign linking posters with advertisements in magazines and newspapers.

The simple proposition made by Baumberger in his poster for the *Neue Zürcher Zeitung* is that there are three editions each day. This he graphically translates into three heads, in silhouette, carefully differentiated as young man, young woman and older man. The strength of the design, however, is undermined by the trite slogan in the lower right-hand corner: 'Leading paper in Switzerland for politics, business, science and art.'

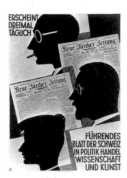

Neue Zürcher Zeitung
'three editions daily'
poster 1928
[Otto Baumberger]

If the Swiss admired American attitudes, the Americans respected the Europeans for their stylishness. They were, in particular, admirers of the tourist posters designed by Herbert Matter. One of the great innovating designers of the period before the Second World War, Matter was persuaded to stay in New York after a visit in 1936. He trained as a painter, first in Geneva and then in Paris, experimenting with collage and montage, and in 1929 he became a publicity manager for the Paris typefounders Deberny & Peignot.

Matter returned to Switzerland in 1931. With an understanding of the imaginative possibilities of photography and of the printing process itself, his first design work was for the printing industry. He did covers for the trade journal *Typographische Monatsblätter* and publicity for the Zurich printers Fretz, using almost surrealist montages. Red, blue and black were his preferred colours. These he employed for tourist brochures and posters in careful montages and superimpositions of cut-out photographs which often give the effect of full colour. Unlike the montages of Heartfield or the Soviets, there is no dramatic conjunction of images; instead Matter contrives an artificial, seamless space.

These posters were printed like illustrated magazines, by the gravure process, which deposited a dense weight and ink on the paper. Their lettering, always in a drawn sans serif, was overprinted to allow for titling in different languages.

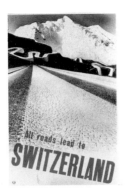 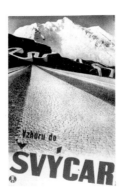

'All roads lead to Switzerland'
'Drive to Switzerland' (Czech version)
poster 1934
[Herbert Matter]

Fretz Brothers
printer's booklet cover c.1934
[Herbert Matter]

In leaflets advertising holiday resorts Matter used similar techniques but he stretched the limits of letterpress printing – overlapping images and allowing them to fade at the edges through grey to the shiny white of the paper, like images dissolving on a cinema screen (see p.22). His colleagues, the photographer Emil Schulthess (later art editor of *Du* magazine, which demonstrated the technical mastery of Swiss printing) and Walter Herdeg (celebrated as the editor of the most influential professional magazine, *Graphis*) played a similar part in tourist promotion with the most up-to-date techniques.

Advertising the products of Swiss engineering, electrical, chemical and construction industries was a task which brought together the avant-garde influences. Anton Stankowski, a new arrival in Zurich, had worked with Burchartz and Canis in the Ruhr. He was the pioneer of 'Industrial Graphics' from 1929 until his return to Germany in 1937.

Thécla Iron Foundry brochure 1932
[Anton Stankowski]

Max Dalang advertising
'How do you make publicity?
One of the ways is with the camera,
which shows goods in such a way
that everyone wants them.'
advertisement 1934

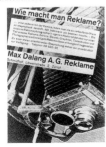

'Swissair's cheap Autumn flights'
advertisement c.1935
[Anton Stankowski]

Stankowski's technique, following Burchartz, was the exact opposite of Baumberger's and Stoecklin's metaphorical illustrations. He presented the product in as clear a way as possible, with only essential information, arranged asymmetrically, and a free use of rules to organize the space and the relationships within it. The typesetting was consistently sans serif – Akzidenz Grotesk in normal and bold weights, using upper and lower case exclusively, with no words set in capitals. Stankowski recalled how he and his colleagues would tackle a job: 'Before we advertised something, we really had to experience it, to understand it, so that we could represent it. . . . To find a good motif for a poster for a vegetarian product, the right thing to do was to live for a time as a vegetarian.' Stankowski took most of his own advertising photographs. In 1934

Switzerland

he collaborated with Hans Neuburg on one of the earliest posters to use a single photographic image, for Liebig bouillon cubes. (It makes an interesting contrast with Cappiello's Kub poster of only three years earlier: see p.86) The package is printed in solid yellow and the logotype 'Liebig' in green. The housewife, wearing a pinafore whose open square check repeats the motif of the cube, photographed from below, is printed in black. In printing the photograph from the negative, Stankowski has exaggerated the child's-eye view, distorting and extending the right-hand side of the image to concentrate attention on the face.

The apparent objectivity of the photograph assured its place in advertising. It could show familiar products in an unfamiliar way, make the banal look interesting, and the product irresistibly appealing.

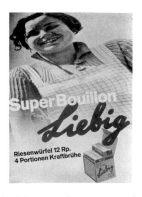

'Liebig Super Bouillon'
poster 1934
[Anton Stankowski / Hans Neuburg]

Tschichold, who had done much to promote the use of photography, had sought refuge in Switzerland in 1933. For an exhibition 'Der Berufs-photograph' ('The Professional Photographer') at the Kunstmuseum in Basle in 1938, he produced the last large work in which he followed his precepts of asymmetrical typography. This is a poster of extreme economy and precision (see colour illustration, p.22). The image is a photograph in negative, its left-hand edge on the centre of the sheet. The word-element, '*photograph*', starts at the edge of the image. With the image overprinted on it, the word forms a unit of meaning which includes the first part of the subtitle, '*sein werkzeug*' (his practice). The second half of the subtitle, '*seine arbeiten*' (his works), is placed after a dash. The dash bridges the image area and the white paper of the sheet, so that the works are, literally, the outcome of the process. The rest of the text information is related by size and position according to its importance. 'Where' (the museum) is aligned horizontally with 'what' (*ausstellung*, the exhibition); this is related vertically to 'who' (the name of the collaborating organization) at the top and to the start of the main title below. 'When' (the dates and opening times) is related, with less evident logic, by the device of reversing the dates in white out of a black rule, making a further 'negative'. Days and times are presented in a tabular form which emphasizes the Sunday morning and Wednesday evening openings. In

werktags	14-19	
mittwochs	14-19	19-21
sonntags	10-12	14-19
eintritt frei		

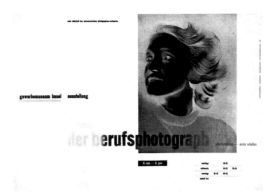

a vertical line of text on the right are listed the designer, photographer, blockmaker and printer. All the type except the main title is printed in black, with the photograph. The remainder, the horizontal rules, main title and subtitle, are printed in a single run through the press, with yellow on the inking rollers on the left, blue in the middle and red on the right.

Tschichold's and Herbert Matter's knowledge of the processes of the printing industry allowed them to use the medium to extend the designer's expressive range. Overprinting served not merely to create the effect of depth but, by allowing images in different colours to exist in the same space without cancelling each other, to modulate the meaning of the images and to reinforce connections between the images and the words.

As a book designer in Basle, Tschichold was coming to realize the limitations of the New Typography. When he renounced asymmetrical layout for book typography in 1946, his most violent critic was Max Bill. Bill had returned to Zurich in 1929 after two years at the Dessau Bauhaus. He was a painter, sculptor, architect, industrial designer and theorist. Frustrated by lack of opportunity as an architect, he designed advertisements 'as an amateur'. In fact, he quickly became a master of design for print (see p.21). He showed the rationality of Tschichold, yet his work at this time has little of the formalism that became associated with Swiss graphic design.

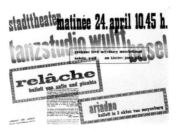

A famous poster for the performance of two ballets in 1931 has survived in two sizes. In a mock-Dada manner, Bill plays with nineteenth-century wood poster type and ornamental borders, using the 'rainbow'

Switzerland

multicoloured technique and black, exactly like Tschichold. Also, like Tschichold, but a true Bauhäusler, he renounced capital letters. Even more celebrated, and a forerunner of Swiss design, is Bill's poster for *Negerkunst*, prehistoric rock paintings of southern Africa. The white oval shape on the buff background is an extreme abstract metaphor. Its geometrical construction, as that of the whole area of the poster, is controlled by simple but exact relationships based on the square and the circle.

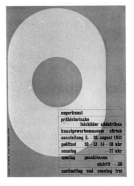

Negro Art:
Pre-Historic Rock Paintings
of Southern Africa
exhibition poster 1931
[Max Bill]

Max Bill's posters are the most noticeable of his contributions to graphic design. The variety of his output and the range of his invention in technical literature, trademarks, stationery, political journals, book covers and advertisements is astonishing. His most significant achievement of the 1930s was his design for the Swiss pavilion at the 1936 Milan Triennale exhibition. Its controlled austerity provided a perfect setting for the radical formalism and economy of the posters displayed. This was the first international demonstration of the 'Swiss style', the dominating influence in graphic design abroad twenty-five years later, and already firmly established.

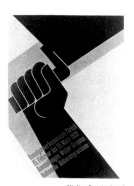

'Walter Gropius' and
'Rational Building Techniques'
exhibitions poster 1931
[Ernst Keller]

Swiss pavilion
Milan Triennale
exhibition design 1936
[Max Bill]

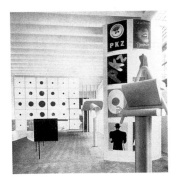

France

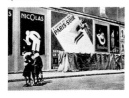

Not only for France, but also for the rest of the world, Paris was still the centre of cultural life and fashion. After the horrors of the First World War, the capital remained an image of modernity, promoted with international exhibitions and the '*spectacle dans la rue*' – its constantly changing display of posters. Posters, as evidently artistic as commercial, marketed luxury and escape as well as everyday pleasures. In the work of the most celebrated and consistently brilliant *affichiste*, A.M. Cassandre, eating, drinking, smoking, enjoying entertainment and travel are given monumental expression.

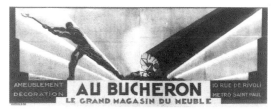

Cassandre's first large poster, for the Paris furniture store Au Bucheron (The Woodcutter), appeared in 1923. It is the woodcutter, the name of the shop, which Cassandre chooses to illustrate, not what it sells. A huge figure swings his axe back to the top left-hand corner of the design, four metres (12ft) long. A falling tree runs out of the picture in the top right and triangles of colour, each shaded from yellow to white, fan out symmetrically from the centre at the base of the tree, above the lettering. Graduated planes like this became one of the main ingredients of the Art Deco style (as it was later called).

Art Deco established itself as the dominant style of France between the two world wars. As had been the case with Art Nouveau at the turn of the century, it existed alongside more popular, straightforward illustration and more informal lettering. It derived directly from the French Cubist painting developed before the war. Apart from shading from light to dark, which emphasizes the edge of carefully selected forms, Art Deco also adopted an obvious geometry. During the early 1930s Art Deco was joined in France by what has become known, usually pejoratively, as *moderne* – a style that had superficial connections with the 'machine aesthetic' of the avant-garde but more to do with the romantic appeal of motor car, locomotive and ocean liner.

Moderne used straight lines, often diagonal, and circles. To Cassandre geometry was fundamental: in the construction of the image, in relating the image to the proportions of the printed sheet, and in the forms of the lettering. Cassandre began, though, with the word. 'In my work', he said, 'it is the text, the letter that . . . sparks the ideas which generate

plastic forms.' His 1924 poster for an aperitif takes the origin of the name Pivolo – a phonetic rendering of the injunction to trainee pilots, *Et puis vole haut*, which suggests to the artist *Pie vole haut* ('magpie flies high'). So a magpie becomes the central motif, integrated with the symmetrically placed glass. In the same way, Cappiello, almost twenty years earlier, had used the trade name as the source of the image, a centrally placed bird, with geometric lettering, in his poster for Albert Robin brandy.

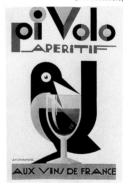

'Pivolo'
poster 1924
[A.M.Cassandre]

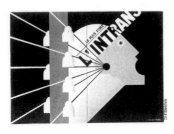

L'Intransigeant
poster for newspaper 1925
[A.M.Cassandre]

Over the next ten years, beginning in 1925 with the diagonal symmetry of *L'Intransigeant*, Cassandre produced several graphic masterpieces among a total output of several hundred posters. While he conferred an aesthetic status on what he advertised, at the same time he stated clearly that the poster was only

> a means of communication between the seller and the
> public – somewhat like a telegraph. The poster artist is like
> a telephone operator: he does not *draft* messages, he *despatches*
> them. No one asks him what he thinks; all he is asked to do is
> to communicate clearly, powerfully and precisely.

As well as posters that gave a poetic allure to means of travel, Cassandre created one of the icons of the period for Dubonnet in 1932. In three stages the outline of a seated figure is filled with brushstrokes; the idea of satisfaction develops as the name of the drink is articulated – DUBO (*du beau*, handsome, fine, beautiful): DUBON (*du bon*, good) : DUBONNET – the complete name, the complete man, and the bottle appears, refilling the glass.

With the word at the centre of Cassandre's thinking, the form of the lettering and its disposition was equally significant. His letters are almost always constructed with drawing instruments and words integrated into

Bifur typeface 1929
[A.M.Cassandre]

'Dubonnet'
poster 1932
[A.M.Cassandre]

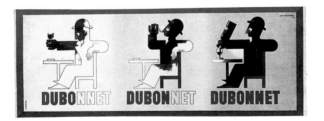

Peignot typeface 1937
[A.M.Cassandre]

'No *R* ... no appetite'
poster 1933
[Paul Colin]

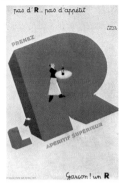

Trocadero Ethnographic Museum
poster 1930
[Paul Colin]

'St. Raphael Quinquina
Red. White.'
enamel sign c.1930

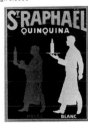

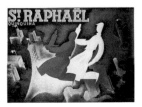

'St Raphael Quinquina
poster 1937
[Charles Loupot]

the overall design or relegated to the borders. His Bucheron poster has many idiosyncrasies, typical of the time before enlarged printers' typefaces were used on lithographic posters. The capital 'C' of BUCHERON is exactly half the circular 'O', and the capital 'I's in the small lettering have dots. In the sub-title, LE GRAND MAGASIN DU MEUBLE, triangles take the place of cross bars in the 'A', the 'E', and the dot over the 'I'. 'G' ends in an arrow.

'The letter only begins to live,' he said, 'when it is in its place in the word. The graphic image of this word . . . forms in our mind a harmony that corresponds exactly to an idea.' Such concerns led Cassandre to the design of typefaces: the poster-like, geometrical Bifur of 1929, and the perverse Peignot of 1937, which has most of its lower-case letters drawn as small capitals, reverting to the stage in the development of writing before lower-case letters had come into use.

Compared with Cassandre's work, lettering in posters by the other celebrated French designers was as banal as their use of single, Cubist-inspired figures. Jean Carlu, Paul Colin and Charles Loupot provided occasional exceptions. The giant 'R' of Colin's poster for the aperitif l'R depended, for its image, on the three-dimensional letter whose spoken sound ('air') made the play on words the central idea: 'no air – no appetite'.

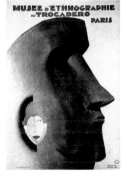

Colin's poster for the Paris Ethnographical Museum in 1930 has the simplicity of a Hohlwein. Like German posters of the time, it emphasizes the flatness of surface and dramatizes the images by an extreme change of scale and viewpoint, from the monumental profile of the Easter Island sculpture seen from below to the straightforward, colourfully Cubistic presentation of the life-size mask.

Loupot began a long association with the aperitif St Raphaël, whose advertising was to become a landmark in graphic design after the Second World War. In a 1937 poster he introduced the pair of waiters, whose silhouettes, one white and one red, had identified the firm's publicity since 1910. In the 1940s and 1950s, they became part of the rare use of abstract images in publicity (see p.148).

Leonetto Cappiello had survived as a poster designer from the period

France

85

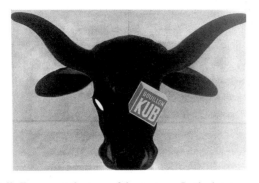

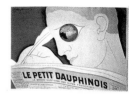

Le Petit Dauphinois
poster for newspaper 1933
[Leonetto Cappiello]

Bouillon Kub
poster 1931
[Leonetto Cappiello]

of the Belle Epoque at the turn of the century. In the inter-war years he produced one of the most arresting, economical images ever to appear on a poster, for Bouillon Kub. The symmetry of the bull's head, the dramatic white of the eye represented by the unprinted white of the paper, and the stock cube shown as an unshaded perspective drawing of the product, need no slogan. It is like a German *Sachplakat*. The product is shown with an image that is both literal and metaphorical. The bull is not only the literal source of bouillon, but also bestows its strength on the cube.

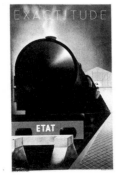

'Exactitude'
poster 1932
[Pierre Fix-Masseau]

With Cassandre, the airbrushed image and geometrical lettering expressed the accuracy of the machine age. The railway poster designed by Cassandre's disciple Pierre Fix-Masseau, with the two words *Exactitude* (Punctuality) and *Etat* (State), stretches the spare geometry of its execution to reflect the punctuality of the service by making the minute hand of the clock, a white circle placed like a halo behind the driver's head, point to the centre of the black circle of the locomotive's boiler.

Poster artists gained authority and control over their productions through the dependence of printers to whom they were contracted. These specialist firms won clients who were drawn to the reputations of individual designers. With the gradual development of the advertising agency, which worked as a team, and the increasing number of magazines in which products could be advertised, the importance of the poster and the individual declined during the 1930s.

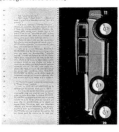

Rochet-Schneider automobiles
booklet 1929
[Draeger Freres Studio]

It was the advertising agencies and printers (Tolmer and Draeger, for example), with their own design studios, who attempted an uncompromising *moderne* style. Although Cassandre had used simple photomontage elements, the size of posters, which involved transferring the artist's original drawing by hand rather than mechanically, precluded the use of large-scale photography. No such limitations restrained designers of advertisements, brochures and catalogues, who took advantage of photography and the new sans-serif typefaces.

The Paris printer Alfred Tolmer was author of a book published in English in 1931, *Mise en Page: The Theory and Practice of Lay-out*, which attempted a radical exposition of the new graphic aesthetics in France. Its extravagant novelty is well expressed: 'The art of lay-out nowadays owes its strength to its free use of processes. From photographic apparatus, scissors, a bottle of Indian ink, a gum-pot, combined with the hand of the designer and an unprejudiced eye, a composition can be evolved and a novel idea expressed by simple means.'

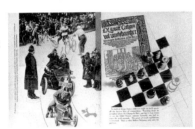

Mise en page
Two double pages 1931
[Louis Caillaud]

Tolmer's suave attitudes were typical of French designers. The avant-garde movements in France, Dada and Surrealism, had little direct impact in graphic design. Cassandre's use of geometry and many of his poster techniques echo the purism of the architect Le Corbusier, whom Cassandre commissioned to design a house. As a theoretician, Le Corbusier was a consistently brilliant user of graphics – cut-out and tightly cropped photographs and diagrams – in his books.

German work reproduced in the magazine *Arts et métiers graphiques* met little response in France, where few designers shared the earnest social commitment of their avant-garde colleagues to the north and east.

Parisian graphic design presented an image of chic modernity. In the late 1920s the long-established store Aux Trois Quartiers adopted the *moderne* style for the facade and its lettering – a standard architectural use of extended geometrical capitals – as well as for its advertising and catalogues. These were the responsibility of a Russian emigré, Alexey Brodovitch, who was to become, with the art editor of the topical weekly *Vu*, Alexander Lieberman, the best-known exponent of layout in New York a few years later. Brodovitch's collaborator at the store, Robert Block, identified three types of advertising:

'Michelin'
photomontage tyre poster
1932

1. Those which must take the viewer by surprise, even to the point of stupefaction;

'Aux Trois Quartiers'
advertisement 1930
[Alexey Brodovitch]

far left
'Odéon'
three-dimensional poster
c.1937

2. Those which use repetition, allowing certain ideas, certain
names, certain forms, certain suggestions, to accumulate in the
individual brain, just as the continuous dripping of water on a
stone will gradually wear it away;
3. Those which stimulate interest, curiosity, the desire to under
stand, to know . . . by their form or their wit.

Such an analysis indicates the mutual dependence of the designer,
client and public. The relationship of artist and patron had been trans-
formed into a professional and commercial partnership.

Citroen symbol 1920s

far left
Citroen factory
photomontage advertising gear mesh
1913

radiator grille 1930s

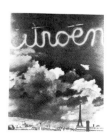

Eiffel Tower illuminated sign 1925
skywriting 1930s

Britain

The avant-garde developments in continental Europe were illustrated and discussed by Tschichold, writing several reports from Germany in the British trade magazine *Commercial Art* in 1930 and 1931. In Britain (where Tschichold was to work in the late 1940s in a practical but painstakingly exquisite traditional manner) the New Typography was only superficially understood. It was seen as a style that was useful to suggest modern sophistication; German work was crudely imitated with sans-serif type and a scattering of rules, and posters weakly emulated the French designers' decorative Cubism. Tradition remained the most powerful influence in Britain.

The only notable avant-garde reaction had, in fact, come before the First World War in response to Futurism. Marinetti visited London in 1913 and soon after, that same year, the Vorticist group of artists was formed. Their thick journal, *Blast*, appeared in only two issues, in 1914 and 1915. It was printed direct from type, the front cover with black poster lettering set diagonally on solid deep pink. The text pages were printed in heavy grotesque type, their size and arrangement reflecting the sense and importance of the words. By choosing such a typeface and exchanging symmetry for the consciously crude layout of popular advertisements, Vorticists were original in Britain in exploiting typographic form as part of a wider reform.

Blast
journal page 1914
[P. Wyndham Lewis]

The Gentle Art of Making Enemies
title page 1890
[J M Whistler]

A House of Pomegranates
by Oscar Wilde
book page 1891
[Chiswick Press]

There had been precedents for asymmetry in title pages, the most remarkable being the polemical publications of the artist Whistler, such as *The Gentle Art of Making Enemies* (1890), inspired in their layout by his friend Mallarmé as well as the Japanese, an influence on some English private presses. The playwright and critic Bernard Shaw, though cursed in the pages of *Blast*, had for some years insisted on a 'ranged left' layout for the title pages of his plays and on a single typeface, Caslon.

It was in the design of letterforms that Britain made a lasting contribution to the appearance of the printed word. The lesson the Arts and

Crafts Movement had drawn from early printed books produced the opposite of Whistler's airy aesthetic: they put more ink on the page, insisting on more robust letterforms with less space between words and lines.

The letters from which words were printed could by the end of the nineteenth century be selected at a keyboard and cast as metal by machine, instead of being typeset by hand from existing type. Competing systems of typesetting needed to offer their customers new typefaces. The first type designed specifically for the Monotype company's casting system was Imprint (1912), named after the typographical journal *The Imprint*, which had played a part in its development and was the first to use it. Further faces based on historical models followed: Plantin (1913), Caslon (1916), Garamond (1922) and Baskerville (1923).

One of the co-editors of *The Imprint* was the calligrapher Edward Johnston. His work took tradition to an extreme. He wrote with goose quills on animal skins and, as a teacher, persuaded generations of students to do the same. His classic textbook, *Writing & Illuminating & Lettering*, first published in 1906, has gone through thirty reprints. In 1915 Johnston was asked by London's Underground Railway to design an alphabet for its signs, 'which would belong unmistakeably to the twentieth century'. The Underground had experimented with letters based on squares and circles a decade before similar German attempts; but Johnston went back to the proportions of Classical Roman capitals, with a completely circular 'O' and the uprights of the 'M' forming two sides of a square, the diagonals meeting in its centre. The lozenge-shaped dots on the 'i' and 'j' and in the punctuation show quite clearly the origin of the letterforms in calligraphy and the diamond shape is natural to a dot made on paper with a square-nibbed pen.

ABCDEFGHIJKLMNOP
QRSTUVWXYZ
abcdefghijklmnopqrst
uvwxyz

In 1928, when Johnston's former student Eric Gill, a master of inscriptional lettering, designed his Gill Sans typeface, he took Johnston's alphabet as a model. Unlike the German sans-serif faces such as Futura, which appeared at the same time, the letters retained many of the traditional subtleties of varying thickness of line, but abandoned the archaic diamond-shaped dots. Gill himself described the design as 'five different sorts of sans-serif letters – each one fatter and thicker than the last because every advertisement has to try and shout down its neighbours'. Ultimately, with inline, outline and shaded versions, there were more than twenty variations of Gill Sans. Gill designed a number of serif

Three Plays for Puritans: The Devil's Disciple, Cæsar and Cleopatra, & Captain Brassbound's Conversion. By Bernard Shaw.

London : Grant Richards, 48 Leicester Square, W.C.

Three Plays for Puritans title page 1901

(in case of overlooked or slight inaccuracies)

handwritten instructions for production of underground lettering (detail) 1915 [Edward Johnston]

MNO
hijkl

London Underground lettering 1915 [Edward Johnston]

Essay on Typography
book page (showing Gill Sans typeface
and 'ranged left' typsetting) 1931
[Eric Gill]

types, including the popular Perpetua, but Gill Sans became the most widely used design of its kind in Britain for the following thirty years, particularly in the printing of timetables and forms.

'The main stream of lettering today is undoubtedly the printed sheet or book . . . neither the chisel nor the pen has now any influence at all', wrote Gill in his influential *Essay on Typography*, first published in 1931, a book which was important partly because it advocated and demonstrated text typesetting that was 'unjustified' or 'ranged left/ragged right', a manner that became commonplace only forty years later. Gill pointed out that 'with words of different lengths, it is not possible to get a uniform length in all the lines of words on a page'. You had either to have uneven spaces between the words or uneven line length. Readability, he thought, was assisted by even spacing rather than by equal length of line. At a time when the most advanced European typographers were still forcing their lines of type into boxes, this was a radical suggestion.

telegram form
before and after redesign c.1935
(Gill typeface)
[Stanley Morison]

The adviser to Monotype who had commissioned Gill was Stanley Morison. A self-educated historian of type design and a typographer, Morison had established himself by his erudition and the power of his personality as a leading authority. He was adviser to *The Times* newspaper, which he redesigned with a typeface produced to his instructions. This was Times New Roman, which, together with its bold version, still remains popular for magazines and books. Morison's criteria were always practical, and he defended his innovations with forthright attacks on the conservatism of the printing trade. 'To be effective you must surprise – *startle*. Here is no one criterion but individuality and novelty. Tempering and controlling these with logic, the progressive printer will create fresh rules for each occasion,' he wrote. This sounds like a programme

The Times
mastheads 1932
[Stanley Morison]

Times New Roman
typeface 1932

ABCDEFGHIJKLMNOPQRSTUVWXYZ
abcdefghijklmnopqrstuvwxyz

Britain

for the book jackets which Morison designed for the publisher Victor Gollancz from 1929. Their bright yellow paper stood out and people picked them up, tempted by the discussion of the book's contents on the front, which were often displayed in a shower of contrasting typefaces. The typography had much of the crude invention of *Blast*, outside any tradition. Morison had no liking for the breaking of rules by the adherents of the New Typography but, ironically, they shared his belief that 'Typography is the efficient means to an essentially utilitarian and only accidentally aesthetic end.'

For the 'vg' monogram symbol on the Gollancz jackets, Morison employed an American poster artist, Edward McKnight Kauffer, the most prolific of the designers commissioned by London Underground. London Transport's enthusiastic publicity manager, Frank Pick, had chosen posters as the means firstly to encourage travel by bus and Underground outside commuting hours and, second, to persuade advertisers that posters on the Underground were an effective medium. The posters' main function was aesthetic, to decorate the stations. A further intention was to provide public art education, and copies could be bought. Paintings provided the images. The lettering was like a label, less to identify the image than to justify its presence.

Kauffer had arrived in England in 1914 after a tour of the Continent. He had been impressed by the German poster artists, particularly Hohlwein, whose mannered use of textured paint appears in Kauffer's first London Transport poster, for the North Downs. Kauffer's best-known work was a design of birds in a Vorticist manner, bought by the *Daily Herald* and given a contrived slogan, 'The Early Bird'. It prompted Winston Churchill to suggest that Kauffer might design an emblem for the Royal Flying Corps. Nothing came of this, but the design might have been the source of the brilliantly successful 'Speedbird' symbol designed by Theyre Lee-Elliott a decade later for Imperial Airways.

Between 1915 and 1940 Kauffer produced 250 posters and 150 book jackets in an Art Deco style of vulgarized Cubism: small areas of colour, squares and triangles and segments of circles and arcs, often faded and graduated by splattering or stippling, are juxtaposed, light against dark, to imply depth. As in France, the widespread use of the airbrush helped this to become an established mannerism. Kauffer and his fellow poster artists, assisted by publicity managers who acted as their patrons, kept their medium in a world of its own: neither art, nor industry, and not yet graphic design.

Most English posters failed to combine their words and images to express an idea. Kauffer's 'Power: the nerve centre of London's Underground' has some of the geometry of a poster by Cassandre. The idea, though, is as confused as its graphic presentation. The poster has three ideas: power, nerve centre, Underground. Power is represented twice, by its source, the power station, which is red, and also by the black, muscular arm and the fist from which the stylized lightning springs, a sign for the type of power – electricity. 'Nerve centre' is more ambiguously

The Running Footman book jacket front 1931 [Stanley Morison] monogram (top left corner) 1931 [E.M.Kauffer]

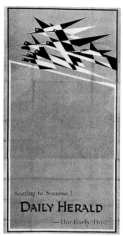

Daily Herald poster 1918 [E.M. Kauffer]

The North Downs travel poster [E.M.Kauffer]

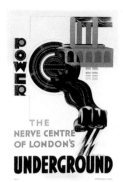

illustrated with the nerves as fine blue vein-like lines on the arm emerging from a black circle, like a gramophone record, which overlaps the power station with the help of spattered ink. At the centre of the disc is the Underground symbol, linked to the word 'Underground' by the lightning. The word 'Power', mostly black, is related by its colour and position, through the circle, down the arm, to the word 'Underground'. The red in the 'Power' lettering connects it to the power station. But red is the colour of the 'nerve centre' lettering as well, so the location of the 'nerve centre' – the place where decisions are taken or control exercised – is obscure. The deployment of a wide range of graphic conventions – metaphorical illustration of the building and arm, the stylized lightning and Underground symbols, the lettering and lines – does not communicate any clear message.

The Shell oil company's posters in the 1930s were as varied as the Underground's. With its own design studio, Shell also commissioned the best-known painters, traditional and modern, for posters which built a cultivated but adventurous middle-class image for the product. Abandoning its trademark, and making no visual reference to the product, they depended on the word Shell linked to slogans in a series which identified a professional group as users of Shell: 'Actors Prefer Shell', 'Musicians Prefer Shell'.

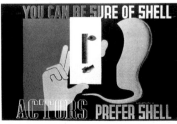
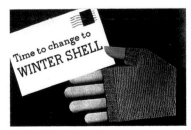

Kauffer, who produced for the Shell series some of his most determinedly modernistic designs, also devised a mascot for the company – the silhouette of an artist's lay figure. Its robot-like character hinted at the machine; its circular joints suggested lubrication; and it was versatile,

Britain

appearing on oil containers, in press advertisements, and as an animated figure in one of the earliest colour advertising films, made in 1935.

Following the example of Frank Pick at London Underground, the London and North Eastern Railway, with two thousand stations, introduced a 'house style'. The LNER chose Gill Sans for the signs and for publicity printing, and persuaded Gill himself to pose for press photographers on a locomotive displaying his lettering. The company's printing, carried out by firms in different parts of the country, could be standardized, which was economical, and the LNER was anxious to 'speak in the same voice'.

'New Shell Lubricating Oils'
detail of poster 1937
[E.M.Kauffer]

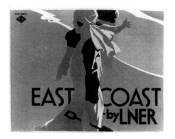

'East Coast'
travel poster 1935
(not Gill lettering)
[Tom Purvis]

In posters, too, the LNER adopted a policy similar to London Underground, commissioning Cassandre and Hohlwein. Its most prolific poster designer was Tom Purvis, whose style of flat colour was an immaculate modernization of the Beggarstaffs'. It was easy to reproduce: there were no graduated tones to be interpreted in the printer's studio; each side of a keyline, the colour was either one or another. Purvis used the whole area of the paper for his designs, in which he incorporated the unprinted white paper not as a background but as one of the colours.

It was not a poster designer who has assured London Transport a place in the history of graphic design, but an engineering draughtsman, Henry Beck. His achievement was the re-design of the Underground map (see p.18). Beck displayed the system on an octagonal grid so that lines met at right angles or at 45 degrees, with the stations placed to show their relationship within the system rather than their actual distance from each other. The inclusion of the River Thames winding across the lower half of the diagram gave a sense of place and scale; interchange stations and connections were indicated with clear conventions, and Johnston's typeface completed the map's geometrical authority.

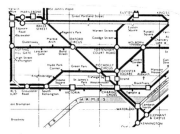

London Underground map (see p.18)
detail of later version
1960s

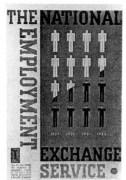

Further symbolic representations of time, distance and quantity appeared in advertisements, on posters, and in trade exhibitions. Theyre Lee-Elliott demonstrated that 'numerical information', shown graphically, 'gives the eye that visual evidence which carries so much greater conviction.'

This kind of statistical graphics derived from the Viennese Isotype system was introduced to England by Tschichold in the pages of *Commercial Art* in 1931, where he also advocated the use of photography. This could come 'in three forms: as a composite photograph, as a double copy and as a photogram'. 'Composite photograph' was the translation of photomontage, a technique which was used by Maurice Beck Studios, who advertised their services regularly in the same magazine.

National Employment Exchange Service
information poster 1936
[Theyre Lee-Elliott]

London Underground
posters c.1935
[Maurice Beck Studios]

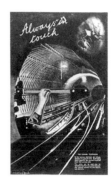

Concern for the safety of the travelling public had given rise to one of the most powerful early London Transport posters, Fred Taylor's 'The Right way to Get Off', in 1914. Now the company wanted to reassure the public that its own technology promoted safety. They commissioned Maurice Beck, whose posters showed man in control of technology: the railwayman's hand and the slogan appearing in handwritten script carry this idea, contrasted with the machinery at the hand's command.

Direct influence from the Continent, and with it a more obviously functional attitude, arrived with the first refugees from political events in Germany. As Tschichold escaped to Switzerland, Moholy-Nagy was among those who sought asylum and employment in England, where he arrived in 1935. Before he left for America, Moholy-Nagy spent two years designing book jackets, posters for the Underground, an exhibition for Imperial Airways, and as display director of Simpson's, the new men's store in Piccadilly. He also worked as a photographer and, for his pictures of the seaside in *Architectural Review*, provided layouts which, by exposing only parts of images on subsequent pages through cut-out holes, involved the reader in an act of discovery.

London Underground
explanation of new automatic doors
poster 1937
[Laszlo Moholy-Nagy]

At Simpson's, Moholy-Nagy was sponsored by its publicity agents, the advertising firm of W.S. Crawford. Crawfords was home to the leading British modernist designer, Ashley Havinden. Joining the firm in

1922, 'Ashley' was responsible for a famous 'streamlined' campaign for Chrysler cars in the late 1920s. Monotype developed the lettering from this into the Ashley Crawford type, and his brush lettering became a typeface known as Ashley Script.

'Drink Milk Daily'
poster 1935
[Ashley Havinden]

Designers, still known as 'commercial artists', were employed by advertising agencies like Crawfords and in the design studios of printers. A few of these, like the Cresset Press and Curwen Press, produced elegant modern brochures and catalogues. There were also commercial art studios, who provided a service, which might include photography and retouching, lettering, illustration and technical drawing, to agencies, to printers and directly to clients.

Other designers were freelance and some worked in association with others, like the Bassett Gray group, founded in 1921, who wanted to 'steer a middle course between the stultifying influence of the commercial art factory on the one hand and the limited opportunities of complete isolation on the other'. By 1932 they could undertake product styling as well as the design of advertisements, posters, exhibitions, packaging and typography. With brochures, leaflets and book jackets, this was the everyday business of young British graphic designers, joined in the late 1930s by colleagues from Continental Europe.

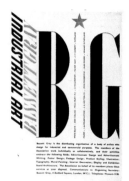

Bassett Gray Industrial Art
poster advertising design services
c.1932
[Milner Gray]

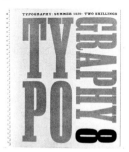

Typography 8
magazine cover 1939
[Robert Harling]

11

The United States
in the 1930s

To many in Europe, including the designer Raymond Loewy, 'America sounded so wonderful, so virile, so modern'. He emigrated from France to the United States after the First World War and re-designed the Lucky Strike packet in 1940. The image of America came not only from the cinema screen, but also from the pages of popular magazines and from their advertisements.

Chesterfield
billboard c.1935

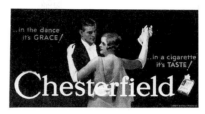

The economic interdependence of magazines and advertising was reflected in the similar design of their editorial and advertising pages. Each had headlines, text columns and the same kind of illustration. As journalism and advertising depended increasingly on images – the 'art' element – their reproduction and the layout as a whole became the responsibility of an 'art director'.

In America, art direction preceded the profession of graphic design. The Art Directors Club of New York was founded in 1920. The yearly exhibition and the publication of its *Annual* helped the recognition of designers whose work was not in itself advertising, such as letterheads and display material.

If Europeans admired America's dynamic commercialism, Americans looked to Europe for modern culture and sophistication. Scouting for talent in Europe, the New York publisher Condé Nast found these qualities embodied in one of his own staff, the Russian-born Mehemed Fehmy Agha, who was at that time working for the German edition of *Vogue* in Berlin. In 1929 Condé Nast brought him to America as art director for *Vogue*, *House and Garden* and 'the Kaleidoscope Review of Modern Life', *Vanity Fair*. As art director, Agha took control of the magazines, even contributing photographs and articles himself. He introduced Parisian chic and German experience, 'bleeding' photographs off the edge of the page and using 'duotones' (black-and-white photographs printed in two colours). In 1932 he used a full-colour photograph in *Vogue* for the first time. He had a complete understanding of photographic and printing techniques, and was aware of the avant-garde. He encouraged his designers to plunder the treasures of 'the temple

97

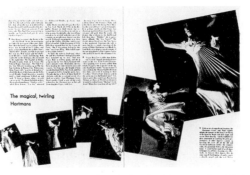

The magical, twirling
Hartmans

Vanity Fair
double page 1936
[M.F.Agha]

of Constructivism'. He introduced the double-spread grid sheet and dummy type so that accurate pasted-up layouts could be produced instead of rough designs drawn in pencil. He was also the first to see a magazine as a series of double-page spreads rather than a sequence of individual pages. He introduced ways of setting text to echo adjacent photographs and of using some consistent device to link the pages of a single feature to make a distinct unit within the magazine. He would plan the issue before any pictures were taken, and employed the best photographers of the period, including Edward Steichen, George Hoyningen-Huene from Germany and the young Cecil Beaton from England.

Vanity Fair
cover 1934
[illustrator Paolo Garretto]
[art director M.F.Agha]

The covers of *Vanity Fair* were usually the work of painters, including Raoul Dufy, and illustrators, notably Paolo Garretto. For the July 1934 issue, Garretto represented intellectuals in government by placing an academic cap and spectacles on the Washington Capitol. Such juxtaposition of symbols has since become a convention of graphic design. The masthead (the title on the front of the magazine) rarely departed from bold sans-serif capitals, but was varied to appear in outline only, with shadows, or in lights, flowers or flags.

Full-colour photographic covers identify Agha as the original modern art director. The graphic tone of the image had to represent the magazine's contents, but the artifice behind the elegance of the image, the attention to every detail so that it contributed to the total effect, needed

Vanity Fair
cover 1934
[M.F.Agha]

The Saturday Evening Post
cover 1916
[illustrator Norman Rockwell]

to be concealed. According to Agha, the art director 'plans, co-ordinates and rehearses, but does not perform; at least, not in public'. Public performances were left to traditional methods of cover illustration. This was exemplified by those drawn, from the time of the First World War until the 1960s, for the *Saturday Evening Post* by Norman Rockwell, whose display of skill was part of the reader's enjoyment. Like most advertising illustration, Rockwell's invented scenes of domestic life, often copied from photographs, could be described as 'photographic', possessing exactly the qualities that were missing in the snapshot, colour and overall sharp focus. Yet it was the fact that a photograph appeared to be made by a machine that gave it authority. Manipulated by the art director, the photograph largely replaced drawn illustration.

Agha remained in Condé Nast until 1943. His techniques were extended and developed on other magazines by designers who had worked with him, and also by Alexey Brodovitch who, arriving from Paris in 1930 to teach in Philadelphia, joined the rival *Harper's Bazaar* as art director in 1934. Brodovitch used some of the same European photographers as Agha, adding Bill Brandt, Brassai and Cartier-Bresson and his own protégés, the Americans Irving Penn and Richard Avedon. For covers, he engaged Cassandre, whose posters had been shown at the Museum of Modern Art in New York earlier in 1936. Brodovitch's effects depended on contrasts. He refined Agha's style of Bodoni typography whose sparkle enhanced the savagely cropped and dramatically juxtaposed photographs, laid out in graphically elegant sequences.

Harper's Bazaar
magazine page 1936
[photographer Man Ray]
[art director Alexey Brodovitch]

Harper's Bazaar
magazine double page 1938
[photographer Hoyningen-Huene]
[art director Alexey Brodovitch]

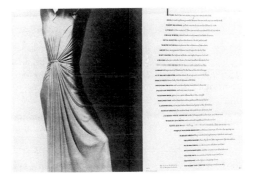

Although art direction was a particularly American contribution to graphic design, commercial competition necessitated graphics of identity to distinguish one brand from another. To do this, a simple message must be memorably and clearly conveyed but there is room for a varying amount of aesthetic expression, as with a trademark like the Coca-Cola logo. Loewy's Lucky Strike package is another example. Since it was a re-design, the extent of aesthetic decision was reduced to the change of colour; but that choice was as crucial to the final effect as it was practical. As Loewy explained: 'Before – the old Lucky Strike package was dark green. On the obverse was the well-known Lucky Strike red

target. The reverse was covered with text that few people read. The green ink was expensive, had a slight smell. After – The new package is white and the red target has remained unchanged. The text on the reverse has been moved to the sides, displaying the red target on both faces. Printing cost has been reduced.'

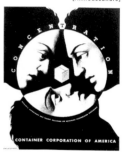

Lucky Strike
cigarette pack redesign 1940
from *Never Leave Well Enough Alone*
[Raymond Loewy]

Such matter-of-fact observations show a concern for the process of print production, for the image of the product – by putting it on both sides of the packet he doubled its exposure; and for the response of the consumer – by making the packet white he thought it 'automatically connotes freshness of content and immaculate manufacturing.'

The direct involvement of the head of a company in its packaging or design disappeared with the greater use of advertising agencies and specialization in company management. The first comprehensive corporate design, however, was carried out by the Container Corporation of America (CCA), and initiated by its owner, Walter Paepcke. In 1936 he appointed an art director, Egbert Jacobson and, for advertising, America's oldest agency, the Philadelphia firm of N.W. Ayer. Charles Coiner, Ayer's art director, was waiting on the quay when Cassandre arrived from Paris in 1936 on a working trip to New York. Before they left the wharf, Cassandre had agreed a contract to design the first in a series of Container Corporation advertisements (which later included the famously pretentious 'Great Ideas of Western Man'). These were aimed at giving the company 'a distinctive personality and identifying it with the best in graphic arts', Paepcke said. In fact, while the association of designers with artists in support of big business established a status for the designer, it was only in the earlier advertisements, before the end of the Second World War, that designers such as Herbert Matter and Matthew Leibowitz had the opportunity to demonstrate that graphic design could combine words with an image to carry an idea.

Business also stimulated Information Design. Pharmaceutical companies, in their promotional leaflets, were particularly important in using charts, maps and diagrams. These played an essential part in the pages of the business monthly *Fortune*. This large-format magazine was launched only months after the stockmarket's Great Crash of 1929. Its covers in the 1930s carried sophisticated illustrations and paintings, often by Leftist artists including Léger, Diego Rivera and Ben Shahn. Gradually this gave way to work by the indigenous graphic designers and immigrants, like Will Burtin, who was *Fortune*'s art director in the 1940s.

Modern European graphics were being spread by the migration to

'Concentration'
Container Corporation of America
advertisement 1938
[A.M.Cassandre]

'America has closed its fist ...
advertising must first overcome
the reluctance to part with ... money.'
poster 1933
[Young and Rubicam]

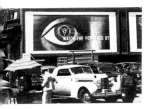

'Watch the Fords go by'
billboard 1937
[A.M.Cassandre]

America of many designers. Their work made an instant contribution. Those who taught, like Brodovitch, were able to educate a new generation. Herbert Matter settled in New York and established himself as a photographer, working for both Agha at *Vogue* and Brodovitch at *Harper's Bazaar*. The Nazi seizure of power forced the emigration of Will Burtin, who left his well-established design practice in Cologne in 1938. Within months of his arrival in the USA he began teaching at one of New York's schools for commercial art, the Pratt Institute. Here he was joined by Ladislav Sutnar, the designer of Czechoslovakia's unbuilt pavilion for the 1939 New York World Fair, and now stranded in the city.

Fortune
magazine cover 1939
[Herbert Bayer]

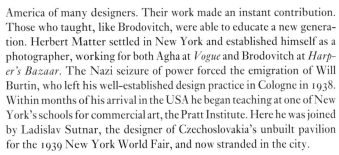

Herbert Bayer, visiting New York in 1936, was given the task of organizing an exhibition about the Bauhaus, which opened at the Museum of Modern Art at the end of 1938. He decided to stay in America and became an important influence, particularly in exhibition design. Schawinsky was teaching with Albers at Black Mountain College. Moholy-Nagy had arrived from England, and with his fellow Hungarian, Gyorgy Kepes, was struggling to establish a new Bauhaus, which was to become the Institute of Design in Chicago. Moholy-Nagy's books published later, *The New Vision* (1944) and *Vision in Motion* (1947), and Kepes's *Language of Vision* (1944) helped to form fresh attitudes to perception in a graphic world which was dominated by photography. Integrating text, image and caption, they were influential in the design of books as well as the layout of magazines.

The New Bauhaus
symbol on first prospectus
Chicago 1937

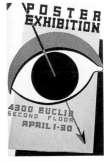

Works Progress Administration
Federal Arts Project
poster, Cleveland, Ohio c.1939
[Stanley T.Clough]

The three native-born American designers whose careers were established before 1940 and who emerged prominently after the Second World War were Lester Beall, Alvin Lustig and Paul Rand. Self-taught, Lester Beall worked as a freelance advertising designer in Chicago from 1927. In 1935 he moved to New York and in 1937 became one of the first American designers to have his work shown in the German monthly *Gebrauchsgraphik*. In this year the Museum of Modern Art exhibited his posters for the Rural Electrification Administration, part of President Roosevelt's programme to improve the conditions of those suffering in the Depression. More than 30,000 poster designs were made as part of this project, mostly printed by silkscreen and hence restricted to simple

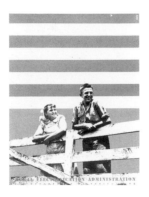

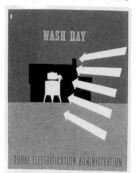

areas of flat colour. Beall said that they were influenced by 'American political posters, the recruiting poster of the Civil War and Die Neue Typographie . . . the designers' search for forms that were strong, direct, and exciting.' Forms abstracted from the American flag provided just the strength, directness and excitement he wanted, and he often used the device with originality. His poster with young farm people leaning on a fence conveys a simple reassurance: under the flag they are part of the New Deal. In many of Beall's recorded views, there is an echo of William Morris utopianism – 'ugliness is a form of anarchy which should be stamped out' – but it was an American version – 'Good design is good business'.

Alvin Lustig's most important work was in book design. His time spent in Frank Lloyd Wright's community was the seed for some of the most original typography. Lustig's use of printer's type material had a controlled invention which makes the use of similar work by German typographers such as Joost Schmidt look crudely undisciplined.

Lustig's later graphic language is often difficult to distinguish from Beall's or the work of the virtuoso Paul Rand. At this time, Rand was the director of the magazines *Esquire* and *Apparel Arts*. For their covers, and for the bi-monthly *Direction*, Rand claimed that he was 'trying to do the work Van Doesburg, Léger and Picasso were doing – to work in their spirit'. In fact, by using montage and collage, especially cut-out flat-

far left
The Ghost in the Underblows
double page book title 1940
[Alvin Lustig]

above
Robinson Jeffers
book title page 1938
[Alvin Lustig]

Apparel Arts
magazine cover 1939
(photogram and montage)
[Paul Rand]

Direction
magazine cover 1938
[Paul Rand]

Funny Business
magazine cover 1937
[Lester Beall]

coloured paper in combination with photography and economical line drawing, he and a few others re-worked the elements of European Modern Art – mainly Matisse, Picasso and Miró – improvising a flexible visual language. It was not merely an exercise in advanced taste. As Beall's American pragmatism insisted, 'There must be a direct functional connection between the design (and its elements), and the theme or message the graphics are required to project.' Together with a developing typographical craftsmanship, their techniques were those of graphic design as it was recognized two decades later.

12
War and Propaganda
1920s to 1945

By the time war was declared in 1939, graphic design had come to play an essential part in political life, particularly at election times. Walls were papered with posters, leaflets strewn in the streets and banners and placards flourished at meetings and demonstrations. In Europe, opponents were vilified in venomous illustrations; heroic images of party members, identified by their symbols, banners and uniforms and recognized by their salutes, represented the strength and unity of a single belief; in civil wars the soldier remained fearless, joined by the resolute worker and peasant; national flags and heraldic symbols were replaced by the Fascist axe and bundle of rods (*fasces*) of Imperial Rome, the hammer and sickle, the red flag and the swastika.

Like the black moustache, bowler hat and walking stick of the screen comedian Charlie Chaplin, the distinct personal images of political leaders were translated into two dimensions. The figures of Hitler, Mussolini and Stalin embodied the power and ideology of Nazi Germany, Fascist Italy and Soviet Russia. Names were replaced by titles, like the names of consumer products: Hitler and Mussolini became known as 'the leader', Der Führer, and Il Duce. Stalin's image appeared alongside that of Lenin, as his inevitable successor. The images of leaders, reinforced by repetition on the front pages of newspapers and illustrated magazines, on posters and postage stamps, became icons.

'No More War'
poster 1923
[Käthe Kollwitz]

Gustav Klutsis retouching
a photograph of Stalin
1932

far left 'Vote "yes"'
Hitler referendum poster 1934

(Mussolini) Year XII of Fascist Era
(photomontage)
poster 1934
[Xanti Schawinsky]

Photography was a particularly useful new medium in propaganda. It transformed not only the making of images but also the way they were seen. Snapshot cameras, in widespread use, demonstrated that what was put in front of the camera lens was more or less objectively recorded. But this reality was often subverted by the extensive use of the airbrush to

retouch the photographic print. Meanwhile, socially and politically committed artists, such as Käthe Kollwitz in Germany and Ben Shahn in America, kept drawn and painted illustration alive in posters.

The Spanish Civil War of 1936-7 saw a huge range of powerful, painted Republican designs with simple lettering, in a wide variety of heroic styles of illustration. They acknowledged the influences of the Russians Deni and Moor and the French 'three Cs' – Cassandre, Colin and Carlu. But it was photography that was the significant innovation. Carlu had founded an international Office de Propagande Graphique pour la Paix in 1932, the year of one his best known posters. Combining a photograph of a mother and child with drawn aeroplanes and bombs, it anticipated the bombing of Spanish towns and the civilian casualties. Photography was demonstrated as a far more effective graphic means of protest at atrocities than the caricatured illustrations used in the First World War.

below, centre
'For Disarmament'
poster 1932
[Jean Carlu]

below, right
'Give her Shelter!'
poster 1937
[Padial]

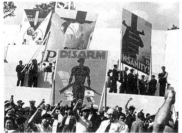

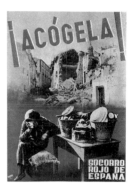

demonstration, Paris 1936
photograph

The photograph, used by Carlu as a rhetorical illustration, now became evidence, helping to create solidarity at home and sympathy abroad. The Republican posters used photographs also as a means of documentary illustration, recording new social provisions, particularly for education and child welfare. But more revolutionary was a dramatic, carefully constructed arrangement of photographic elements which alone carried the message.

far right
Republican poster 1937
[Roca Catala]

'In the Ministry of Education schools, the sons of our fighters are living healthy and happy lives'
poster 1937
[Mauricio Amster]

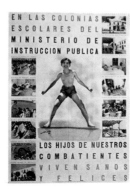

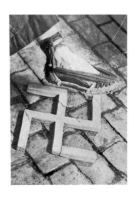

War and Propaganda 1920s to 1945

Apart from photography's documentary role, it could be used to manipulate symbols by lighting and the way the images were cropped. The poster with the foot wearing a peasant's rope-soled shoe, poised over a broken swastika, is a single photograph, not montaged. The slogan is a small caption in Catalan, '*Aixafem el Feixisme*', 'Let's Smash Fascism'. Printed below the image, it is superfluous, given the several meanings of the photograph. This records an event: 'Look, the peasants are smashing the Fascists', it declares; 'they are tough enough to tread them underfoot.' Just as much as the swastika symbolizes Nazism, the sandal represents the peasant, and it replaces the stereotype image of totalitarian militarism, the jackboot.

'Let's Smash Fascism'
poster 1937
[Roca Catala]

Nazi street parade
photograph c.1933

Uniforms and badges were essential in the political warfare of the 1920s and 1930s, particularly in Germany. Nazism, from its birth in the 1920s, incorporated existing conventions into its visual propaganda, adopting the red, white and black of the imperial flag for its banners. In *Mein Kampf*, published in 1920, Hitler planned the symbols for each aspect of his National Socialist German Workers Party. National Socialism was to be represented by the white and the red: white for Aryan racial purity and, for its social programme, it was to be the same red which had impressed him at 'a Marxist rally . . . a sea of red flags, red scarves and red flowers'. The swastika, already used as an anti-semitic emblem and later combined with the German imperial eagle as the symbol of the Third Reich, survived the Nazis to identify right-wing, usually aggressive, factions. The Red Front of the Communist Party, with its red flag and five-pointed star, was faced not only by the swastika of the Nazis, but also by the three diagonal arrows of the Social Democrats' Iron Front.

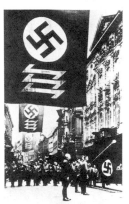

For the Allies in the Second World War, Hitler's image – the hair falling across the forehead, the black moustache and the Nazi armband – became a symbol of the enemy, hated but ridiculous.

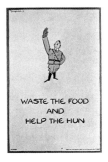

WASTE THE FOOD
AND
HELP THE HUN

Social Democrats'
Iron Front symbol
defeating the Nazi
swastika
detail of
poster c.1930

'Waste the food
and help the Hun'
poster c.1942
[C.K.Bird /'Fougasse']

He appeared on many occasions overhearing 'careless talk', a subject common to both sides. In Britain this topic inspired 'Your Talk May Kill Your Comrades', one of the most brilliant in a series of posters designed by Abram Games, remarkable for both ideas and technique. The posters are usually composed of several linked or fused images, chosen to be instantly understandable. These are connected to simple slogans. The

'Your Talk May Kill Your Comrades'
poster 1942
[Abram Games]

'Talk Kills'
poster 1942
[Abram Games]

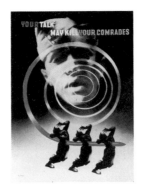

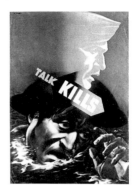

words are not used as captions to the images, nor are the images mere illustrations of the slogans. 'Lettering, in particular', Games said, 'must work equally with the design and not be merely an added afterthought. . . Posters should not tell a story . . . but make a point.'

Games's technical skills with paint were prodigious. He produced every element of his posters without using typesetting or photography. He drew the slogans in condensed capitals or condensed slab-serif lettering, perfectly spaced and often broken into parts, with some of the message dark on light and the rest light on dark. The son of a photographer, he could draw with the airbrush in a range of tones that imitated the photograph. With this technique he produced at his drawing-board the exact images he needed, the right size and in the right position. Their apparent three-dimensional realism increased the shock of their dramatic juxtapositions and gave a consistent texture to the whole area of the poster.

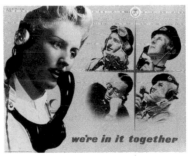

'We're all in it together'
General Post Office telephones
poster c.1943
[F.H.K.Henrion]

While Games was employed directly by the War Office, the work of other designers in Britain was organized by the Ministry of Information (MoI). In a spirit of urgency and professional competition, they produced posters to rally morale, encourage production and give specific instructions to civilians on how to cope with war-time situations. Designers adapted their manner of work to suit the subject. Techniques varied from humorous cartoon drawings to the use of studio photographs as diagrams in sequences of numbered instructions. The posters were

War and Propaganda 1920s to 1945

markedly direct, but radically surrealistic effects were not excluded, particularly in the work of G.R. Morris and Reginald Mount.

It was many years before colour photography was used for posters. The most common pictorial medium was the black-and-white photograph overlaid with areas of flat colour. In war-time Britain, this technique was used by Henrion in a number of posters. With the United States' entry into the war in 1941, Henrion was employed in London by the US Office of War Information as well as the MoI. The OWI produced propaganda aimed both at workers and civilians at home and at troops at the front.

'Wait! Count 15 slowly before moving in the Blackout' poster 1942 [G.R.Morris]

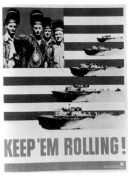 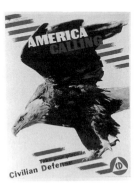

'Keep 'em Rolling!' Office for Emergency Management poster 1941 [Leo Lionni]

'America Calling' poster 1941 [Herbert Matter]

The Government had commissioned posters from some Modernist designers, including Matter and Leo Lionni. Lionni used repeated photographs in his *Keep 'em Rolling* posters, and he and many others followed Lester Beall's device of references to the US flag. Jean Carlu, who happened to be in New York when France surrendered to the German forces, was commissioned for a poster to boost industrial output. A hundred thousand copies of *Production* were printed and distributed to factories. As a result of its success, the OWI retained Carlu as an adviser on posters.

Office of Civilian Defense insignia c.1942 [Charles Coiner]

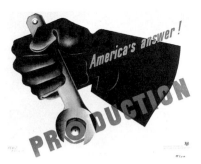

'America's answer! Production' OEM poster 1942 [Jean Carlu]

The OWI produced huge numbers of government reports but it also designed often elaborate leaflets, with photographs and statistical diagrams, which were showered from aircraft onto enemy territory, along with tabloid newspapers telling the story of the war from the Allied

viewpoint. Among its publications for American readers were two magazines, the photojournalistic *Victory* and the curiously elegant *USA: A Portrait in Miniature of America and Americans in Wartime*. It was designed by Bradbury Thompson in a tiny 5 x 4-inch format, laid out in a combination of the styles of *Life* magazine and *Reader's Digest*.

Westvaco Inspirations
magazine double page 1942
[Bradbury Thompson]

Thompson was making his name designing a paper company's publicity journal *Westvaco Inspirations* (see pp.116-117). During the war much of the subject matter of *Inspirations* was the war itself, just as the Container Corporation advertisements demonstrated the company's part in the war effort.

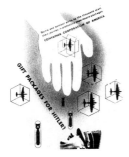

'Gift packages for Hitler'
CCA advertisement 1943
[Jean Carlu]

'All three in one –
pulp materials - paper-making mills -
and packaging factories . . .
all in one organization !'
CCA advertisement 1943
[Matthew Leibowitz]

'Press the button. Buy war bonds . . .
release bombs'
CCA advertisement 1943
[Leo Lionni]

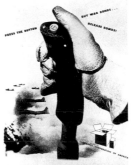

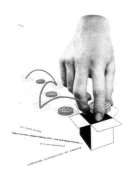

Advertising in totalitarian regimes reflected state ideology, and in Nazi Germany it provided the party with a huge income. Its retreat from modernism in favour of a variety of nationalistic styles appeared also in the USSR, where the country's posters adopted elements of the artistic style of Socialist Realism.

As the most modern medium for propaganda, exhibitions had become important in many countries. Constructions and images on a huge scale overwhelm the viewers, at the same time confronting them with real objects and models. Most significant in pre-war Europe had been the Fascist Revolution exhibition in Rome in 1933 and Hitler's 'Give Me Four Years' in 1937, but trade fairs continued in the Axis countries during the war. In America, too, exhibitions were seen as an effective means of involving viewers in wartime concerns. At the Museum of Modern

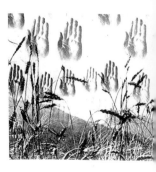

Art in New York, Herbert Bayer completed two contrasting exhibitions in 1942 and 1943. The title of the first, 'Road to Victory', was the key to Bayer's layout. Visitors were directed on a route past a display of text and photographs, some of which were huge, pasted directly on the walls of the gallery, illustrating American ideas of freedom. For 'Airways to Peace', Bayer's concept was 'to let the magic of maps and the geometry of globes give the idea character.' The exhibition combined a history of map-making with the story of the evolution of flying. 'Airways to Peace' allowed Bayer to develop his Bauhaus notions about the angles of viewing which he had used in the 1930s. These matched the viewer's perspective with that of the photographer: the exhibition included a ramp where visitors could look down on aerial panoramas. The exhibition's central feature was a huge globe. Visitors walked inside to view a map of the world on the inside of the sphere where they could see distant parts linked in a way which was impossible on a conventional globe, where more than half the world remains invisible from a single point of view.

Early in the war Britain had established an exhibitions branch at the MoI, whose first Director-General was Frank Pick, the design impresario of London Underground. It was led by Milner Gray (of Basset Gray), who assembled a team kept busy on exhibitions which varied widely in content, range and size. They were intended to boost morale, stressing the war-time achievements of Britain, like 'London Pride', about the Blitz bombing; but they also included ideas about democratic freedom and post-war reconstruction. Others, such as 'Poison Gas', told the public what to do and how to behave in particular circumstances. The exhibitions were set up in a variety of unconventional locations – bomb sites, underground stations – and they travelled to all parts of the country as well as overseas. Exhibitions became a means of providing information to the public that survived well beyond the war years in trade fairs and international exhibitions.

Although the most conspicuous of the designers' contributions to political struggles and war-time propaganda, the poster declined over the next twenty-five years as a means of advertising. Magazines, giving news of the war to those at home (those at the front also had their own

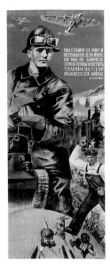

'We stand for peace. But we are not afraid of danger and ready to answer the warmongers blow for blow. – Stalin'
poster 1932
[Gustav Klutsis]

Air Defence
exhibition poster 1943
[Kumi Sugai]

US aircraft marking
before and after 1943

right
War Economics
Fortune
magazine double page 1942
[illustrator Irving Geis]
[art director Francis Bremner]

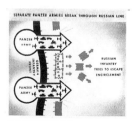

Tank battle techniques
Fortune
magazine diagram 1942

special newssheets) gained in importance and became one of the main employers of graphic design in the post-war years. Less noticeable was the impetus that the war gave to methodical design procedures and to the idea of design as a means of solving problems of communication. Principles developed in Gestalt psychology, which were to have their peace-time counterpart in market research, were applied in areas such as camouflage and identification. US aircraft identity was revised, modifying its circular emphasis to avoid confusion with red Japanese insignia. Most significantly, war-time pressures, which required the rapid understanding of facts and situations before making decisions, encouraged the development of Information Design.

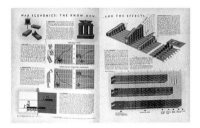

The United States
1945 to the 1960s

In the 1930s, it had been art directors who had established graphic design, mainly in advertising and magazine layout. In the following decades designers made themselves an accepted part of business communications, between the corporation and its customers and within the company itself. Business and industry increasingly employed designers. How these professionals were to describe themselves was a subject of considerable debate. In 1958, art directors found the 'art' connotation unhelpful, according to *Print* magazine, and 'have been discussing seriously the need to change their professional title to "visual engineering" or "graphic designer"'. But the most influential book of the time, Paul Rand's *Thoughts on Design*, first published in 1947, links the word 'graphic' with 'art', not 'design'.

The 1951 *Art Directors Annual* specified the areas of professional activity before they were extended into film and television: six categories of design for print which have remained more or less constant for fifty years: 1, 2 and 3, magazine, newspaper and trade periodical advertisements; 4, direct mail and house organs; 5, posters, cards, calendars, record albums and book jackets; 6, editorial design (magazines). Individual designers worked in one or several of these areas at any single time. They might work alone, or with assistants, or in a group practice, the design department of a large organization, or in an advertising agency.

Changes in print technology affected the designer's relationship with the industrial process. In all types of printing, letterpress was giving way to lithography. Many fewer words were transferred to paper direct from metal type. The designer still gave the printer instructions for typesetting, but the proofs were often cut and pasted in position in the studio, ready to be photographed to make the printing plate, rather than assembled in the printer's composing room. This gave the designer greater control. New materials made it possible for the designer to add tone to the design in the form of dots, and the use of photostats, a simple technique for enlarging and reducing images, allowed designers to experiment with changes of scale, negative and positive, and type reversed as white out of solid black. Paul Rand, who had become the most influential spokesman among the country's leading designers, devoted an essay to the use of black. One of the illustrations was his design for the front of a catalogue. 'The tension between black and white in the cover is heightened by opposing a large area of black to a small area of white.'

Rand dominated first advertising and then corporate identity design for a long period. From 1941 to 1954 he was art director at the William H. Weintraub agency in New York. In his often reprinted *Thoughts on*

'20th century Art
Arensberg Collection'
catalogue cover 1948
[Paul Rand]

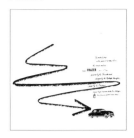

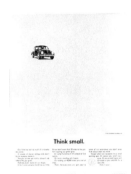

Design, he saw the designer as needing to 'discover a means of communication between himself and the spectator'. He made the most of the whole battery of Modern Movement techniques, particularly collage, photograms, cut-outs and borrowings from painters, such as Miró and Arp, and Paul Klee's horizontal stripes remained a recurring feature of his work. While Rand used photography, it was usually as a ready-made image and not one he had originated and art-directed. The unerringly elegant free-form asymmetry of his typography is often contrasted with handwriting. His signature in the design reinforces the idea that it is the designer, not the client, who is communicating with the spectator.

For an advertisement 'to hold its own in a competitive race, the designer must often steer clear of visual clichés by some unexpected interpretation of the commonplace'. Rand played a major part in changing the way words and images could be combined to convey a single idea. He was a pioneer of the New Advertising, where the spectator was active, not passive, where curiosity was aroused and intelligence needed to complete the sense. This technique matured in the Volkswagen advertisements of the early 1960s. Type and image were isolated without any apparent aesthetic content other than the craft skills demonstrated in the photography and typography. Headlines appeared as (often incongruous) labels or slogans which repeated the voice of a television commercial. The headlines looked like spoken words. The text ('copy') was made inviting to read by its straightforward arrangement in narrow columns, with short sentences and frequent new paragraphs.

An intermediate stage before the introduction of the New Advertising was the total integration of word and image with minimal text. The product in the Disney Hats advertisements – one by Rand in 1947 and the other by Gene Federico in 1949 – shifts from the world of sophisticated design, manipulating existing images, to the simulated 'real' world of glamorous romance which the art-directed photograph describes.

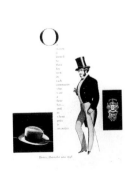

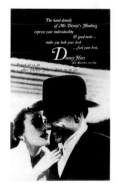

At the agency Doyle Dane Bernbach, founded in 1949 by a copywriter colleague of Rand's at Weintraub's, Federico produced further brilliant examples of art-directed advertising. To persuade agencies to buy advertising space in *Woman's Day* magazine, Federico arranged photographs

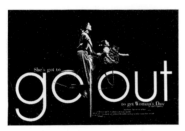
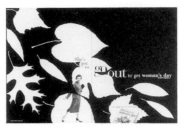

Woman's Day
double page
advertisements 1951-54
[Gene Federico]

of a *Woman's Day* reader, across double pages. These established her status as a consumer by including references to her needs – looking after herself, children and pets – because when she goes out, the agencies are reminded, 'Woman's Day isn't all she buys!' As graphic design, the faultlessly executed device of substituting the white bicycle tyres for the 'o's in 'go out' made it an art directors' favourite.

Federico had spent nearly a year working at *Fortune* magazine whose art director from 1945 to 1949 was Will Burtin. In the new Atomic Age, Burtin used the editorial pages of *Fortune* to present comprehensible science and statistics to the technocratic business world. Its covers were a decorative reflection of information graphics. In the war he had designed gunnery manuals for the US Air Forces which demonstrate his methods. His commentary is one of the clearest and most coherent expositions of graphic design. 'Whenever a mere recitation of facts is insufficient, too time-consuming or unclear to the reader, and an accented visual organization is imposed on them, design is the result. That design must have the qualities of good prose. It must read well.' Burtin analyses two pages that taught airmen how to assemble a gun. They used cinematic techniques, not square pictures that would have broken the visual stream. The headings were in bold, rather than larger type, for the same reason. With complex subjects, such as allowing for the angle and speed of attacking aircraft, Burtin devised elaborate but clear diagrammatic illustrations. 'As happens whenever all the elements of a design are recognized, studied, and brought coherently together, the result is hardly ever unpleasing to the eye – indeed, it achieves a certain beauty

Airforce manual
for weapon servicing
designer's overlaid arrows
showing
eye movement over page
c.1944 and 1948
[Will Burtin]

of clear statement – and is effective in its purpose. By the use of these visual aids and principles, training time for aerial gunners was cut exactly in half, from twelve weeks to six.'

Burtin believed that 'as life grows more complex, it requires a greater and greater extension of language. Graphic representation is that extension, that synthesis of art and science now urgently demanded by contemporary life.' His work for the pharmaceutical firm of Upjohn, where he took over art direction of their house magazine *Scope* from Lester Beall in 1948, expressed his desire to 'link the character of the advertiser with the nature of the pharmaceutical business and its scientific background'.

Scope
magazine cover 1948
[Lester Beall]

Scope
magazine contents page 1954
[Will Burtin]

blood cells diagram
Scope magazine page 1949
[Lester Beall]

Scope
magazine cover 1948
[Will Burtin]

Burtin's first *Scope* cover brought together a hand holding a test tube as 'an immediate, almost telegraphic symbol of science. A cool silvery background gave the hand an impersonal quality. Then, to evoke the warmth of life and the purposes of pharmaceutical science in preserving it, various life symbols were placed in or behind the test tube – a herbal leaf, a flower, a Da Vinci infant.'

This was a prelude to the spectacular tasks of visual design that Burtin undertook for Upjohn. In 1958 he built a model of a single blood cell enlarged to over seven metres (24ft) across so that viewers could walk inside its open structure of transparent plastic. He followed this in 1964

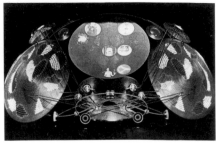

above, left
The Upjohn Cell
exhibition 1959
[Will Burtin]

above
The Upjohn Brain
exhibition
and detail *below*
1960
[Will Burtin]

with a vast model of a human brain, which employed forty miles of wire to carry power to forty thousand lights simulating the paths of messages whose images were displayed on multiple screens. With these colossal enterprises Burtin moved graphics into three dimensions. By comparison, Beall's use of engravings of old machinery as metaphors for the workings of the body in *Scope* belongs to an earlier period of design.

Engravings were used by Bradbury Thompson in *Westvaco Inspirations*. As art director at a large firm of printers, Thompson could experiment confidently in *Inspirations*: type was set perfectly in arcs and circles and printing blocks re-used from advertisements, positioned and repositioned to give effects of depth and movement. Yet the wit and playfulness were always attached to some message. A cut-out figure rows a boat across lines of type, arranged to suggest water, at the top of a left-hand page. A similar figure on the right-hand page holds a rod, printed from printer's metal rule in magenta ink. From this is suspended a line of type repeating the message 'use colour for bait'. The line ends in a hook formed from a capital 'J' which dangles at the open mouth of a cut-out fish. This is printed in blue from the same block as parts of two other fish on the facing page. The left-hand page is printed in black only on an off-white cartridge paper. The right-hand page is 'art' paper, printed in the four 'process' colours of blue, magenta, yellow and black (used to print the full-colour photographs on other pages), which make coloured bubbles with the letter 'O'.

Westvaco Inspirations
magazine double page 1949
[Bradbury Thompson]

Uppercase

lowercase

Monalphabet
from *Westvaco Inspirations* 1945
[Bradbury Thompson]

Alphabet 26
from *Westvaco Inspirations* 1950
[Bradbury Thompson]

aBCDe
FGHIJK
LmnOP
QRSTU
VWXYZ

Ballet
photographs and book design 1945
[Alexey Brodovitch]

Apart from such improvisations, Thompson also used *Inspirations* to promote his ideas on the alphabet. He echoed Bauhaus pleas for a single set of signs instead of the different designs for capitals and lower-case letters. In 1945 he published his 'Monalphabet', with lower-case Futura letters enlarged so that they could act as capitals. He saw a continuing need for some indicator to take the place of a capital letter at the beginning of a sentence, and he suggested the use of lower-case bold as an alternative. In 1950 the text of a whole issue was set in his 'Alphabet 26' by using 'small caps' (capital letters the same height as the lower-case 'x') mixed with the lower-case 'a', 'e', 'm' and 'n'.

Whereas the design of *Inspirations'* 160 issues was a creative response to its low budget, *Portfolio*, a magazine equally influential with designers, was ruined by its extravagance. There were only three issues between 1950 and 1951. Designed by Brodovitch, it had a large format like the photojournalism magazines *Life* and *Look*, and was printed on mixtures of paper, with inserts and foldouts. He worked by trial and error with photostats of pictures, and headlines, which he would order from his office at *Harper's Bazaar*, in different sizes, and from which he would produce a full-size layout. The contents were visually interesting, particularly American subjects, such as cattle brands, and the magazine presented the work of individual artists and designers. The real content of *Portfolio*, as in *Harper's*, was the pictures, which he had simply to manipulate in a polished and dramatic sequence. They demanded nothing from the reader but admiration. Brodovitch had produced the book *Ballet*, his key work, in 1945, using his own photographs, in a horizontal format echoing the proportion of the 35mm negative frame. The images suggested movement by blurring some part of the dancer's figure, an effect enhanced by the very wide lines of text positioned to reflect the dominant element in the facing photograph.

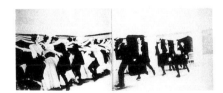

In 1949 Brodovitch's art direction reached a climax of mannerism in *Observations*, the book of celebrity photographs by his protégé Richard Avedon. Such pictures, individual images, without chronology or narrative, depend on the art director to give them a coherent sequence and relationship to the text. This Brodovitch achieved with the device he often used in magazines: a large initial Bodoni capital letter to begin the first line of text on the page, which was aligned with the key feature of the image on the facing page.

For the cover of the summer issue of *Portfolio*, Brodovitch reproduced a collaged kite design by Charles and Ray Eames. The Eames office in California became important, first as a nucleus of design activity in

Portfolio
magazine cover (Eames kite)
1951
[Alexey Brodovitch]

Arts and Architecture
masthead 1938
[Alvin Lustig]
magazine cover 1942
[Ray Eames]

Arts and Architecture
magazine cover 1946
[Herbert Matter]

California during the Second World War and later in pioneering the use of graphics in multi-screen projected displays, films and exhibitions. Charles Eames was an architect who had gone to the West Coast in 1941 and turned to plywood techniques for furniture and for medical splints for the US Navy. His wife Ray, trained as a painter, practised graphic design. Between 1942 and 1944 she designed more than half the covers of a new monthly magazine *California Arts and Architecture*, incorporating the standardized masthead designed by Alvin Lustig using a condensed geometrical sans serif. Her graphic language was similar to Rand's in its influence of abstract art and the use of cut-out and superimposed photographs.

When *Arts and Architecture* devoted much of an issue to Eames' work, the cover and layout of the article were designed by Herbert Matter, who worked in the Eames office from 1943 to 1946 and went on to design publicity material for the Knoll furniture firm in New York. Eames furniture was distributed by Herman Miller, and its advertisements and catalogues, designed in the Eames office, took up the European Modern tradition of Information Design.

Eames furniture
brochure, front and back 1948
[Eames office]

Ladislav Sutnar had been art director of Sweet's Catalogue Service since 1941, which supplied industry with information on products. In the books *Catalog Design* (1944) and *Catalog Design Progress* (1950), both published by Sweet's, he pleaded 'not only for more factual information, but for better presentation, with the visual clarity and precision gained through . . . patterns capable of transmitting a flow

Sweet's Catalog Service
symbols

Catalog Design Progress
double page 1950
[Ladislav Sutnar]

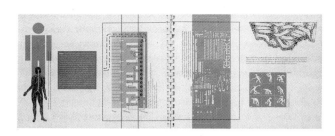

Addo-x business machines
logotype and symbol 1956
[Ladislav Sutnar]

IBM
variations of 1956 logotype
in *IBM House Style* 1969
[Paul Rand]

ABCDEFG
HIJKLMNO
PQRSTUV
WXYZ&
123456789

IBM alphabet 1956

Westinghouse

Westinghouse former trademark
logotype and symbol used as
advertisement illustration 1961
[Paul Rand]

of information'. The one hundred pages of *Catalog Design Progress*, sub-titled *Advancing Standards of Visual Communication*, are among the central texts of graphic information design in English. Sutnar's argument is presented in short sections with very rarely more than a paragraph of text on any page. Flat areas of colour in simple geometrical shapes on the page, particularly wedge-shaped arrows, circles and ellipses, are used to organize the flow. The book has numerous examples of problems and solutions and all kinds of illustrations, including an Eames chair and a Rand advertisement. Sutnar showed how charts and diagrams helped to reduce the amount of text.

'A design need', wrote Sutnar 'may be analytically polarized into function and form, content and format, utility and beauty, the rational and the irrational, and so on. The function of design may thus be defined as one of resolving the conflict of such polarities into a new entity.'

Sutnar's work on catalogues obliged him to deal with the design of trademarks and the standardization of graphics throughout a company, as at the Container Corporation. Rand also was involved in some of the best-known, beginning with IBM in 1956, acting as an outside adviser. Different divisions of the company were given complete freedom in the use of 'the basic unifying element that ties all IBM printed material together' – Rand's IBM logo. But since the publishing division alone produced two hundred separate printed items each month, there had to be simple guidelines which included 'the use, wherever possible, of a standard typeface [similar to Trump's City Medium] as well as a simple and functional design solution.' By the end of the 1960s, these simple rules had developed into a huge loose-leaf binder, the *IBM Design Guide*. The eccentric type was not to be used 'unless absolutely essential' and was replaced by a conventional sans serif.

IBM's guide was one of the first of such manuals that are regarded as necessary to a corporate design programme, intended to enforce visual discipline throughout an organization by a set of comprehensive rules. These include not only the design of the trademark or logo but also the way in which it can be applied, its size and colour in particular situations, the way of setting out every piece of stationery, every package, every vehicle, every sign. Its basis was always the trademark and lettering, exemplified, again by Rand, in designs for Westinghouse, which took account of the possibilities for its animated use in film and television. In answer to the questions 'Why all this bother about images? Why not let's

just run our companies', *Harvard Business Review* took up the idea of a book by Kenneth E. Boulding, *The Image* (1958), pointing out that 'it is not mere knowledge and information which direct human behaviour, but rather it is the images we have . . . the image . . . negates the complexity of the modern diversified corporation. But this does not make it less workable as an operational tool. Far from it. In fact, it is the reality which creates the need for illusion.'

Visual identity schemes were often seen as a way of disguising reality. In 1955, the New York, New Haven and Hartford Railroad sought Herbert Matter's advice at a time when commuters were protesting at the poor quality of its service. The company president considered that 'contemporary design and technological advancement of engines, cars and signal systems, coupled with a dominating corporate image, would mean more in terms of progress than if I had used the old logotype and the uninspiring colours of Tuscan red and olive green.' Matter chose red, black and white, but the painting of the rolling stock was still being carried out when the president resigned. In fact, Matter's programme, like Rand's at IBM when it was first introduced, depended on the logo; the one rule to follow was that when it was used in one colour only the 'N' should be separated from the 'H' by a narrow space. Matter also designed an annual report cover whose geometry carried faint echoes of the railway posters of his old master, Cassandre.

New Haven Railroad
livery 1954
[Herbert Matter]

In 1946 Matter had taken over the advertising for Knoll furniture begun by Alvin Lustig. For the Knoll trademark, Matter began with the full word Knoll, and then adopted the 'K' alone. In the *New Yorker* magazine, the same advertisement ran, once a year from 1958 to 1971, inside the front cover. This showed a soot-covered chimney sweep sitting on a bright, new red chair. The opposition of Matter's favourite red and black, of positive and negative on neutral white, of clean and dirty, suggests properties of wholesome modernity and hygiene, which are identified, through the red 'K', with the company. Like the New Advertising, the effect of the advertisement depended on a surprising juxtaposition. Here, it is not the tension between word and image, but within the image itself. He also produced a pair of advertisements, two images in sequence on separate pages. The first showed a mysterious, brown-wrapped package; the second revealed it to have been a chair and its occupant. In this

Knoll
back cover of catalogue
c.1949
[Herbert Matter]

Knoll furniture
logotype 1950s
[Herbert Matter]

Knoll furniture
advertisements (consecutive pages)
1959
[Herbert Matter]

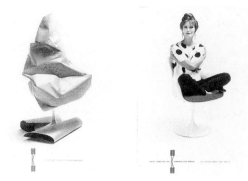

way, with no text except the address of the company, Matter broke new ground by allowing the image alone to carry the message.

A fellow Swiss, who had preceded Matter to New York in 1934, was Erik Nitsche. As consultant to General Dynamics, a company engaged in advanced weapons and space technology, his task was to interpret its president's expressed corporate purpose: 'The profitable translation of the basic forces of nature into useful work under the sea, on the sea, on land, in the air, and in space beyond the earth's atmosphere.' The vaguely scientific imagery that Nitsche had employed for record covers perfectly suited the series of posters *Atoms for Peace*, which were designed for international distribution in 1955. In subsequent years, for General Dynamics Nitsche designed annual reports, a means of business communication which became increasingly important in the next thirty years. Nitsche was one of pioneers of their design, integrating text, photography and diagram.

'Atoms for Peace'
General Dynamics
poster 1955
[Erik Nitsche]

'and what did Walter Winchell
(the critic) say?'... 'bravorchids'...
theatre advertisement 1952
[Erik Nitsche]

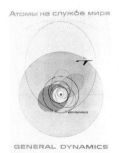

In the early 1950s Nitsche had art directed for the 20th Century-Fox Film Corporation. He had designed advertising campaigns for movies using a typical graphic design vocabulary, unlike the conventional film publicity, which had traditionally depended on realistic composite illustrations. This use of simplified, symbolic images was developed by a Los Angeles designer, Saul Bass. Advertising the films of director Otto Preminger, which included *The Man with the Golden Arm* (1955), *Anatomy of a Murder* (1959) and *Exodus* (1960), Bass employed a wide variety of

Man with a Golden Arm
poster and title sequence 1955
[Saul Bass]

*Anatomy
of a Murder*
1959
Exodus
1960
film logotypes
[Saul Bass]

techniques. From the simplest paper cut-out to the most sophisticated studio photography, he interpreted the essence of each film in an arresting emblem.

Working on advertisements for *The Man with the Golden Arm*, he and Preminger asked each other, 'Why not make it move?' So, as well as advertisements, Bass moved on to designing title sequences, using the same techniques of visual metaphor. This was a new, hybrid medium. Graphics were transformed when in movement and reinforced by sound. The credit titles of *The Man with the Golden Arm* are a straightforward animation of the publicity graphics, but by the time he made the sequence for *Walk on the Wild Side* in 1962, the metaphor was entirely conceived as live-action film. Charles Eames, too, moved towards film, but by another route. In 1953 he used a full range of graphics in a twenty-minute film that explained communications theory.

A Communications Primer film 1953
[Charles Eames]

Called *A Communications Primer*, its technique was a development of the methods that Eames had experimented with in multiple-screen slide shows, combining diagrams, animation, still photographs and live action with a voice-over by Eames himself. It was the forerunner of a series of films and multi-media presentations that Eames produced during the following twenty-five years. Mostly popularizing scientific ideas and history, they often accompanied exhibitions. American ideas were having a significant impact outside the United States. Eames's successor to the *Communications Primer* was *The Information Machine*, an animated film sponsored by IBM for the Brussels World Fair in 1958, where the display

Amerika
'Carnival of the Eye'
magazine cover 1963
[Herb Lubalin]

in the American pavilion was designed by a newly formed partnership, Brownjohn, Chermayeff & Geismar. It comprised fragments of the American environment, including parts of a giant Pepsi-Cola sign and pedestrian traffic signals.

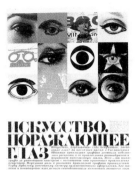

Graphic signs became the way in which the United States communicated its character to the outside world during the period of the Cold War. In 1959, the Russian-language magazine *Amerika*, distributed by the United States Information Agency in the Soviet Union, devoted an issue to the American graphic arts, because 'so much of the vitality and spirit of this country is expressed in graphics'. As designer and writer of the issue called 'Carnival of the Eye' the New York advertising designer Herb Lubalin provided a useful summary: 'At the heart of American graphics is the idea, the concept. All else – photography, typography, illustration, design – is its handmaiden.' Lubalin's career exemplifies a particularly American type of graphic design and its development.

Like many of the designers whose careers began before the Second World War, Lubalin had worked for the 1939 World's Fair. He worked in advertising agencies, since 1945 at Sudler and Hennessey, who specialized in pharmaceutical products. Here, Lubalin's first contribution was in using words as images. He stretched the limits of metal typesetting by cutting proofs, re-spacing, and by an attention to details in a way described in a book called simply *typography*, published in 1961. Its author was Aaron Burns, a designer who was a director of The Composing Room, a typesetting firm which, apart from its exhibition space, published the pre-war *PM* magazine and its successor *A-D*. The enthusiastic Burns introduced designers to new typefaces and in 1960 he produced four small booklets: with Lester Beall (on cars), with Brownjohn, Chermayeff and Geismar (on New York), with Gene Federico (on apples) and with Lubalin (on jazz). These were the mature expression of modern graphic design in the United States. (They aroused much excitement in Europe when reprinted in the German print trade magazine *Der Druckspiegel*.) By now a vernacular of words and images was used with wit and assurance, serviced by a graphic arts industry that supplied photography, typography and printing of expert craftsmanship.

Sudler, Hennessey & Lubalin logotype 1959
[Herb Lubalin]

medical advertisement 1958
[Herb Lubalin]

Lubalin also contributed to the development of magazines. In 1961 he was given the task of re-designing *Saturday Evening Post*. His heavy, tightly packed capitals in place of the thin Roman type in headings, and fiction illustrated with still-life photography instead of realistic paintings, were innovations that dismayed the readers of small-town America. The following year Lubalin designed a new, hardback, expensive magazine, *Eros*. Laid out with improvised chic, like a set of visual exercises, it was short-lived. Lubalin followed it with an economical style for *Fact*, a fierce masthead in Times Bold on the cover, and inside a simple two-column setting of Times with centred headings.

'Love of Apples'
from *About US* series
Composing Room Inc
booklet 1960
[Gene Federico]

Saturday Evening Post
magazine cover 1961
(illustrator Norman Rockwell)
[Herb Lubalin]

Fact
magazine cover 1964
[Herb Lubalin]

Lubalin's insistence on the 'concept' as the key characteristic of American graphics was underlined by the covers of *Esquire* magazine, where two of the chief designers of the period worked successively as art directors. They were Henry Wolf and George Lois. When Wolf became art director in 1952, *Esquire* had a logo and a trademark – a round-headed, pop-eyed head with a white moustache. Wolf retained both but exploited and later absorbed them into his photographic or montage cover designs. The moustachioed face appeared as a phrenological head, as the back of a wrought-iron chair, on a balloon, on an egg, as a campaign button, as the head on a postage stamp. The editorial pages were designed to fit the content. Pages of short stories were laid out in two columns with sober illustrations; features, like that on the New York stock exchange in November 1957, used dramatic photographs bled off the page, headings in telex-style and bar charts reminiscent of *Fortune*. Poster-like headings designed into compact groups were typical of Wolf's style, which is integrated with the journalistic

Esquire
magazine cover 1955
[Henry Wolf]

Harper's Bazaar
magazine cover 1959
[photographer Richard Avedon]
[Henry Wolf]

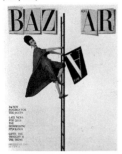

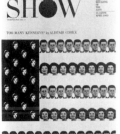

Show
'Too many Kennedys'
magazine cover 1963
[Henry Wolf]

Esquire
'The masculinization of
the American woman'
magazine cover 1965
[photographer Carl Fischer]
[George Lois]

idea. Usually, as the *Esquire* editor said, commenting on an exhibition of magazine design arranged by Wolf in 1965, 'In the complicated business of getting messages out of one mind and into another (communication, they call it), magazines are unique. They are the result of warfare. Warfare not necessarily unto death, but certainly unto deadline. Two sorts of people put magazines together, and their points of view are usually in opposition. There are the word people – the editors – who care about how magazines read. And there are the picture people – who care about how the magazines look . . . In no other form of communication does this kind of tension persist unabated.' No sign of this tension is apparent in pages designed by Wolf.

By the time this was said, though, Wolf was at *Harper's Bazaar*, where he produced startlingly original covers. His carefully controlled studio photographs introduced a surrealistic shock, a technique that he repeated in a new magazine, *Show*, launched in 1962.

These covers by Wolf were photographic concepts. They did not rely on words, except as a label, or as a pretext for the image. By contrast, the covers for *Esquire* produced by Lois, as an advertising art director, depended on the collaboration of the words and the image, and on the cooperation of the viewer in resolving the tension between the two, which released the meaning. 'Designed work', he said, 'has no place on a magazine's face. A design is a harmony of elements. A cover is a *statement*.'

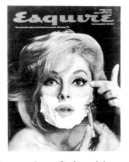

The earliest total integration of advertising with corporate identity was achieved by CBS Television, and was the result of an interested chief executive and the professional commitment of his successive art directors. The first was William Golden. After working with Agha at Condé Nast, Golden joined Columbia Broadcasting System in 1937, long before the arrival of television. He returned there after the war as art director, and was responsible for its trademark 'eye', with a realistic understanding of its effectiveness for CBS: 'If you like the programs it broadcasts, you probably think of its symbol as a good one.' He also had a down-to-earth account of its conception 'as a symbol in motion. It consisted of several concentric eyes. The camera dollied in to reveal the pupil as an iris diaphragm shutter which clicked open to show the network identification and then closed shut.' A still version was most often used. Golden suggested a year later that they try something else but was reminded

Columbia Broadcasting System
symbol 1951
[Wiliam Golden]

of an old advertising axiom: 'Just when you're beginning to get bored with what you have done is probably the time it is beginning to be noticed by your audience.'

The lettering Golden chose for CBS was a French neo-classical design from about 1800, similar to Bodoni. Golden obliged staff designers (one of whom at that time was Lois) to re-draw the alphabet, letter by letter, one letter a week. Yet there was no rigidity of application. Golden did not always include this type, or the symbol, in a long series of press advertisements notable for their graphic wit.

Golden died in 1959, and was succeeded by Lou Dorfsman, already on CBS staff. Dorfsman initiated the most ambitious projects, and emphasized the professional toughness needed to implement them. The designer, he said, 'must be able to show that the project answered a need, how it will work, what it will cost, to whom and how it will be distributed'. One of the most memorable advertisements appeared in the entertainment industry's weekly *Variety*, inserted among the dense typesetting of columns listing homes for sale. It said simply that CBS programmes reached 'three-quarters of a million more homes' than the second network. No reader could miss this, the only item on the page printed in red.

Golden had said that 'corporate image' meant 'the total impression a company makes on the public through its products, its policies, its actions and its advertising effort'. This Dorfsman achieved in countless advertising campaigns based on the principles of the New Advertising in the manner of Lubalin, using type to make the image, or like Lois, where type and image, separated on the page, came together in a single idea.

The corporate image as good design showed in Dorfsman's layouts of promotional books and annual reports, which matched *Esquire*'s in their use of photographs and elegant typography. It was extended throughout CBS with almost manic zeal. When the company moved to new offices, eighty clocks had to be removed from their cases in order to replace the numerals with the standardized CBS lettering.

By the mid-1960s, graphic design was established as a specialist profession. Evidence of its well-being was shown monthly in its trade magazines *Print*, *Communication Arts* and *Art Direction*. Every large city in the United States had its own art directors' club or association, and the American Institute of Graphic Arts (AIGA) nominated its 'Art Director of the Year'. Designers were eclectic, with many styles and attitudes

CBS logotype 1951
[William Golden]

CBS radio advertisement 1950
[designer Irving Miller]
[art director William Golden]

CBS programme title
c.1957
[Georg Olden]

CBS booklet cover 1956
[Lou Dorfsman]

CBS advertisement 1962
[Lou Dorfsman]

Thelonius Monk
record cover 1965
[photographer W.Eugene Smith]
[Jerry Smokler]

flourishing. One tendency was represented by the nostalgic, illustrative designers such as Joseph Low and Push Pin Studios (founded in 1954), who avoided the use of the standard four-colour printing processes. Push Pin work appeared in its self-promotional *Monthly Graphic*, as well as in book jackets and record sleeves. Publishers and recording companies also employed more modernist designers such as Lustig and Roy Kuhlman, whose work had a typically American appearance, marked by the use of large condensed poster-like typefaces set in capitals.

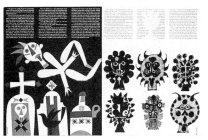

The ideas of the pioneering period of European graphic design had been integrated by such designers as Bayer, Burtin, Sutnar and Walter Allner. Born in Dessau, Allner had spent a short time as a Bauhaus student. On a visit to Otto Neurath's Isotype studio in Vienna he had met Tschichold, who arranged for Allner to work as an assistant to Piet Zwart in Holland. After Zwart, he went to Jean Carlu in Paris in 1933, arrived in the USA in 1949 and joined *Fortune* in 1951.

Moholy-Nagy had died in 1946 but his book *Vision in Motion* (1947) was influential both for its exposition of the new ways of seeing, which had resulted from the discoveries of modern art, science and technology, and for its layout. At the time, most illustrated books had their pictures printed as 'plates', on shiny 'art' paper to give a brighter result, in sections within the book, or at the back. Moholy-Nagy was keen that 'illustrations should accompany the copy and not be searched for . . . they are placed where mentioned in the text, either small-sized on the large margin, or larger-sized within the main text or on the opposite page.' This was the mature development of 'typofoto' employing text as 'verbal illustrations'.

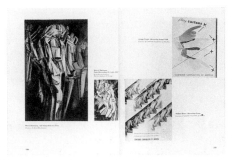

Vision in Motion
book double page 1947
[Laszlo Moholy-Nagy]

Herbert Bayer had formed a successful practice in New York during the war and had designed 'Modern Art in Advertising' in Chicago in 1945, an exhibition of the artwork for the Container Corporation of America's advertising. The following year he became the company's design consultant. While he was associated with its 'Great Ideas of Western Man' public relations advertising, Bayer also designed the *World Geo-Graphic Atlas*, sponsored by CCA, between 1949 and 1952. In the history of graphic design it is a landmark of Information Design; it is as much an advertisement of the possibilities of illustrational techniques to explain and relate distance, time, movement and quantity as it is an atlas of the world's systems and resources.

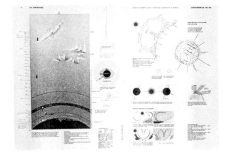

World Geo-Graphic Atlas
book double page 1953
[Herbert Bayer]

Almost all the important designers were involved in teaching, so that the programmatic attitudes of Sutnar and Burtin mixed with the pragmatic eclecticism of Beall, Rand and the perfectionist aestheticism of Brodovitch. Foreign companies, such as the Swiss pharmaceutical firms Geigy and CIBA, opened their own design offices in the United States, as IBM did in Europe and Japan. With these initiatives, through the European magazines *Gebrauchsgraphik* and *Graphis*, American design was not only internationally recognized, it also became pre-eminent.

The tension that had always existed between the 'Good Design' (such as that approved by the Museum of Modern Art in New York) and graphic design that commercial pressures seemed to require, was beginning to find expression. Henry Wolf, successful in hugely increasing the circulation of *Esquire*, had misgivings about the awkward professional status of the designer. He saw that 'problems which should come to us clean

Butazolidin
rheumatoid arthritis drug
Geigy advertisement 1964
[Fred Troller]

International Harvester
logotype 1960
[Raymond Loewy]

Chase Manhattan Bank
symbol 1963
[Chermayeff & Geismar]

Green Lighting Company
symbol c.1955
[Louis Danziger]

and clear, and with only the most essential requirements weighing down their chances for a fresh solution, come to us with voluminous recommendations and research findings which too often again point towards the sacred, safe middle.' The work of large commercial design organizations, like Raymond Loewy's, was based on consumer research, 'giving the consumers what they want and plenty of it!', he said. Nevertheless, they could produce work that was not, by any standards, inferior to those of the new design groups like Chermayeff & Geismar. Loewy, for example, provided one of his clients, the agricultural machinery makers International Harvester, with a trademark that combined the recognizability of the front of a tractor with the firm's initials.

New techniques were devised to discover more about consumers and what they wanted. CCA had set up its Design Laboratory in 1940, equipped with a camera that could record eye movements over a design. Landor Associates worked with its Institute for Design Analysis, observing and interviewing shoppers in its own mock supermarket. By the mid-1960s the only real difference between products was the way in which they were perceived by the customer. One product could be distinguished from another only by the image it projected – or had projected on it. As Walter Landor said, 'The battle for the consumer's heart is just beginning.' Other immigrant designers responded less confidently, brought up on such European idealism, represented by Moholy-Nagy's dictum that 'Man, not the product, is the end in view.'

Better Vision Institute
(montage portrait of Walter Gropius)
booklet cover 1950

'Great Ideas of Western Man...'
"The things that will destroy America
are... the love of soft living and
the get-rich-quick theory of life"
from *The Letters of Theodore Roosevelt*'
CCA advertisement 1960
[Herbert Bayer]

Schawinsky's wry comment was a fragmented portrait of the Weimar Bauhaus director – used as an image for the Better Vision Institute. Herbert Bayer's CCA advertisement illustrates the American 'love of soft living' in a montage of the elements of 'conspicuous consumption'.

Switzerland and Neue Graphik

Modernism in Switzerland became a crusade in the years following the Second World War. Its assumptions became matters of faith. At the Kunstgewerbeschule in Basle students reprinted key works of the 1920s such as the Bauhaus letterhead. Their teacher, Emil Ruder, was puzzled that this work was considered obsolete, but Tschichold, champion in 1925 of the New Typography, claimed that it had introduced two misconceptions. The first was the rejection of the centred layout, the second, the exclusive use of sans-serif type which, he now considered, was 'a basic form suitable for small children; for adults it is more difficult to read than types whose serifs have a function and are not merely ornamental. Nor is asymmetry in any way better than symmetry, it is just different. Both methods are valid.'

Max Bill, replying to such arguments in 1946, said that they were typical of those who wanted to return to the methods they thought effective merely because they had survived. 'Fortunately,' said Bill, 'there are young, forward-looking people, who do not blindly accept arguments like these.' The most articulate of the young people Bill had in mind was the Basle designer Karl Gerstner. In 1955 the professional architecture and design magazine *Werk* devoted an issue to graphic design. It was given to Gerstner to edit and lay out. Like Bill, Gerstner was a painter in the Swiss post-Constructivist school of 'Concrete' artists, who used mathematical ideas and systems. In *Werk*, Gerstner went to great pains to make it clear that graphic design was nothing to do with art, but that it could certainly benefit from the rigorous disciplines of Concrete Art, which he and others extended into design. Whereas Tschichold was interested in the geometry and proportions of book pages, what Gerstner and his colleagues did was to develop the controlling 'grid'. The method can be seen in a simple form in the early books written out by scribes, where the position of the columns and the lines has been transferred to subsequent pages by 'pricking through'. Its modern use was thought to have originated with Bayer at the Bauhaus and was used 'as a proportional regulator', Gerstner explained, 'for layout, tables, pictures, etc.' He quoted Einstein on the module: 'It is a scale of proportions that makes the bad difficult and the good easy.' Unlike Tschichold's divisions of the page, Gerstner's grids originated not in the proportion of the given sheet, but in a basic unit of typographic measurement. These were often elaborated into almost cabbalistic constructions of gratuitous complexity, but he used the grid expressively, to control ideas.

In the novel *Schiff nach Europa* (*Ship to Europe*) which Gerstner designed for his colleague Markus Kutter in 1957, the surface is divided into six squares; each of these is further divided into squares, seven

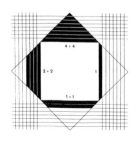

diagrammatic analysis
of painting by Max Bill from
Kalte Kunst? (Cold Art?) 1957
[Karl Gerstner]

'secret canon' of
book proportions in
the late Middle Ages
diagram 1953
[Jan Tschichold]

grid for
Schiff nach Europa 1957
[Karl Gerstner]

by seven; these are then divided by the smallest unit of type size (plus the space between the line) into smaller squares, three by three. This gave him what he termed a 'flexible screen in which the typographical image is accommodated, with almost unlimited freedom of expression'. This he exploited to emphasize the author's use of different types of discourse, including the styles of newspapers, advertising copy and film-script as well as traditional narrative.

Schiff nach Europa
cover and double pages 1957
[Karl Gerstner]

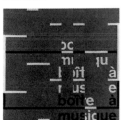

'boîte à musique'
music shop disc sleeve 1957
[Karl Gerstner]

National Zeitung
from poster series 1960
[Karl Gerstner]

Gerstner ran an advertising agency with Kutter in Basle from 1959. He experimented with the basic units of typography. For Bech Electronic Centre Gerstner made permutations of BEC and played with the typographic elements of 'boîte à musique' shop. His ideogram of the 'N' and 'Z' of *National Zeitung* (*National News*) showed similar ingenuity.

Such work was supported by a series of theoretical statements and practical programmes. With Kutter he published the first comprehensive survey of the history and rationale of the Modern Movement in graphic design, *Die neue Graphik* (1959), followed by the more theoretical *Programme entwerfen* (*Designing Programmes*, 1963) and *Compendium für Alphabeten* (*Compendium for Literates*, 1971). Common to these books is the concept of System, where an aesthetic effect emerges from a clear choice of limited graphic means: the principle that he employed until he more or less abandoned design for art in the early 1970s.

To write about advertising in his issue of *Werk*, Gerstner had chosen his contemporary, Siegfried Odermatt, a designer with several years' experience of a Zurich agency. Odermatt freely reworked ideas of Stankowski and Cyliax, the Zurich pioneers of the new advertising in the 1930s. His work emphasized the distance between the advertising ideas of New York and those of Zurich. The most obvious difference is that the Swiss advertisements looked like the work of designers rather than art directors. They rarely depended on a single headline; the largest type was the name of the product; the image derived directly from the product rather than illustrating a marketing concept.

In *Werk*, Odermatt described advertising as following four principles:

1. Getting attention.
2. Clear, objective presentation of product, service or idea.
3. Appeal to the consumer's instincts.
4. Fixing it in the memory.

Odermatt distinguished between single advertisements and those produced as a series which, by functional design, carefully planned repetition (and especially through the series' basic idea), could extend the normally short life of a single design.

His series for Bassick castors in 1957 demonstrated this. Odermatt presented the product by engineering drawing, dramatized by the graphic contrast of reversing fine white lines out of black. The accurate mechanical drawing not only suggested the precision of manufacture, but the black also represented the colour of the rubber wheel, and the white, the metal – just as Beardsley treated outline and colour.

The following year Odermatt produced a small-format series of advertisements for insurance policies in German and French. He dramatized a risk such as 'Robbery' and 'Accident' by incorporating the word photographically into a single image.

With his partner Rosmarie Tissi, he developed a refined use of space, regulated by a grid, in which the parts of the message were related in a clear structure, immaculately demonstrated in his work for the Globus store's *Form '60* competition, where holes in the grid are used to relate, to separate and emphasize. Odermatt and Tissi's undogmatic discipline and prolific output of industrial and cultural publicity over three decades have given them a lasting international reputation.

Bassick castors
advertisement 1957
[Siegfried Odermatt]

The Yellow Book
cover drawing 1894
[Aubrey Beardsley]

Neuenburger / La Neuchateloise
insurance advertisements 1960
[Siegfried Odermatt]

Form 60
advertisement announcement of
winners of design competition 1960
[Siegfried Odermatt]

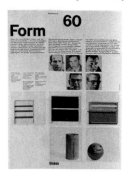

Switzerland's international influence depended on the magazine *Graphis*, published monthly from Zurich since the last days of the war in Europe. *Graphis* balanced the reproduction and discussion of commercial art from abroad with reviews of fine art printmaking, limited edition books and historical subjects. A more specifically Swiss influence was the magazine *Neue Grafik* (*New Graphic Design*), launched in 1958 by four of the older guard, Richard P. Lohse, a Concrete painter; two graphic designers, Josef Müller-Brockmann and Hans Neuburg, who had been Stankowski's collaborator – and Carlo Vivarelli, who had worked for Boggeri in Milan (see Chapter 15) and was also an architect and artist. Vivarelli had been responsible for a key work of Swiss Neue Grafik – the poster *Für das Alter* (*Help the Aged*), in 1949.

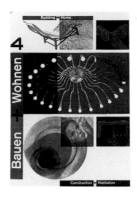

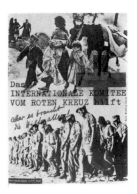

Für das Alter
poster 1949
[Carlo Vivarelli]

Bauen und Wohnen
magazine cover 1948
[Richard Paul Lohse]

'The International Committee
of the Red Cross is helping –
but it needs everyone's help'
poster 1944
[Hans Neuburg]

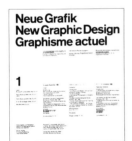

Neue Grafik
magazine cover 1958
[Carlo Vivarelli]

musica viva
concert poster 1958
and diagrammatic explanation
[Josef Müller-Brockmann]

Together the editors set out 'to create an *international platform* for the discussion of modern graphic and applied art. Contrary to that of existing publications, the attitude of *Neue Grafik* is characterized by exclusiveness, consistency and lack of compromise.' Indeed, the magazine published very little contemporary work from outside Switzerland. But it became the chief means of disseminating the work of the pioneers of the 1920s and 1930s, many of whom wrote from their own experience. Chief of these was Max Bill, whose practice spanned several decades and ranged over art and architecture as well as design, and contributed to most of the early issues.

Müller-Brockmann was the most commercially active of the editors. The series of posters that he designed from the early 1950s for the Zurich Tonhalle (Concert Hall) shows the emergence and development of what the group called '*Konstruktive Grafik*'. Müller-Brockmann started with mannered, whimsical illustration, unthinkable to a designer committed to Neue Graphik, which rejected the use of free drawing as being neither objective nor 'constructive'. He followed this by adding type to a 'concrete' (mathematical) image of flat geometry, and in 1958 integrated the text and image through the grid.

For its images, apart from technical, geometrical drawing, Neue Graphik demanded photography. Müller-Brockmann conformed with posters on traffic dangers dramatized by changes of scale; heavy cropping

 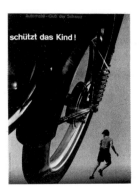

'Less Noise'
poster 1960
[Josef Muller-Brockmann]

'Mind the Child!'
poster 1953
[Josef Muller-Brockmann]

Giselle
ballet poster 1959
[Armin Hofmann]

letters in Neue Haas Grotesk type
[Max Miedinger 1957]

of the black-and-white photographs; often a diagonal axis; coloured lettering for slogans of four or five syllables and injunctions that suggested that they could be shouted: 'Less noise', 'Mind the child!'

As a typeface, Müller-Brockmann and his colleagues used, almost exclusively, Akzidenz. It is paradoxical that more geometrical types such as Futura were not thought to fit with rigidly geometrical graphics. In the second issue of *Neue Grafik*, Emil Ruder introduced the new Univers typeface, designed by the Zurich-trained Adrian Frutiger for the Paris typefoundry of Deberny & Peignot (see p. 153). This design, although it was sans serif, had a slightly calligraphic character. In 1957 another new sans-serif design appeared, known as Neue Haas Grotesk, soon renamed Helvetica. To fit a consistent programme of weights and widths, it lost much of its strength, which was that of the old wood poster letter. Large sizes of the heavier weights became essential graphic elements in the 1950s and 1960s, exploited by all the 'constructive' designers.

When designers placed a word vertically, they emphasized its abstract, purely graphic qualities. A 1959 poster for ballet in the open air used a re-drawn version of the medium weight of Akzidenz for the title. The much flatter curves of Helvetica would have a far less dynamic parallel to the movement of the figure, intensified by the blurred photograph and its tight cropping. The word 'Giselle' has become an equally powerful image: the dot on the 'i', a circle instead of a rectangle, the white curves of the 's' and 'e's against the bars of the 'l's and 'i', echo the movement of the ballerina in the spotlight.

The designer of the *Giselle* poster was Armin Hofmann, who taught at the Basle Gewerbeschule from 1947 and also in Philadelphia and at Yale in the 1950s. An expert in lettering, it was his teaching and example, with that of Ernst Keller and Alfred Willimann in Zurich, that helped give Switzerland hundreds of well-drawn trademarks and logotypes.

Steiner
shopfitters' logotype 1953
[Alfred Willimann]

Therma

Carlo Vivarelli's Therma lettering designed in 1958 was a true logotype of joined letters: as a single piece of metal it could be easily incorporated into items of kitchen equipment designed by the firm whose programme of corporate design included the whole range of promotional activities in a similar way to Olivetti (see Chapter 15).

Like the Therma logotype, other symbols, for Electrolux (Vivarelli, 1962) and for the 1964 Swiss National Exhibition (Hofmann) resulted from competitions. Such public recognition of design included awarding commissions for postage stamps and banknotes. The annual selections of the Best Swiss Posters, the Best-Designed Books of the Year, and the series of design exhibitions at the Gewerbemuseum (Arts and Crafts Museum) in Basle and Zurich encouraged a responsive public and stimulated clients like Therma. Books were published in the 1960s that demonstrated the integration of graphic design into the country's commercial and cultural life: *Graphic Design of a Swiss City*, *Swiss Industrial Graphics*, *Graphic Design for the Chemical Industry*.

As in America, the pharmaceutical industry employed designers, often as full-time staff. Tschichold's revisionist symmetry served Roche; the team at Geigy, which in the early 1950s included Gerstner and Gérard Ifert, under the art directors Max Schmid and Gottfried Honegger, consolidated the early 'Swiss style'. At the same time as this style spread to the United States (where Schmid took over the Geigy design office in 1955) other powerful elements remained, either (like Tschichold) based in a refinement of conservative attitudes – particularly in book design – or in the tradition of the illustrated poster.

below, right
Geigy 'Micorene'
advertisement 1956
[Enzo Rösli]

below, far right
Roche 'Mogadon'
brochure title page 1965
[Jan Tschichold]

Insidon
Geigy pharmaceutical
package and advertisement 1963
[Harry Boller]

jetzt kassenzulässig! Insidon: Psychovegetatives Harmonans. Geigy

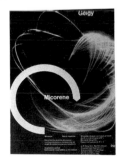

In 1964 the International Council of Graphic Design Associations (ICOGRADA) met in Zurich. Some of those who launched the profession, including Stankowski from Germany, Schuitema from Holland and Burtin from the United States, debated the issue of 'Professional Design or Commercial Art?'. Neuburg introduced the 'friendly disputants' as 'the free classic graphic artist with his inclination to drawing or painting' and 'his constructivist, functionally minded and intellectu-

Switzerland and Neue Graphik

135

al counterpart', the latter representing the Neue Graphik tendency. The debate was already universal. In 1959 Masaru Katsumie, the editor of the Japanese magazine *Graphic Design*, emphasized his preference for 'constructivist' designers: 'Rather than Raymond Savignac, I selected Max Bill. Rather than Herbert Leupin, I chose Josef Müller-Brockmann. Instead of Hans Erni, I introduced Karl Gerstner.'

By emphasizing Graphic Design, which he saw as 'firmly connected with printing', rather than Commercial Art, Katsumie seems to have been making a distinction connected with reproduction. Graphic Design's images were produced by photography, part of an industrial process, reproducible in multiples from the original negative. On the other hand, Commercial Art employed the hand-drawn illustration.

The distinction between the two categories of designer was not necessarily so exclusive. Many of the leading Swiss designers worked in several graphic media. In 1945, Kurt Wirth was producing posters with his own linocuts, printed by letterpress. At the same time, he produced work that was indistinguishable from 'constructive' graphics. In 1954 Hans Erni had painted a memorable composite image similar to the photographic skull and atomic explosion designed as a nuclear disarmament poster in 1961 (see p.7). Whether the image was produced in paint or by photomontage had only a marginal effect on the graphic idea.

'Atomic War: No'
poster 1954
[Hans Erni]

The poster designer Leupin had established himself in the 1940s with a hyper-realist presentation of the product. Later he adopted an informal style similar to the French *affichistes*. A famous linked pair of posters for Bata shoes in 1954 is typical.

Bata shoes
double poster 1954
[Herbert Leupin]

In 1955 Leupin created one of the most economical word-image composites, combining 'morning' and 'newspaper' in the white coffee-pot, animated by the tilted lid, open like a mouth.

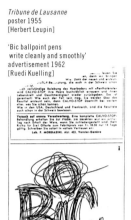

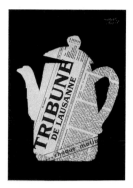

Ruedi Kuelling, who had worked with Grignani in Milan (see Chapter 15), designed one of the simplest and most memorable graphic marks, used on posters and in small press advertisements for Bic pens. Made with a ballpoint, the image perfectly describes the means which made it. Produced by Swiss designers in Switzerland, such work belongs to a longer tradition than the 'Swiss style'.

Neue Graphik consummated the desires of the pre-war pioneers for objectivity in visual communication; it was an internationalizing force in the new profession, and helped give 'Information Design' a typographical language and discipline before the arrival of photo-typesetting and computer graphics.

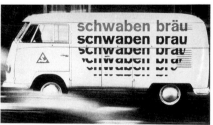

15

Italy and the Milanese Style

While Futurism in the 1930s had provided the main impetus for a continuing avant-garde in Italy, associated with the magazine *Campo Grafico* (see p. 43), it was a single man, Antonio Boggeri, who was mainly responsible for the avant-garde's later development. In 1924 Boggeri, a professional violinist with an enthusiasm for photography, joined the management of Alfieri & Lacroix, a Milanese typesetting and photoengraving firm. In neighbouring offices he found copies of *USSR in Construction* and the English *Commercial Art*, which carried Tschichold's articles explaining the New Typography and the technique of photomontage. Inspired by such examples, Boggeri established a studio in Milan in April 1933. The following year, the cover of *Campo Grafico* carried a Studio Boggeri photograph, and Boggeri aligned himself with the magazine's modernist attitude to typography, though 'typofoto' was his real interest. He aimed to persuade enough clients that 'the unusual aesthetic taste and visual seduction of the means of communication would demonstrate the excellence of the product'. The aesthetic taste of Studio Boggeri evolved into the post-war Milanese style.

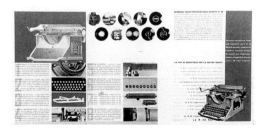

Olivetti M40 typewriter
leaflet 1934
[Xanti Schawinsky]

Studio Boggeri had a European rather than a particularly Italian outlook. Its symbol was designed in Paris by Deberny & Peignot; Boggeri met leaders of the avant-garde, like Bayer and Moholy-Nagy, through Xanti Schawinsky, who set up a design office in Milan in 1934. Schawinsky brought with him typical late-Bauhaus design techniques – realistic drawing with use of the airbrush, montage and disciplined layouts in a simple, clear grid – all developed by other designers associated with Boggeri in the 1930s.

Studio Boggeri
symbol 1933
[Deberny & Peignot]

Through Boggeri, Schawinsky worked for Olivetti, who made typewriters and office equipment. Led by the engineer Adriano Olivetti, the firm had a programme of comprehensive design which included housing, hospitals and schools for its employees. Schawinsky chose and assembled the components of image and text that would identify Olivetti and link its name with the twentieth century and the benefits of technology. His photomontaged poster of 1934 repeats the direct symmetry

Phonola
radio brochure cover 1940
[Luigi Veronesi]

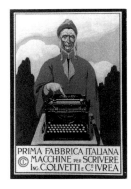

of Wolf Ferrari's of 1912, which refers to history and authority. In a landscape setting, Dante pointed a patrician finger at the name on the typewriter; the slogan has the classical style of an inscription. Twenty years later, Schawinsky put the typewriter firmly in the modern world. In a two-dimensional, perspectiveless space and using the mechanical medium of photography to make his images, he connected the machine with the idea of sophisticated glamour through the film-star appeal of the model: her hands caress its surface and her red lips echo its colour, even its form. For a poster, where the idea had to be conveyed in a glance, the composite image, without a slogan, was complete in its effect.

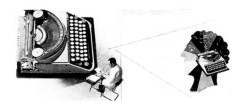

An advertising leaflet for the same portable typewriter allowed the reader more time to take in a similar message, which Schawinsky elaborated in an astonishing display of graphic techniques – tinted cut-out photographs, airbrushing, an engraving of sixteenth-century surgery contrasted with a film still of an operating theatre, and even x-ray hands on the keyboard. Together with subsidiary 'ragged-right' text typesetting, the pages present an argument that the 'giddy rhythm of progress' demands that the reader 'abandon the pen. Take up the Olivetti portable.' Schawinsky designed a new logotype for the firm – one of the first and few in lower-case letters only – following the forms of the alphabet on the typewriter.

Designers who had worked with Boggeri were responsible, in 1956 and 1970, for subsequent Olivetti trademarks and logos. Erberto Carboni was one, whose career spanned the development of Italian graphic design over thirty years. He was a specialist in exhibition design for trade fairs, a field in which Italy excelled. He had worked in a mixture of post-

Cervo Bantam
poster for hats 1936
[Erberto Carboni]

Barilla Egg Pasta
'Get this idea out of your head'
advertisement 1956
[Erberto Carboni]

Cubist styles during the 1930s and in 1936 had included a full range of modernist ingredients in his poster for Cervo 'Bantam' hats: lace collage on the photomontage of the child's face and the hat against a flat chequered background. The image remains graphic, not representational. There is a contrast between the two-dimensionality of the support (paper) and the spatial depth implied by the tones of photography. Carboni's attachment to a rigorous modernism was still evident in his later work, even for a popular market, exemplified in his promotion and packaging for the pasta firm of Barilla in the 1950s and in his severely geometrical symbols for Italian Radio and Italian TV.

Italian Radio
symbol 1949
[Erberto Carboni]

Italian Television
symbol 1953
[Erberto Carboni]

Linea Grafica
cover design 1954
[Bruno Munari]

Such frank display of graphic methods and manipulation of space, constantly renewed through the use of the latest technical means to develop new forms, was particular to Milan. Design was part of the economic and cultural life of the city and was promoted in the Triennale exhibitions. Its growth was supported by journals of the print trade like *Linea Grafica* and *Pagina* and recognized in the design and architectural magazines such as *Stile Industria* and *Domus*, which published graphic design from abroad, particularly the United States, as well as studies of communications theory and research in such fields as traffic signs.

The most important single figure associated with Boggeri was Max Huber, the first of a number of Swiss designers to descend on Milan who were crucial to the development of Boggeri's graphic language. Swiss supremacy had already been confirmed by its pavilion at the 1936 Milan Triennale, designed by Max Bill – with whom Huber collaborated during the war years. Huber arrived in 1940, equipped with formidable technical skills, the experience of working in Zurich in an advertising agency and at one of the most advanced printing enterprises. He remained eighteen months, before the Second World War obliged him to return to Switzerland. In Milan, as well as brochures and catalogues, he designed Boggeri Studio's letterhead and an advertising panel which listed, entirely in lower-case letters, the jobs it undertook: posters, catalogues, displays, shop windows, folders, stationery, advertisements, trademarks – in fact, the work of the design groups which did not emerge in many countries until nearly twenty years later.

Italstrade
highway construction company
advertisement 1941
[Max Huber]

Studio Boggeri
brochure cover 1945
[Max Huber]

Sirenella
dance hall poster 1946
[Max Huber/Ezio Bonini]

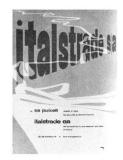

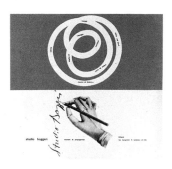

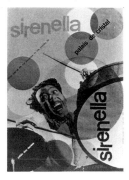

Huber's restrained manner slowly loosened into a more dynamic use of photography. He combined flat colour with perspective, creating tension by emphasizing the flat plane of the printed sheet, yet at the same time implying the three-dimensional space suggested by the photographic image. These stylistic conventions were the basis of post-war Italian graphic design, to which Huber returned in 1945. He used a post-Constructivist, exclusively sans-serif or Bodoni typography, often superimposed on photographs. His interests in jazz and social issues stimulated a series of posters and magazine covers in the 1940s and 1950s where he developed an adaptable and expressive visual technique.

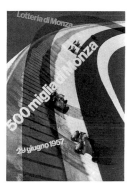

'Monza Grand Prix'
poster design 1957
[Max Huber]

Swiss Grand Prix
programme cover design 1938
[Max Huber]

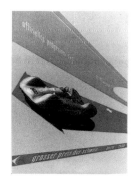

The progress of his methods is well illustrated in Huber's series of posters for the Monza motor race. In 1938 he had designed a race programme cover showing a car on a banked track made up of a red arrow, an extended Swiss flag, with the edges of the track indicated by long wedges of blue and green. In 1957 he repeated similar elements for the Monza five-hundred-mile race. Meanwhile, for the Monza Grand Prix lottery in 1948, he made a radical design, impeccable in its execution. Like an abstract painting, huge arrows in flat colours (red, blue and green) curve and overlap across the design in a space created by the sharp perspective of the hand-drawn lettering. Cut-out photographs and flat colour became conventional ingredients of Italian graphic design, but it was Huber who pioneered their inventive use.

Beginning in 1950, Huber helped the department store La Rinascente

introduce a unified style, which was developed under successive art directors. It linked labels, packaging and promotional material inside the shop with window displays, posters and press advertising. For the trademark, Huber combined a capital 'R' in Futura Bold with a Bodoni italic lower-case 'l' in a single sign: a conjunction that symbolized Milan's position as the meeting place of northern and Mediterranean cultures. Such a conjunction of opposites had been a long-standing rhetorical device in advertising. The most common was the demonstration of cause and effect in the use of 'before' and 'after', a favourite for patent medicines, and adopted by graphic designers.

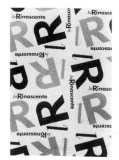

La Rinascente
department store wrapping paper 1950
[Max Huber]

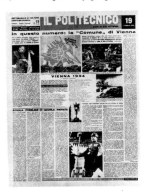
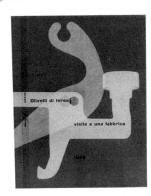

Il Politecnico
weekly newspaper design 1945
[Albe Steiner]

Visit to an Olivetti factory
booklet cover 1949
[Albe Steiner]

Ar-flex
logotype 1956
[Albe Steiner]

One of the most celebrated of such juxtapositions, of 'war' and 'peace', was achieved by turning a photograph of smoking guns through ninety degrees, changing them into factory chimneys. This image appeared in a leaflet advertising the Milanese left-wing cultural weekly *Il Politecnico* in 1945. Its designer was Albe Steiner, who had been an early collaborator with Boggeri. His political commitment involved Steiner in the wartime Resistance, in postwar reconstruction, in teaching and writing, and in a literacy programme in Mexico.

Steiner was the art director of La Rinascente from 1950 to 1954. The store sponsored an annual award for design. This was a pair of dividers that broke a line into the proportions of the Golden Mean designed by Steiner and which he converted into a graphic sign to be used in publicity. His graphics employed avant-garde techniques; with Lissitzky, he was one of the very few designers to make a photogram for commercial use. (Typewriter components appeared on an Olivetti booklet cover in 1949).

Olivetti's advertising is primarily associated with Giovanni Pintori, who joined the firm as a designer in 1936 and was art director from 1950 to 1968. Its techniques were varied. Pintori himself often created an ambiguous, poetic ambiance in which the name alone referred to the product. Press advertisements depended on the isolation of one aspect of a machine that could be developed as the main graphic element. The same bold italic grotesque typeface appeared in headings and for the name of an Olivetti product. Like the pharmaceutical companies, Olivetti was one of the first multinational companies to establish a co-ordinated

La Rinascente *Compasso d'oro*
design award 1954
[Albe Steiner]

Olivetti Lettera 22
poster 1950
[Giovanni Pintori]

Olivetti
logotype 1947

olivetti

Olivetti
symbol 1954
[Marcello Nizzoli]

olivetti

'Cinturato'
Pirelli tyre advertisement 1967
[Pino Tovaglia]

SUL CAMION
COME
IN SPIDER
CINTURATO
PIRELLI
IL PRIMO
GIGANTE RADIALE
CON SPALLA
DI SICUREZZA

Pirelli
poster c.1960
[Andre François]

Far right
Pirelli
advertisement 1963
[Gerhard Forster]

house style through offices abroad, with IBM as its main competitor.

Pirelli, the international rubber company, aimed not at standardization of its design, but at high standards. For posters, like Olivetti, they used Savignac, André François and Armando Testa, who ran his own agency in Turin. For exhibitions, they used Carboni, and for the one thousand printed items they produced each year, they employed the outstanding Milanese talents, particularly Ezio Bonini, Aldo Calabresi, Bob Noorda, the team of Confalonieri and Negri, and Pino Tovaglia. These designers were fortunate: Pirelli had an established logotype, so simple and recognizable that it could become a central element in the design, but they invented a wider vocabulary in their graphic representations of a tyre and its qualities than was made for any other single product.

Much of the most original work of Milanese designers depended on pharmaceutical publicity: in the 1940s, the Boggeri designers Huber, Bonini, Walter Ballmer, Remo Muratore and Vivarelli applied abstract graphics to Glaxo Laboratories promotions; in the 1950s and 1960s Bonini, Calabresi and others introduced photographs to give a non-clinical context to Roche products. Pharmaceutical promotion also gave opportunities to the most original and internationally influential of the Milanese designers, Franco Grignani. Grignani exploited the achievements of modernism, particularly its spare typographic layout, but added to them

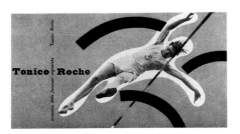

'Roche Tonic'
leaflet cover c.1949
[Ezio Bonini]

an imaginative use of graphic elements. His career shows stages of development like that of an artist. He trained as an architect, was a Futurist painter in the 1920s and became a graphic designer in the 1930s, making the most advanced use of both photography and technical drawing, the two means he employed to extend the scope of graphic expression. He was an early user of photograms. These provided abstract images that evoked chemical and physical processes. By laying objects like syringes or phials on photographic paper, Grignani gave the ordinary paraphernalia of medical treatment an unexpected elegance. As art director of the Dompé company magazine, *Bellezza d'Italia*, he showed that sophistication need not consist of the obvious delicacy of Bodoni: he gave it a robust mid-twentieth-century *Bd'I* for its symbol (see p.198).

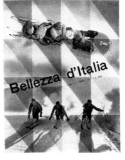

Grignani also designed a logotype of initials for Alfieri and Lacroix. The firm gave Grignani the opportunity to experiment in a series of advertisements in the printing trade press. Addressed to his fellow designers, the message was, month after month, 'Watch me. See what I can do.' He advertised aspects of graphic design and linked them to Alfieri and Lacroix with didactic statements like

Bellezza d'Italia
magazine cover 1950
[Franco Grignani]

Alfieri and Lacroix
logotype c.1956
[Franco Grignani]

speed alters graphics
speed alters colour
speed alters vv ii ss ii oo nn

and

Alfieri & Lacroix
'Graphics creates emotion'
printer's advertisement 1957
[Franco Grignani]

where does a sign live?
Not within the arc of space granted it
nor in its own architecture
cut off by the conventions of graphics.

It lives through its ability to bring energy
to the scene of dialectical play
which is a performance, a vivid dialogue . . .

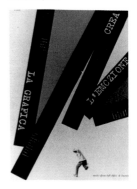

After exhausting the conventional techniques of cut-out half-tones, flat colour and type reversed out of solid colour or black to show white, which he did in the most dramatic manner, Grignani began his improvisations. At first, he used lettering abstractly, as shapes and not as signs. Often he distorted them through water or irregularly patterned glass, an

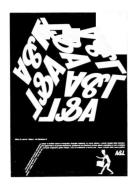

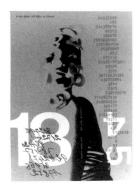

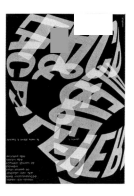

idea that Huber had used in the lettering of a book cover in 1945. Grignani's work often anticipates Optical Art of the 1960s, but another precedent is the advertising for a family engineering concern designed by its vice-president, Antonio Pellizzari. Grignani made photographic images flat by 'posterization'; that is, he knocked out the middle tones so that the images were either light or shadow, and the shadows decoration, a process that became one of the most over-used techniques of the following decade. Photographing striped and chequered material allowed Grignani to play with spatial illusion. He later experimented with lettering and images projected onto three-dimensional objects and conjured with space by distortions in complex geometrical perspectives.

Grignani believed that the creative person in Italy, unlike in America, 'is often his own art director, as well as designer, photographer, technical draughtsman and retoucher.' He thought that working as part of a team could inhibit the designer's inventiveness. It was more usual in Italy than elsewhere for designers to work in more than one field. Some made important contributions in several specializations. Marcello Nizzoli, for example, had become art director for Olivetti in 1938; and after the war the typewriters he designed for the company had an international success. Typically versatile, too, were Bruno Munari (see p.43) and Enzo Mari, both of them interested in three-dimensional design. Munari's 1960 poster, which brought together more than thirty printed versions of the Campari name on a red background, was almost unique in its use of collage for consumer advertising. In the 1960s Munari also worked with Huber in designing books for the publishers Einaudi, emphasizing

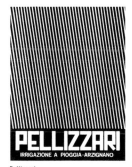

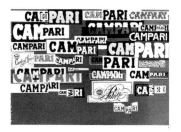

Italy and the Milanese Style

their three-dimensionality, with powerful rectangular elements, echoed in Mari's book covers for the firm of Boringhieri. Italian work, particularly Grignani's, was admired abroad, along with the typographic perfection of advertisements for Luigi Franchi hunting rifles, designed by Calabresi at Boggeri. This work reconciled disciplined typography with a dramatic, objective image. Calabresi was Swiss, but while his design was underpinned by Swiss rigour, it had typically Italian playfulness and inventive contrast.

Luigi Franchi
sporting gun advertisement 1960
[Aldo Calabresi]

Piccolo Teatro di Milano
theatre poster 1965
[Massimo Vignelli]

In the mid-1960s, the Swiss style – as an efficient, predictable use of rules and a sans-serif or Bodoni typeface – was formalized by Massimo Vignelli in his typographical posters for the Piccolo Teatro di Milano. This was the style that shortly afterwards he and Noorda, in the consultancy Unimark International, transplanted to New York. It was some years before designers came to the same realization as Boggeri, that by relying exclusively on a rigid purism, Swiss graphic design (Neue Graphik) exposed its own weaknesses, and risked repetitiousness and banality. Italian designers avoided these dangers in their own work, through an individuality that gave it protection from casual plagiarism abroad.

above left
International Wool Secretariat
symbol
[Francesco Saroglia]

Gauloises
cigarette pack 1936
[Marcel Jacno]

France's postwar graphic design retained much of the character of the 1930s. One of its most enduring images, the blue package of Gauloises cigarettes, was first redesigned by Marcel Jacno in 1936. After the war, in 1947, he refined it by using a less stylized winged helmet and changing the smaller type from sans serif to bold roman. Seventy million were printed each week in the 1960s, making it one of the most widely recognized graphic designs. Its light blue colour isolates the title and image from their surroundings. Like a Cappiello poster, a symbolic image and a headline stand out on a coloured background.

Gallic directness is exemplified in Jacno's work for the Théâtre National Populaire which he began in 1951. He reduced the twenty-four letters of the title to three initials, 'TNP', and then contrived to match the popular style of the productions. Consciously aiming for a 'French Revolution' appearance in the posters and programme covers, he gave the letters an irregular edge to echo the crude, rustic look of 1790 printing. He printed in red, blue and black on white to recall the tricolour of the national flag and the uniforms of the Garde Nationale.

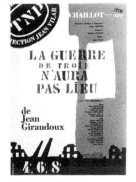

Théâtre National Populaire
poster 1960s
[Marcel Jacno]

The TNP stencil-form lettering was adapted as the typeface Chaillot in 1956 by Deberny & Peignot, who before the war had produced two other designs of Jacno's, Film and Scribe, and a third, Jacno, in 1948. Their flamboyant oddness, which typified so many French letterforms, like those drawn by the poster artist Roger Excoffon – Mistral, Choc and Calypso – limited their usefulness, but they found a place in shop signs, turning French streets, already well furnished with enamel advertising signs, into graphic fairgrounds.

Film
typeface 1934
[Marcel Jacno]

Jacno typeface
1950
[Marcel Jacno]

Mistral typeface 1953
[Roger Excoffon]

Choc typeface 1955
[Roger Excoffon]

Calypso typeface 1958
[Roger Excoffon]

France

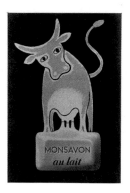

Painted posters still flourished. Pre-war artists like Carlu and Jean Colin were active but Cassandre devoted himself mostly to painting and theatre design. A younger generation was giving new life to the painted poster. The designs of Bernard Villemot and two of Cassandre's former assistants, Raymond Savignac and André François, were less pictorial and more cartoon-like. Savignac reacted against the method of juxta-posing ideas. 'A single image for a single idea' was his aim, achieved with what he called 'a visual scandal' – usually an odd, surreal conjunction whose unexpected humour would carry an idea without depending on words. He said that he 'came of age' when he was 41, with his Monsavon poster, which perfectly met his demands. The single idea, that the soap contains milk, finds a unique expression.

The most significant survivor from the pre-war period was Charles Loupot. He cunningly geometricized the traditional symbol of the Nicolas wine firm (the delivery man named Nectar carrying several bottles in each hand – already modernized by Cassandre in 1935). In 1945 Loupot developed the logo he had designed for St Raphaël, making it even more angular and cutting up the name into parts, suppressing the 'St' by making it smaller. Like Cassandre's 'DU-BON DUBONNET', he deployed 'St Ra-pha-ël' as flexible abstract units that were assembled on walls, on vans and in publicity.

Nicolas wines
(drawing of Nectar, the delivery man
by Dransy)
poster 1920s

Nicolas symbol
c.1950
[Charles Loupot]

St.Raphael
billboard 1950s
[Atelier Charles Loupot]

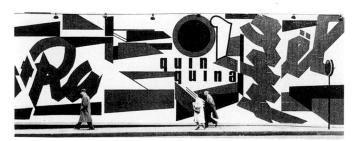

This graphic extravagance found its most original and energetic expression in the bindings and text pages of books designed for book clubs. These clubs sold directly to the subscriber, who undertook to buy

four titles a year from the four published each month. Jacno had designed a Bible for the Club Bibliophile de France in 1947, but the key figure in this enterprise was Pierre Faucheux, who worked for the Club Français du Livre from its beginnings in 1946. Its books were new editions of classics; lesser-known works from earlier periods; and translations of foreign texts. Unlike the limited edition books which included artists' prints, these books were illustrated with graphic material from the period of the book's first publication, 'for the sake of authenticity'. Nearly five hundred such books were produced by Faucheux. In his hands, the book, its pages and cover, became a total space in which to design. Faucheux had made a study of old books, learning how to position type on a page with mathematical control; nevertheless, he always insisted on 'innovation'.

Faucheux's own innovations included extreme contrasts of type size and style, as in the opening pages of *Tom Sawyer*, and the use of odd printer's ornaments and letters as signs for the characters appearing in Henri Pichette's *Les Epiphanies*. He had experience of composing type himself, and was uninhibited in using any typeface he happened to find at the printer. In Lautréamont's *Les Chants de Maldoror*, a sequence of single pages are each entirely filled with a huge single letter, spelling out M A L D O R O R (in the same alphabet design that was re-drawn for the CBS logo a few years later – see p. 126). Preliminary pages of a book were often used in this way, like film titles, to establish the book's character in a series of double-page spreads.

Faucheux went on to design a vast number of books, both for clubs and commercial publishers. His account of working on a cover described the current methods of graphic design:

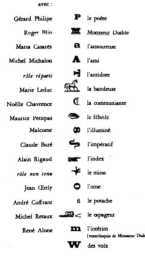

type on transparent film, changeable coloured background, photographic image on film or paper (iconography), all laid out within a window the size of the finished cover surrounded by a black or white mask. The mask is like a window which forms an isolating border between the developing design and its surroundings, transforming this window into a theatre stage.

Within the fixed frame, these actual size elements can be moved, altered, superimposed, manipulated as much as one likes. From the moment the stage is set, it remains to us, for each cover, to prepare, invent, manipulate the symbolic or descriptive elements which, when they are brought together, will transform a collection of elements into a sign of signs: a completed, successful cover.

France

149

One of Faucheux's early designs was for Raymond Queneau's *Exercices de Style*, an anecdote repeated in more than one hundred variations of narrative style, which was echoed in the typography. The book was reworked in a larger format in 1962 by Robert Massin, who had been one of Faucheux's book club assistants.

Exercices de style by
Raymond Queneau
Club des libraires
de France
book design 1956
[Pierre Faucheux]

Exercices de style
book design 1962
[Robert Massin]

The arrival of photo-typesetting in the 1960s and the increased use of photographic manipulation of text and images gave designers a new expressive freedom. Massin was one of the few to exploit its possibilities. For his book of Ionesco's play *La Cantatrice chauve (The Bald Prima Donna)*, he collaborated with the photographer Henry Cohen, presenting the characters as images in high contrast, clearly differentiated by their clothing. Each speaks dialogue in a distinct individual typeface, the women in italic; there is no punctuation, other than question marks and exclamation marks. Words and phrases change size, are set at angles and overlapped to suggest the tone of voice. For the action, Massin found a graphic equivalent: when the curtain opened to reveal an unlit stage, the pages of the book were black; elsewhere, unprinted white paper served to represent silence. Massin nevertheless sought to maintain the sequence of dialogue reading left to right, helped by using the speech bubbles of strip cartoons and by isolating individuals in close-up, a sophisticated adaptation of the techniques used in the popular photo-romances.

photo-romance 1960s

La Cantatrice chauve
by Eugène Ionesco
book design 1964
[Robert Massin]

Following the success of the book clubs, the Club Français du Disque was launched in the early 1950s. Its record sleeves were brilliant in visual effect and practical in use. Printed in black and one or two flat colours, they had a standardized format which was a prototype for designing related items, like a series of paperback books. For easy reference and

storage, a coloured square in the top left-hand corner carried the initial letter of the composer's name and the number of the record in the club list. To the right, a strip bore the name of the composer and the title of the work. Below this, the club designers' demand for the iconographic document was met by a contemporary picture of the composer or, in the case of jazz or folk music, the performer. The remaining three-quarters of the sleeve was free for images which, unlike many American covers, were never drawn illustrations but abstract photographs, printed in black, without tones, over a second image printed in colour.

record sleeves c.1958
[Jacques Darche / Pierre Comte]

The most convincing of these sleeve designs were the work of Jacques Darche. He designed for the book clubs and, like Faucheux, insisted on documentary illustrations, even accompanying the poems of the fifteenth-century François Villon with photographs from picture agencies.

A photograph was now recognized as having a symbolic quality, not merely the record of a moment in time. In the weekly news magazines like *Paris Match*, and the American *Life* and *Look*, an event could be reconstructed in a sequence of selected photographs by a picture editor. The layout became crucial. Following the example of American magazines like *Redbook*, *McCall's* and *Seventeen*, the women's weekly was transformed by a young Swiss designer, Peter Knapp. Knapp had worked at the printer Tolmer and, in 1959, became art director of the publicity studio at the department store Galeries Lafayette when he was only 25. His considerable staff at *Elle* consisted of 14 designers working on layout, 2 retouchers, 1 lettering artist, 5 darkroom assistants to make photographic prints and enlarge title lettering, 5 typesetters, 5 illustrators and 6 in-house fashion photographers, each with an assistant. The designers (*équipe visuelle*) were split into two teams, which did alternate issues of the magazine and competed with each other.

Elle
magazine double pages
below 1960
[photographer E.Bronson]
right 1964
[Peter Knapp]

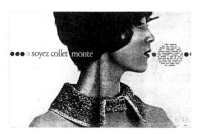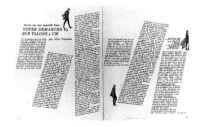

soyez collet monté

France

151

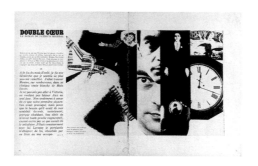

Elle
photomontage illustration
double page 1964
[illustrator Roman Cieslewicz]
[art director Peter Knapp]

Knapp was himself a photographer, and posed his models with an understanding of their two-dimensional effect on the page. Photographs were taken against black or white backgrounds to emphasize the outline of forms (and make retouching easier), patterns were arranged to contrast with or complement each other, and flat areas of colour, sky or wall were included to provide a simple background for the text of captions. Text was typeset by the old 'hot-metal' composing machines, whose conventions Knapp tried to loosen by setting the type ragged, often ranged right, which was then uncommon in France.

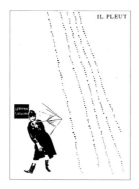

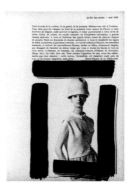

Galeries Lafayette
advertisement 1960
with *Calligrammes* by Apollinaire
(see p.37)
[Jean Widmer]

Jardin des modes
magazine page 1963
[Jean Widmer]

Swiss designers like Knapp had received a disciplined training and were used to technical standards unknown in France. *Elle*'s headlines were prepared by a fellow Swiss, Albert Hollenstein, who had set up a photo-lettering and typesetting business. Also Swiss was Knapp's successor at Galeries Lafayette, Jean Widmer, who went on to art-edit another women's magazine, *Jardin des Modes*. His career developed as one of the most important and influential in graphic design in France (see pp.197–99). It was the young Swiss in Loupot's studio who carried out the vast abstract St Raphaël advertising panels, and the United States Information Service employed the most astringently Swiss-style Gérard Ifert to design its posters.

'American Books'
United States Information Service
exhibition poster 1960
[Gérard Ifert]

The most significant Swiss contribution in France was Frutiger's typeface Univers, designed specifically for filmsetting and available in a co-ordinated system of widths and weights. Like Gill Sans earlier,

ABCDEFG
abcdefghi
ABCDEF
abcdefgh
ABCDEF
abcdefgh

1		AF 1015 B707 F/Y	AF 707 B707 F/Y
Lyon	dp		1055
Paris	ar		1150
Orly	dp	1000	1300
Boston	ar		
	dp		
New York	ar	1200	1500
Kennedy Inter. Airp.	dp	1315	1630
Washington			
Dulles	ar	1430	

Univers did much to help rationalize the typography of technical literature and timetabling. For Air France, Frutiger designed not only printed information but also the signs and lettering at Charles de Gaulle airport. This became another typeface called Frutiger, almost an intermediate design between Univers and Gill. Air France's logotype, designed by Roger Excoffon, became Nord (1959), yet another sans-serif series in many weights.

House style and corporate identity in France did not at this time attract as much energy as in America, but Loewy's Paris office had been active since 1953. In 1963 the pharmaceutical firm Roussel-Uclaf adopted a Loewy symbol not unlike that of the Chase Manhattan Bank designed by Chermayeff & Geismar. It was composed of three identical parallelograms, arranged symmetrically within an equilateral triangle, leaving a similar equilateral triangle at the centre of the design. Many geometrical images of this kind could be found in a ready-reference book, *Hornung's Handbook of Designs and Devices*. Rationalizing the choice of such symbols became a corporate identity practice. Roussel-Uclaf's is typical: 'Incisive, balanced, open, its personality does not represent any particular specialization and allows the group's identity to extend beyond the confines of the pharmaceutical industry.'

The Loewy office was also responsible for transforming the image of New Man, a clothing company. The first New Man lettering had suggested the Wild West. Too closely identified with cowboy boots, it was replaced in 1969 by an electronic New Man logo, identical upside down.

France

153

The new New Man demonstrably belonged to the age of the graphic designer rather than the commercial artist. The symbols of an earlier period, like the Michelin man and the St Raphaël waiters, which survived decades with modifications, part of an unbroken tradition in France, were seen as belonging to culture rather than commerce.

New Man
logotype 1967
re-design 1969
[Raymond Loewy / CEI]

Citroen DS19
brochure 1964
[photographer William Klein]
[Atelier Delpire]

Poster designers like Cassandre were household names whose association with a product or enterprise carried prestige. In this way Cassandre was commissioned in 1963 – one of his last jobs – to design the lettering and logotype for the couturier Yves Saint Laurent. In this same spirit of patronage the artist Victor Vasarely was asked to revise the symbol for the Renault car company a few years later. While Jacno described the young public as 'so gullible that it enjoys what the product promises rather than the product itself', it was this same young public that gave new life to the French tradition in the posters of the Atelier Populaire in 1968 (see p. 184), which decorated the walls of Paris just at the time Cassandre died.

Renault
symbol 1972
[Victor Vasarely]

Yves Saint Laurent
logotype 1963
[A.M.Cassandre]

Northern Europe

Britain

The war had crippled the economies of the countries of northern Europe. Raw materials were in short supply and in order to suppress consumer demand, printing and advertising were restricted. In Britain a revised issue of the pre-war manual *Making a Poster* expressed the hope that now, in 1945, 'the Poster will be used increasingly not only in the interests of Commerce, its customary mainstay, but also as a means of educational propaganda by the State – in the fashioning of that new world which is our aspiration.' This reflected immediate postwar realities, where the Government and public services were much the largest advertisers. Posters signed by the designers who had made their names before and during the war, such as Tom Eckersley, Abram Games, F.H.K. Henrion, G.R. Morris, Reginald Mount and Hans Schleger, appeared not only on the London Underground and on the stations of the newly nationalized railways, but also on the wooden hoardings around the cities' bomb sites. They continued the war-time use of simple images and direct verbal appeals for safety at work or to 'Keep Britain Tidy'.

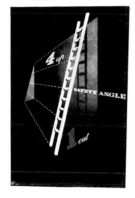

'Safety angle - 4 up - 1 out'
poster 1947
[Abram Games]

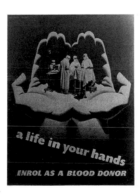

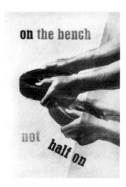

'a life in your hands'
blood donor poster 1948
[Reginald Mount]

'on the bench - not half on'
safety poster 1951
[Robin Day]

Design in Britain became part of a programme of economic and social reconstruction. The Council of Industrial Design, established in 1944, made its intentions clear in a 1946 exhibition confidently entitled 'Britain Can Make It'. To demonstrate the range of possibilities in the design of a single object, one of the displays presented more than fifty differently shaped and produced egg cups. This section was designed by Design Research Unit (DRU), a group practice that was born at the height of the war when the sole member of staff for its first year was the poet and art critic Herbert Read. Read was one of the few articulate supporters of

modern, particularly abstract, art; his book on design, *Art and Industry*, with a layout by Herbert Bayer, had appeared in 1934. Now he enrolled a group of designers and architects that included Milner Gray and Misha Black (the author of the egg-cup display). DRU's work included industrial design. In graphics, much of their work was three-dimensional: in exhibition design, where it was modern, and in packaging, particularly for the drinks industry, where it allowed Gray to indulge in a genteel Victorianism intended to evoke traditional values of quality.

This revival of nineteenth-century typefaces and typographical ornaments and engravings, and interest in 'popular art', signwriters' letterforms, old shop signs and the painting of canal barges, betrayed the British distrust of modernism, which was still seen as 'foreign'. An underlying concern with a national design heritage surfaced in the pages of the *Architectural Review* – balanced since the 1930s between traditionalism and the Modern Movement – and in the work of the painter, illustrator and photographer John Piper. The nostalgic tendency was vividly apparent at the Festival of Britain exhibition of 1951, where it presented a dramatic contrast to the buildings' blatant modernism and the display of advanced engineering skills.

In graphic design, contrasting attitudes to modernism were represented by the magazines *Alphabet and Image*, which took a generally traditional standpoint, and the progressive *Typographica*, launched by the designer Herbert Spencer in 1949. This quarterly journal included the work of contemporary designers, particularly from abroad – such as Grignani and Huber – and ran a series of introductions to modernist pioneers like Lissitzky and Zwart. Spencer himself was one of a number of British designers who had adopted asymmetry almost as a principle. He worked at the Central School of Arts and Crafts in London, where the teachers were practising designers, including in the early 1950s the printer and typographer Anthony Froshaug. For several years Froshaug had his own printing workshop, setting the type himself. He introduced a playful wit into a range of jobbing work in a rational, modern manner which integrated the lessons of the New Typography into a romantic Arts and Crafts programme.

The Unquiet Grave
book jacket 1956
[John Piper]

far left
St George's Gallery Books
change of address postcard (A6) 1954
[Anthony Froshaug]

'Man, Machine and Motion'
(typeset by typewriter / offset printed)
exhibition catalogue 1955
[Anthony Froshaug]

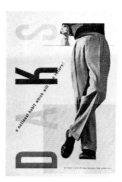

Modernism in British commercial advertising was dominated by Ashley Havinden, at Crawfords. Ashley held the view, which became accepted only many years later, that designers 'regard themselves as solvers of problems of communication in whatever medium is required.' They felt free, he said,

> to draw on classical antiquity; Bauhaus functionalism; eighteenth-century symmetry; Renaissance realism; Cubist experimentalism; early Victorian quaintness; Surrealist dream images; candid camera snapshots; engineering blueprints; the space divisions of abstract art and modern architecture; the typography of the fifteenth century; X-ray photography; wood engravings; statistical diagrams; the new typography of Tschichold; fantastic decorated display letters, etc., etc.'

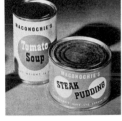

Maconochie's
tinned food labels c.1947
[P. Booker-Cook]

Such a list covers the entire vocabulary of international graphic design, and was remarkable in identifying and recording the essential eclecticism of the designer.

Ashley's own tendency was towards functional modernism, like the soup labelling produced in 1946 for Maconochie's which gave straightforward information. Similar commercial innocence, unhampered by market research, was demonstrated by the pack for Guards cigarettes designed at DRU in 1958. Its clean white rectangularity, its restrained red, black and gold and the embossed figure belong more to the art school design studio than to the tobacconist's shelves.

Some of the most original advertising in London was designed for the

Guards
cigarette pack 1958
[Design Research Unit / Alan Ball]

'D.H.Evans - Fashion Wise'
poster 1948
[Arpad Elfer]

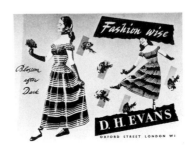

D.H. Evans store by Arpad Elfer. His simple slogan 'Fashion wise', and its Bodoni logotype, exuberant combination of drawings and brush lettering placed at an angle, with cut-out photographs, printed in red, black and green, together made an immediately recognizable style.

Brush lettering – like Ashley's typeface Ashley Script – was an important feature of one long-lasting house style from the 1950s, for the Macfisheries' chain of fishmongers. Designed by Hans Schleger, its symbol, incorporating four fish into the Scottish St Andrew's cross, began life as a geometrical drawing; Schleger let it evolve with a calligraphy which reflected the fishmonger's hand-painted notices of the day's fish on sale.

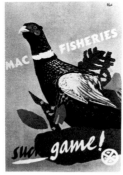

'Such Game'
MacFisheries poster 1955
[Hans Schleger]

MacFisheries
symbol and logotype c.1953
[Hans Schleger]

He played in a similar way with the symbol for Finmar, importers of Scandinavian furniture. Designed like a typeface in a light, medium and bold version, its identification with a fir tree was wittily exploited. Schleger's work was often unorthodox. He embedded a Waterman fountain pen in a solid block of transparent plastic for a counter display; produced a triangular bottle for Grant's whisky; and gave the art-paper pages of *The Practice of Design* (1946) a plastic comb binding within a cloth cover. To reflect the book's contents, which had 'something of the documentary film and of the contemporary exhibition', Schleger used old engravings printed on pastel blue or buff for chapter openings, and an asymmetrical layout worthy of Tschichold.

Finmar
Scandinavian furniture importers
symbol

The magazine *Design*, published by the Council of Industrial Design, began in January 1949 with a bloodless centred layout, and took many years to become more than a bland parade of manufactured goods, and to include critical articles and a more sophisticated layout and typography under its art director from 1956 to 1962, Ken Garland. It reproduced graphic work, and the Council promoted such exhibitions as that arranged in 1952 to coincide with the publication of an important manual by Spencer, *Design in Business Printing*. In his 'Typography in Britain Today' exhibition (1963) he recognized that 'In a prosperous society, energetic and ambitious young executives and editors have emerged, determined to establish their reputations by the impact they can make rather than, as so often in the past, by the economies they can introduce.' During the 1950s art-school trained designers had been helped to acquire

'Ernestine Anderson Sings'
record sleeve 1957
[Ian Bradbery]

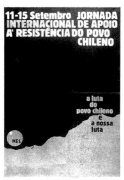

'International Day of Support for the Chilean People's Resistance' newspaper supplement poster 1974 [Robin Fior]

Pirelli de-icing pack 1962 [Derek Birdsall]

Designers and Art Directors Association logotype 1963 [Alan Fletcher]

a professional identity through membership of the Society of Industrial Artists. This gave them a code of practice similar to that of architects, and guidance on fees.

Of the freelance designers in Spencer's exhibition, Ian Bradbery was typical of the 1950s, Robin Fior of the 1960s. Both taught part-time. Each was able to use his work to serve private interests. Bradbery's friendship with musicians led to his designing record sleeves and the magazine *Jazz Music*. At the same time he was working on exhibition stands for large clients like the drug company and pharmacy chain Boots and the Central Office of Information.

The self-taught Fior designed pamphlet covers and posters. In 1960 he redesigned the weekly *Peace News*, setting the larger type in bold Akzidenz sans serif as well as in the American typeface Record Gothic. *Peace News* followed the lead of Huber's *Politecnico* and anticipated the redesign of the London *Guardian* newspaper in the 1980s by one of Fior's students, David Hillman. At the same time Fior designed advertisements for manufacturers of papermaking chemicals and finance firms. Less typically, both designers were later to leave Britain to work abroad, Bradbery in Australia, and Fior in Portugal, where he produced some remarkable political posters and a newspaper.

There were fewer designers working alone. As graphic design became more established, it was common practice to share office space, an assistant and a secretary. BDMW Associates (formed in 1960) comprising Derek Birdsall, George Daulby, George Mayhew and Peter Wildbur, was an early partnership of this kind. Each of the partners retained a distinct identity and separate clients, unlike DRU or Brownjohn, Chermayeff & Geismar in New York.

Designers promoted themselves in the exhibition 'Graphic Design London' (1960), and the Designers and Art Directors Association, London, was founded in 1963. Its early annual exhibitions showed the influence of ideas from Switzerland and, more obviously, from America. Some of the exhibitors were visitors from New York working in London. Most significant was Paul Peter Piech, who had worked with Bayer at the Dorland agency in New York and came to Crawfords to work under

'StrEtch – Intol Synthetic Rubber' advertisement 1956 [Paul Peter Piech]

'Compression' Avery testing machines advertisement 1955 [Paul Peter Piech]

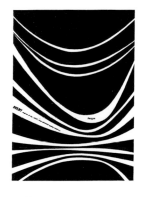

Ashley in the mid-1940s. He produced some of the few advertisements which integrated word and image. For Intol synthetic rubber he condensed a capital 'E' in 'squeeze' and extended it in the word 'stretch', at the same time illustrating the idea in carefully lit photographs. For Avery, 'makers of the world's most advanced testing machines', he used the simplest drawing techniques of line and silhouette as dramatic illustrations of the different kinds of test.

New York designers, such as Robert Brownjohn, best known for his titles for the James Bond movie *Goldfinger* (1964), and Bob Gill, came to work in England, and American agencies opened London offices: Doyle, Dane, Bernbach, with their advertising 'concepts', and Papert, Koenig and Lois, with their art director Tony Palladino. Palladino was responsible for the graphically most original campaign, for Perfectos Finos cigarettes. The text referred directly to advertising techniques and used coupons and mock questionnaires, whilst making it plain that each advertisement was one of a series. 'Our last advertisement asked you if we should show our Perfectos packet. 25% of our readers said "Yes". So here's 25% of it.' Words and images were made into compact units on the page. Instead of showing the packet as the product, it showed an individual cigarette, with a match and the slogan as part of the copy: 'One match, one Perfectos, tells all.'

Bob Gill, an established freelance designer and illustrator in the United States, formed a partnership in 1962 with the English designers Alan Fletcher and Colin Forbes. Both had been assistants to Spencer, and Fletcher, after a postgraduate year at Yale, had worked for the Container Corporation and *Fortune*. Of the examples of design that Fletcher, Forbes and Gill included in their compendium *Graphic Design: visual comparisons* (1963), more than half were from America and, apart from their own work, only six from Britain, and two of these were cartoons. This was a fair reflection of 'the climate of the sixties' which they aimed to illustrate. 'Our thesis is that any one visual problem has an infinite number of solutions; that many of them are valid; that solutions ought to derive from subject matter; that the designer should have no preconceived graphic style.' Fletcher/Forbes/Gill were the first significant

Advertisement 1962
[Tony Palladino / Papert, Koenig, Lois]

Doyle, Dane, Bernbach; (you rascals!) Welcome to London.

Perfectos
cigarette advertisements 1967
[Tony Palladino / Papert, Koenig and Lois]

Troubadour
record sleeve 1967
[Bob Gill]

Pirelli
Cintura tyres bus poster 1963
[Fletcher/Forbes/Gill]

Pirelli
bus poster for slippers 1963
[Fletcher/Forbes/Gill]

REUTERS

Reuters
news agency logotype 1961
[Fletcher / Forbes / Gill]

design group of this period, producing exemplary house styles for large companies like BP, Rank Xerox and Reuters. They designed advertising for El Al, the Israeli airlines and for Pirelli, which included a remarkable poster for the side of a bus whose top-deck passengers were made to appear as if wearing Pirelli slippers. At this time it was almost unthinkable for designers to recommend anything other than upper and lower case sans-serif letterforms, particularly for signs. Fletcher/ Forbes/Gill were innovators in re-designing several typefaces for lettering (set out later, in 1970, in their book *A Sign Systems Manual*, 1970). For BP, it was based on Futura; for Rank Xerox, a condensed grotesque; for airport signs a Helvetica-like typeface that resulted from re-drawing Akzidenz Grotesk. This typeface was also the basis for the lettering of the highly successful British motorway signs designed by Jock Kinneir, and known as Transport.

The relative readability of signs, either all in capitals or in upper and lower case, was much disputed. But the importance of these signs was less their lettering than Kinneir's modular system which controlled the spacing of the words. This derived from the width of the directional route lines, making the content of each sign dictate its size, rather than having a standard size of sign into which longer words or more complex signs were condensed.

WOLVERHAMPTON
KEIGHLEY
Wolverhampton
Keighley

Alternative suggestion for
road sign lettering 1961
[David Kindersley]

ABCDEFGHIJKLMN
OPQRSTUVWXYZ
abcdefghijklmn
opqrstuvwxyz
1234567890⁴¹²³⁴

British traffic sign
and tile spacing system 1964
[Jock Kinneir]

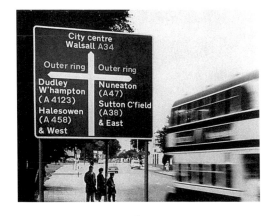

Joint decisions on corporate identity schemes could have lasting results. From 1952 the Design Research Unit was given the job of providing a new house style for British Railways – which included the design of staff uniforms, colour schemes for the trains and new lettering. The shortening of 'Railways' to 'Rail' in its name occurred by chance. Milner Gray had asked his design team to draw out some letterforms: 'I told them it was unnecessary to spell the name out in full. When I saw the shortened name, I thought what a much better title it made and what an advantage this would be in the saving of space in many settings.' The new symbol was as convincing as that of London Transport's in the graphic economy with which it suggested rail travel. The lettering, adapted from Helvetica by Margaret Calvert, matched the symbol in character and weight. A widespread application of new design attitudes was demonstrated in paperback books, especially their covers. Tschichold had come to work in England in 1947 for the publishers Penguin. Between 1947 and 1949 he had established standards for the typography of the text pages and refined the symbol and the standardized covers. Since the 1930s these had used Gill Bold type and vertical bands of colour which identified books by category: orange for fiction, light blue for non-fiction, green for crime, yellow for miscellaneous, magenta for travel and grey for current affairs. In an attempt to compete with other paperback publishers, Penguin introduced full colour on covers and appointed Abram Games as art director in 1956. He put the Penguin symbol on a coloured rectangle with the author and title, in Gill Bold and Extra Heavy, in black on a horizontal white band at the top, with the rest of the space left for illustration. Full colour was abandoned two years later and, after the appointment of a new art director, Germano Facetti, in 1960, a grid was introduced to control the designs; the coding colours were then used as a second colour to a black printing, and a Continental sans-serif face adopted. This gave a new house style, and two series with exemplary covers were added. The first, Penguin Education, art directed by Derek Birdsall, used a white background and a condensed Victorian sans serif, which gave individuality to the title on the spine of each book. The front covers carried sharp, witty graphics by himself and a small group of designers, notably Philip Thompson. The covers to the

British Rail
symbol 1952
design manual page 1965
[lettering Margaret Calvert]
[Design Research Unit]

Penguin symbol and re-design 1947
[Jan Tschichold]

Penguin Books
crime and non-fiction series
cover grid 1962
[Romek Marber]

The Naked Society
Pelican non-fiction series
book cover 1963
[Derek Birdsall]

The City
Penguin Education series
book cover 1972
[Philip Thompson]

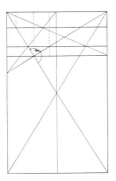

Marcus Aurelius *Meditations*
Penguin Classics series
book cover 1967
[Germano Facetti]

Hadfields
paint manufacturer's symbol
and logotype 1967
[Wolff Olins]

Ocean Oil Company
symbol 1966
[Minale, Tattersfield]

Queen
magazine double page 1963
[Tom Wolsey]

second series, Penguin Classics, designed by Facetti, used a black background with the new Helvetica typeface in white capitals, centred. Documentary images, usually paintings or sculpture, imaginatively suggested the period and spirit of the books.

Publishers were among the main clients of the young independent designers but, as in the United States, only design groups could provide all the services demanded by industry and business in a newly prospering economy. Of those London groups founded in the 1960s, Minale Tattersfield in 1964 and Wolff Olins in 1965 were typical of those who acquired and shed partners and clients but retained an independent character. Wolff Olins was important in re-introducing pictorial symbols as trademarks, ignoring the pervasive logotype (a fox for a paint manufacturer in 1967, and a humming bird for a construction firm in 1971).

Magazine publishing varied widely in design, from *Picture Post* with its layout little changed from pre-war days, to the adventurous *Contact*. The former, which survived until 1957, set high standards of black-and-white topical photographs but isolated each element of design – headline, photograph, caption and text – and rarely organized the double-page spread into an effective whole by cropping and contrasts of scale. *Contact*, an expensive cultural and literary magazine, laid out by Henrion and subsequently John Denison-Hunt, did just that, using cut-out photographs and dramatic cropping. Printed partly on tinted paper, it was influenced by the still enterprising *Architectural Review* as well as American magazines like *Esquire*. One of the first to use colour profusely was the specialist fashion and textile trade magazine *Ambassador*, which also commissioned artists for covers.

The 1960s saw the launch and re-launch of several magazines and with them the careers of many 'editorial designers' and art directors who moved from one magazine to another. Headlines, text, pictures and captions combined in double-page spreads to give each magazine its individual character. Photographs were used less for their value as documentary records than for their graphic quality – their appeal as simple images which could be 'cropped' and positioned to suit the art director's aesthetic preference. The extreme contrast and heavy grain of photojournalists' work produced under difficult lighting conditions, for

example, was appropriated for fashion photography. The monthlies *Queen* and *Town* displayed a designer's fastidiousness, particularly under the art direction of Tom Wolsey, in the directing of photographs and their organization on the page, attention to typographic detail in the text, and inventiveness in the headings.

Increased prosperity, the arrival of television as an advertising medium and the development of 'web offset' printing (onto reels of paper) stimulated a demand for more colour in printed advertising. In 1962 the *Sunday Times* colour section was launched, the first of the colour supplements to the more expensive London Sunday newspapers. The designers of these new magazines made a wide public familiar with documentary photojournalism. Initially, the layouts were good imitations of American magazines and the fashion pages derived from *Elle*. Studio photography and illustration, commissioned by the art director, came to dominate the text. Maps, charts and all kinds of diagrams, already familiar to readers of popular newspapers, particularly the *Daily Express*, were now incorporated and made more effective with colour.

Elaborately documented publications, such as the *History of the 20th Century*, appeared in weekly parts, dense with carefully researched pictures and impeccable technical illustrations. They often gave permanent reference to related television programmes before the arrival of the video recorder.

Daily Express
column heading 1961
[Raymond Hawkey]

Sunday Times
'A Dictionary of the (1917) Revolution'
magazine double pages 1967
[art director Michael Rand]
[designer David King]

Because the Sunday supplement was free to readers of the newspaper it could promise advertisers a guaranteed circulation with its printing technique giving excellent colour reproduction. The number of pages of colour in any issue depended on the number of pages of advertising sold. The way a picture story flowed over a sequence of pages depended on the requirements of the advertisements. Over the next few years, under its art director Michael Rand, the *Sunday Times Magazine* grouped as many pages as possible without advertising, sometimes as many as sixteen, by placing text only on the same pages as advertisements, and by printing some black-and-white photographs in full colour – as a richer black or in sepia or bluish 'gunmetal'. By the mid-1960s the *Sunday Times Magazine* was developing a way of telling 'investigative' picture stories, such as 'Who killed Kennedy?', by techniques that stressed their documentary aspect: leaving the original telexed caption

attached to the photograph, and deliberately unretouched pictures, particularly snapshots or photographs sent by cable.

By the mid-1960s it was often difficult to tell the editorial pages of a magazine from the advertisements: ordinary photographs could look like film stills. Conversely, the art director of the contemporary German magazine *Twen* sent photographers abroad after showing them pre-prepared layouts of their reportage. *Twen*'s design was an important influence, particularly on the women's monthly *Nova*, launched in 1965. It had a standardized, very heavy Victorian typeface used in stacked capitals for headlines, which competed with Lois's *Esquire* covers.

Images in magazines, which had been the raw material of Dadaist collage and 'mass communications' in general, were attracting the attention of artists during this period. This interest was vividly expressed in the exhibition 'This is Tomorrow' at the Whitechapel Art Gallery in London in 1956. The catalogue was designed by Edward Wright, who had been adept in the advertising manner of Elfer at Crawfords. The catalogue cover carried very condensed poster type printed by silkscreen, and its spiral-bound pages were among the first to use cheap offset lithography and type reproduced from typewriting. It looked forward to the do-it-yourself improvisations of the 'alternative' magazines of the 1960s and represented the beginnings of Pop Art in the collages by Richard Hamilton of images from American picture magazines. As a designer, Hamilton had produced a strong and effective symbol for one of the new television companies, Granada, in 1956 – a significant contrast to that devised by Games for the BBC.

CBS in America had shown the importance of the identifying symbol of a television channel. Title sequences, credits and trailers promoting programmes took a significant proportion of screen time, and the use of graphics in weather forecasts, educational broadcasts, in the presentation and comparison of statistics, particularly at election times, led to the development of graphic design departments in the television companies. Beginning in the 1950s with the simplest illustration and lettering placed in front of the camera, these departments' techniques evolved in the mid-1960s into elaborate animated sequences of extreme originality, exemplified in the titles for the BBC's 'Doctor Who' series designed in 1963. In the period before colour transmissions, the small size of television screens required concentrated, economical images, and the speed of production and the relatively simple equipment encouraged the creative improvisation of moving images. Their effect was heightened by and often depended on the extra dimension of sound.

Television and what was soon to be described as the 'communications industries' (public relations, marketing and advertising) had taken the designer out of the studio into the offices where, as a member of a group, 'design solutions' would be developed in discussion. The search for an accepted professional identity had been a continuing debate among graphic designers. In 1963 a group in London signed a manifesto deploring the adulation of those who have 'flogged their skill and imagination to advertise consumer products. We think there are other things worth using our skill and experience on.' It was an appeal to work more in the areas which showed a bias towards the left of Schwitters chart on p. 56 – towards 'information'.

Doctor Who
television title sequences 1967
[BBC / Bernard Lodge]

'First Things First'
manifesto 1964
[Ken Garland]

The Society of Industrial Artists had existed in Britain since 1933 to nurture the interests of the design profession in general. Its largest grouping was the commercial artists. To link such organizations in different countries, Britain had taken an important initiative in 1963 in London with the foundation of ICOGRADA, the International Council of Graphic Design Associations. During the next three decades, with conferences, meetings, student competitions and seminars, ICOGRADA helped designers to a greater awareness of their role in a wider community by promoting an interest in such topics as the standardization of sign systems.

Campaign for
Nuclear Disarmament
Easter March
poster 1965
[Ken Garland]

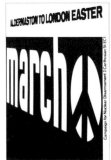

Germany

In Germany, with the country devastated by war and divided into East and West, it took a decade before graphic design began to be effectively revived. There was still a graphic design department at the Schule für Freie and Angewandte Kunst (School of Free and Applied Arts) in West Berlin, established in 1919 by the packaging pioneer Otto Hadank. He taught there himself until 1949, having been co-founder of the Bund Deutscher Gebrauchsgraphiker (BDG) through which Germany became a member of ICOGRADA. Other important designers who survived the war and were now teaching in various parts of Germany were F.H. Ehmcke (in Munich), Hans Leistikow (in Kassel) and Max Burchartz (in Essen). The most energetic survivor was Anton Stankowski, who remained an influential designer well into the 1980s. A student of Burchartz in the late 1920s, he had been a leading advocate of 'objective advertising' in the 1930s. He started work after the war as picture editor of the weekly *Stuttgarter Illustrierte* in 1949 and was soon promoted to chief editor.

below, right
Stuttgarter Illustrierte
posters for magazine1951
[Anton Stankowski]

Lorenz
advertisement c.1952
[Anton Stankowski]

Lorenz
symbol for calendars and
advertisements 1955
[Anton Stankowski]

Lorenz / SEL
electronics advertisement
symbol and logotype 1954
[Anton Stankowski]

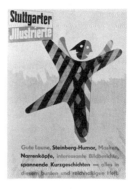

Stankowski produced small posters which were delivered to the bookstalls with each issue. Designed overnight and printed the following day in two colours by lithography, they summarized the main contents in a simple drawn image, with a few lines of text and the magazine's masthead. He also designed dozens of symbols and logotypes for companies and organizations, finding geometrical constructions for emblems that would evoke specific character.

His methodical approach (set out in several books) argued for active participation in research. In this way graphic designers could keep pace with the constant supply of new scientific ideas and technological inventions and find ways of expressing them. In the 1950s Stankowski demonstrated this approach in a series of advertisements for the electronics firm of Lorenz in Stuttgart. Their abstract mechanical drawing derives direct from the visual research undertaken by Stankowski at his painter's easel.

This application of abstract geometrical drawing was followed by a number of designers in publicity for industry, notably Harald Gutschow

for Mannesmann Steel and Herbert Kapitzki for Porsche. Kapitzki, a postwar student of another of the typographer-painter pioneers, Willi Baumeister, was one of the new generation invited to lecture at the design school at Ulm. This was the Hochschule für Gestaltung, with buildings designed by Max Bill, its first rector, which opened in 1951. It was important less for the design work it produced than for its thinking, which was reflected in design schools across the world. The school was concerned with evolving methods using mathematical logic for solving design problems. Ulm's significant contribution was in its attempt to find a critical system and language to examine visual communication. They borrowed from linguistics, advancing the idea of 'visual rhetoric', and employed semiotics (the science of signs) in the analysis of advertisements.

The full-time staff included Vordemberge-Gildewart and, in the first few years, Anthony Froshaug from England, whose typographic invention was submerged in a rigid ranged-left orthodoxy. In 1962, the head of the Visual Communication Department, Otl Aicher, exemplified the systematic approach in his corporate design for Lufthansa. The result was a neat 'Swiss' or International style of layout using Helvetica. But Aicher was unusual in insisting that the company's advertising was an extension of its corporate image, including even the style of photograph – squared-up images with no narrative or expressive content. It remained unchanged over several decades. 'Conviction in an image is revealed in the detail', said Aicher's report, an attitude which found further expression in his systems for the Munich Olympic Games in 1972 (see p.201). Even the pictographic athletes used as symbols for each sport were fitted into a comprehensive octagonal grid. This systematic attitude was a lasting international influence.

'The Scientific View of Mysticism' lecture poster c.1956
[Otl Aicher]

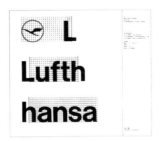

Lufthansa airline symbol, logotype, from style manual 1963
[Otl Aicher / Entwicklung 5 / HfG Ulm]

West Germany's most important stylistic contribution abroad at this time was the monthly magazine *Twen*, first published in 1959. A German equivalent of the American *Esquire*, having roughly the same format, *Twen* appealed to the affluent young of the German economic revival, mixing images of flesh, pop musicians, film stars and gurus with topical social or cultural reports. Its designer, Willy Fleckhaus, used a grid of extremely narrow columns to give great flexibility, from lines of type extending across the whole page to columns only one-twelfth of the width. The small engraving of a trumpet punctuated the pages of rich gravure printing. Fleckhaus's layout device was contrasting opposites:

symmetry with asymmetry; huge black condensed sans-serif titles above text in Times; photographs against white backgrounds alternated with those against black; double-page spreads of heavily cropped colour close-ups, which loomed like frozen film screens over long shots the size of a 35mm contact print. Such manipulations of text and image in an aura of modish hedonism marked the moment at which the needs of consumerism and the aims of the designer coincided without conflict.

As well as photographers, Fleckhaus employed young German illustrators. Of these, Hans Hillmann had used dramatic drawings that converted film stills into powerful images for film publicity. Similar work was done by one of the early German design partnerships, that of Gunther Michel and Hans Kieser. Apart from posters for films and jazz festivals, they introduced unusually informal silhouetted drawings collaged with old engravings to a series of advertisements for post office services. Michael Engelmann used the language of nursery rhymes. Similar, even more dramatically simplified silhouette images were used for Uhu glue.

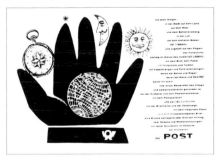

Engelmann, who had returned from the United States in 1949 and worked in Amsterdam and Milan, developed the *Twen* manner of cropped photograph, combined with Swiss-style sans-serif type, in posters and advertisements for Bols liqueurs and Roth-Händle cigarettes. They were formal to an extreme; they suppressed perspective and excluded anything that did not concentrate the idea.

The Bols advertisements showed part of a face in profile, cut off at the

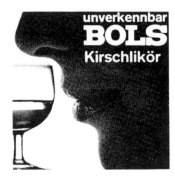

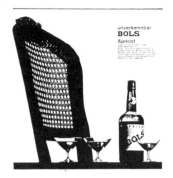

Bols
liqueur advertisements 1962
[Michael Engelmann]

Rothhändle
cigarette poster 1962
[Michael Engelmann]

middle of the nose and point of the chin. The nose is placed just above the rim of the glass, to inhale the aroma of the drink which is level with the lips. The absence of the eyes sharpens the focus on smell and taste, which were the means of establishing that the product is, in the single word of the headline: *unverkennbar* (unmistakeable).

Randolectil
Bayer pharmaceutical advertisement
1964
[Graphicteam]

'300 capsules of Natabec'
Parke Davis advertisement 1967
[Pierre Mendell and Klaus Oberer]

Later Bols advertisements linked text and product simply by aligning the left-hand edge of the type with the left-hand edge of the bottle. The images were carefully art-directed photographs of a bottle and glasses with silhouettes of different types of chair – an antique dining chair, an office armchair, a folding garden chair – to evoke situations in which Bols might be enjoyed. These were the work of Pierre Mendell and Klaus Oberer, partners in a new design practice, whose work had overlapped with Engelmann's in advertising for Renault cars. Their 1964 packages for Chat dans la Gorge cough remedy and advertising for Parke Davis pharmaceuticals in 1967 were seen as new classics of the International Style.

Chat dans la gorge
cough remedy package 1964
[Pierre Mendell and Klaus Oberer]

As in other countries, the chemical industry was a prime user of graphic design. In Germany it nurtured another design group formed in the 1960s, Graphicteam, made up of five designers formerly employed by the firm Bayer. They were responsible for theWestdeutsches Fernsehen (West German Television) screen identity, whose geometry has the Stuttgart tendency to linear abstraction in the manner of Stankowski.

Television titling and book covers and jackets were particularly suited

West German Television
symbol and logotype 1965
[Graphicteam]

to the illustrational image-making identified with the Kassel school led by Hillmann. The quality of book design in Germany was based on the standards of typesetting established by Renner and Tschichold in printing trade schools before the war, so that words and lines of type were properly spaced, an aspect of design given scant attention in other countries (particularly in France). Germany also had the benefit of energetic typefoundries like Bauer, Berthold, and Stempel and type designers like Georg Trump and Hermann Zapf, whose popular typeface, Optima, appeared in 1958 (although it was greeted with scornful hilarity by designers, who referred to it as 'Pessima'). Zapf himself set the standard for book typography in his own work and in his *Manuale Typographicum* (1968).

Eastern Germany, although it had the presence of John Heartfield in Berlin until his death in 1968, was dependent on the traditional skills of its printing industry in Leipzig. In Czechoslovakia and Hungary, where there had been important avant-gardes between the wars, the poster tradition begun at the turn of the century had survived and, since there was no commercial competition, it was cultural events, especially films, which inspired posters with drawn images.

Suhrkamp Verlag
paperback series design 1964
[Willy Fleckhaus]

Communicatons Research
Fischer Books 'World in Evolution' series
cover 1962
[Wolf D. Zimmermann]

The Chinese Revolution
DuMont Dokumente paperback series
cover 1962
[Ernst Brücher]

The Shepherd's Daphnis
Deutscher Taschenbuch series
cover 1961
[Celestino Piatti]

In the design of paperback books, Germany was also a leader. The standardization of books in series began in the mid-1950s with Fischer Bücherei's *Bücher des Wissens* (Knowledge Books). Fischer used their publisher's colophon symbol prominently on the front of their books, while others depended on a layout and single typeface common to all their books to establish a brand image, like any packaged commodity.

In the 1960s the Deutscher Taschenbuch series was designed by the Swiss Celestino Piatti, using colour illustrations and black type on a white background. The Signum crime series were always in black and red, Rowohlt's thrillers in black and white, and Suhrkamp covers were arranged by Fleckhaus into a coded spectrum of brilliant flat colours with simple ranged-left Garamond titles. Jackets to hardback books ranged from Ulm-like geometry to the graphic freedom typical of Polish design.

Poland

Best known for its film posters, Poland was one of the few countries to develop a recognizable national graphic style in the two decades following the Second World War. With echoes of folk culture, it owes something to the influence of Cassandre through Tadeusz Gronowski, whose poster for Radion detergent, showing a black cat jumping into a washing tub and emerging white, had won the Grand Prix at the Paris Arts Décoratifs exhibition in 1925.

Radion
household soap poster 1925
[Tadeusz Gronowski]

far left
Chapaev
film poster 1947
[Mieczyslaw Berman]

The Septembrist Heroes
film poster 1948
[Roman Cieslewicz]

The style of the posters was modern, but with no trace of the Polish avant-garde of 1930. This had been notable for the typography of Henryk Berlewi, whose *Mechano-Faktura*, a version of Constructivism, sought to relate art to life through advertising; for the magazines *Blok* and *Praesens*, laid out by Wladislaw Strzeminski and Henryk Stazewski; and for the photomontages of the brilliant Mieczyslaw Szczuka (who died in 1927) and Mieczyslaw Berman. Berman survived the war to become one of the early leaders of the new school of Polish poster design, though he was exceptional in using photography, partly because photographic reproduction materials were in short supply.

The designs consisted of painted illustration and drawn lettering. It could be straightforward, simplified realism; sometimes decorative and at other times dramatic, often with surreal elements; sometimes dream-like, often nightmarish. The foremost exponents after the war, apart from Berman, were Tadeusz Trepkowski, Henryk Tomaszewski, Jan Lenica, Waldemar Swierzy, Julian Palka, Eryk (Henryk) Lipinski,

The Wages of Fear
film poster 1954
[Jan Lenica]

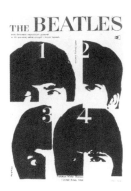

Wojciech Fangor, Roman Cieslewicz and Wojciech Zamecznik and Stanislaw Zamecznik. They produced more than two hundred posters a year for the cinema alone, under the patronage of the state publishing agency, Wydawnictwo Artystyczno-Graficzne (WAG). Publicized by the magazine *Projekt*, their work became part of subsidized culture and a means of popular artistic education.

The art director of WAG was the designer Josef Mroszczak, who taught with Tomaszewski at the Warsaw Academy of Fine Arts. They and their colleagues enjoyed a freedom emulated in the other countries of Eastern Europe, particularly Czechoslovakia and Hungary which, like Poland, had inherited important poster traditions and, before Fascism, had harboured vigorous avant-gardes.

The lithographic reproduction helped create graphics that carried a special conviction. Hand-drawn marks revealed the presence of the designer, more usually and increasingly the hidden manipulator behind printers' typefaces, anonymous photographs and geometrical constructions. This tradition had survived in France with the *affichistes* like Savignac. From 1963 Lenica worked in France and Cieslewicz settled permanently in Paris. It was here that the wit, warmth and directness of the tradition was absorbed and where it was developed in the 1970s by the Grapus group (see pp.196–97) into a vehicle able to carry a heavier load of information and argument.

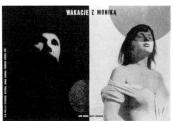

Northern Europe

The Netherlands

In the two decades following the war the most internationally influential Dutch designer was Willem Sandberg. Mainly self-taught, he had worked in the 1920s for a printer in Switzerland, visited the Bauhaus in Weimar and Dessau, and had studied Otto Neurath's system of visual statistics in Vienna. This had led him into graphic design, and in the 1930s he came to work for the PTT in The Hague and for the municipal museums in Amsterdam.

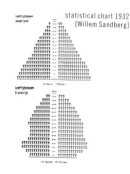

statistical chart 1932
[Willem Sandberg]

During the Nazi occupation many printers and designers were involved in illegal printing or forging documents. Sandberg, while in hiding, produced the first of his nineteen *experimenta typographica*, handwritten and collaged booklets, which were graphic expressions of short quotations. Emphasis was given to certain parts of the short texts through contrasts in lettering, and by the position and spacing of the lines. Sandberg was also interested in the decorative possibilities of individual letters and particularly fond of their counters – the negative spaces within the letter.

The first of these booklets was typeset and printed secretly in 1944. The *experimenta* established a manner Sandberg employed for many years in the posters and catalogues he designed for the Stedelijk Museum in Amsterdam, where he had been a curator of modern art from 1937 to 1941, and was himself its director from 1945 to 1962. He used poster-sized types, not only for posters, but on catalogue covers, for which he most often chose the coarsest boards and wrapping papers. This incongruity of texture and scale was balanced by a delicate handling of ragged text type. His outlook is well summed up in part of his 1969 text called 'warm printing':

i don't like
luxury in typography
the use of gold
or brilliant paper
i prefer the rough
in contour and surface
torn forms

from *nu* Quadrat-Print
cover and booklet pages 1959
[Willem Sandberg]

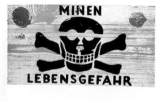

What makes Sandberg's work important is his attempt to use the sense of words and the structure of sentences to determine their layout, ending a line of text where there was a break in the meaning. Images, and sometimes letterforms, were produced by printing from shapes torn out of paper, and used as stencils. Many of the techniques were borrowed from Werkman (see p.73). Sandberg had a similar do-it-yourself, intentionally direct, even confrontational, attitude to accepted commercial methods.

Sandberg's mature typographical design is brilliantly exemplified in an illustrated account of the history of signs and communication, published as the Christmas 1966 issue of the trade journal *Drukkersweekblad*. Its elegant structure had its sequence of pages typeset in Gill Sans. They integrated torn-paper images, examples of artists' brushwork and their signatures with photographs, many of them Sandberg's own, of signs in the street.

Informality and improvisation were the chief elements in Sandberg's work; he preferred bold nineteenth-century grotesque sans-serif types and slab-serif 'Egyptian' faces for large titling, but he used all kinds of typeface. In a single job he favoured the use of all capitals or all lower case, commonly not using capitals for the initial letters of artists' names. This mannerism was almost the only trace of pre-war avant-garde dogma.

Of this avant-garde, Schuitema and Zwart were still working and teaching. Another significant surviving member of the Ring neuer Werbegestalter was Vordemberge-Gildewart, established since 1938 as a designer in Amsterdam. Apart from designing labels for packaging artificial foods, he also produced books of poetry in war-time circumstances where all printing had to be licensed by the occupying powers. His most important achievement was a memorial volume to the printer Frans Duwaer, who had produced Sandberg's and Vordemberge's own clandestine books before his execution for taking part in illegal printing. The book's pages pay a graphic homage to Duwaer, using type and cut-out half-tone blocks, a technique Vordemberge went on to develop in designs for the Amsterdam architectural magazine *Forum* in the early 1950s.

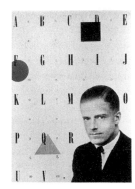

Uncompromising abstraction survived in the geometrical windows designed by Vordemberge for the three Bijenkorf department stores in Amsterdam, Rotterdam and The Hague in 1950. Vordemberge argued that they provided a neutral, undistracting background to the goods displayed for sale, but they were nevertheless greeted with public abuse. There had already been a retreat from austere modernism before the war, even by Zwart. Dick Elffers, who had been an assistant to both Schuitema and Zwart, had begun to use whimsical line drawings rather than photographs. After the war this changed to the kind of Expressionist illustrational style of his 1946 exhibition poster *Weerbare Democratie* (Defensible Democracy): the combination of civilian and soldier in one figure is crude as a graphic technique compared with the startling conjunctions provided by a Heartfield collage or the fusion of two images such as Abram Games made with his airbrush during the same period.

'Defensible Democracy'
exhibition poster 1946
[Dick Elffers]

Rayon Revue
magazine cover 1948
[Otto Treumann]

Paradoxically, the smaller-scale typographic work of Elffers and of Wim Brusse respected the craft traditions of elegance of an older generation, displayed in a 1946 postage stamp by the type designer Jan van Krimpen. Elffers's design for the 1957 Europa stamp is typical of the more cautious approach to design of the PTT, which had been forced into a collaborationist role during the war, after the death of Van Royen in a concentration camp in 1943. Modernism returned in 1964 with the photographic stamps of Cas Oorthuys and the following year in the black-bordered set of three designed by Otto Treumann to celebrate the twentieth anniversary of the Liberation.

Treumann also designed *Rayon Revue* for the Algemeene Kunstzijde Unie (General Rayon Company) from 1946 to 1959. Similar 'house' magazines produced by large companies demonstrated the revival of business and industry; two for the multinational conglomerate Philips were *Contact*, designed by Elffers, and *Range*, by Alexander Verberne and Ton Raateland.

With economic recovery came a need for designers, for catalogues, publicity and house style – corporate identity. In 1963 Treumann collaborated with the British designer George Him to produce one of the most successful commercial symbols, for Israel's El Al airlines, in Roman

'Sonsbeek '52'
exhibition poster 1952
[Otto Treumann]

Steendrukkerij de Jong
symbol 1959
[Pieter Brattinga]

'The Man Responsible for PTT Design'
exhibition poster 1960
[Pieter Brattinga]

'new alphabet'
design for computer reading 1967
[Wim Crouwel]

conventional lower-case 'a' digitized
lower-case 'a' in 'new alphabet' 1967
[Wim Crouwel]

and Hebrew letters. At the same time, KLM (Royal Dutch Airline), expressing doubts in its own country's designers, turned to Henrion in Britain for its house style. Yet Dutch graphic design was well publicized abroad, not only by Sandberg's work but also by *Kwadraat-Bladen* (Quadrat Prints). These were issued by Steendrukkerij de Jong, printers in Hilversum, from 1951 to 1974. Edited and designed by Pieter Brattinga, whose father owned the business, these were square folders on subjects related to design, complete in themselves. They accompanied exhibitions arranged in a small gallery at the printing works, but were widely distributed overseas. The square was a motif in the accompanying posters which were based on a grid of five squares high by three wide.

The grid (typical of the Swiss work which was to influence the next generation of designers in the 1960s, not only in Holland) was exploited to great effect by Wim Crouwel. Crouwel's attitude was the opposite of Elffers's. If Elffers's posters smelt of paint, Crouwel's looked as though they were conceived as well as produced by machine. Crouwel extended the use of the grid to meet the new electronic means of generating images. As used by the Swiss, the grid helped the designer to organize rectangular units of typography, but Crouwel made it into the basic matrix within which the letters themselves were constructed. Although his 'new alphabet' was remarkable as much for its unreadability as its ingenuity, it indicated Crouwel's early recognition that the computer was about to change the way words and images could be made and reproduced. For him, the electronic revolution demanded new forms, and these forms would be determined by the requirements of the technology itself. He was plainly right when he argued, for example, that the letters of his alphabet could not be distorted on the display screen because their horizontals and verticals matched the digital matrix. In the event, it was the technology that was refined to the point where traditional typefaces with the finest hairlines could be reproduced with greater precision than ever before by computer.

The first design group in The Netherlands, Total Design, was founded by Crouwel with four colleagues in 1963. It was 'total' in the sense that it included three-dimensional design, an advantage that became

clear in the work for its first corporate commission. This was to overhaul the visual identity of the oil company P A M, including the design of petrol stations. In 1965 Total Design was asked to make proposals for a 'routing system' at Amsterdam's Schiphol airport. Directed by Benno Wissing, this was one of the earliest comprehensive signing schemes. Its sans-serif lettering and matching arrows became the prototype for subways in Milan, New York and Tokyo, and signing for public transport in many parts of the world.

PAM (Steenkolen Vereeniging)
oil company logo and symbol 1964
[Total Design]

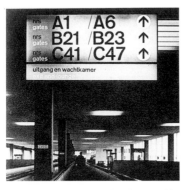

Schiphol airport
signing system 1967
[Benno Wissing / Total Design]

Total Design grew into a large organization working in teams. Consistency was encouraged by standardization of formats and procedures. The Stedelijk catalogues, for example, were controlled by a standard grid and single typeface so that, whoever was responsible for an individual catalogue, the design would retain the overall character of the museum's publications. The rectangularity of Dutch design (broken by Zwart in the 1930s and which had returned with Total Design) was about to be eroded by social pressures and the arrival of new technology. A more expressive manner became possible through the use of photographic and electronic techniques which released designers from the constraints of the rectangles.

18
The Late 1960s

During the 1960s graphic design was seen as solving problems of communication. It was also presented in the popular media in the same way as fashion: concerned with good taste, with being up-to-date, even advanced. Because it was visual, graphic design responded to fashion, but changes in its style were the result of a number of pressures, from developments in technology, in the media and in society. And because it was not only visual but also verbal, it could be addressed by academics who were becoming aware of the social importance of communications. The Canadian Marshall McLuhan, beginning with an analysis of advertisements in 1958, developed his notion that 'the medium is the message'. He contended that 'societies have always been shaped more by the nature of the media by which men communicate than by the content of the communication'.

According to McLuhan, the tradition of typesetting which began with Gutenberg belonged to a near-defunct, mechanical age. This technique, he suggested, had induced certain patterns of thought which encouraged specialization and alienation; the new 'electronic technology' would make us all members of a 'global village'.

The Medium is the Massage
book double pages 1967
[Quentin Fiore]

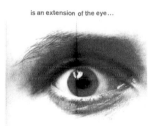

McLuhan had recognized the intersection between technology and political change. If graphic designers had always been aware that there was more to communication than its obvious content, they were only now beginning to sense the effect of technical change. Their barely established profession had already come to terms with successive changes in printing technology. Photography was the fundamental innovation, first as a medium to generate images (in black and white, now also in full colour); second, as a medium for typesetting, where it brought a freedom in the spacing of letters – impossible when printing directly from metal type. Computers now made possible the rapid organization and storing of information. But at this time they did not significantly affect graphic designers, who continued to work on paper, not at a computer screen, whose use became widespread only in the 1980s.

Professional habits of work were challenged and diversified more by cultural and political factors than by these pressures of technical change. Reaction to the Vietnam War (1964–75), social protest, typified by the events in Paris in May 1968, the Cuban revolution, mass culture and pop music and the use of hallucinatory drugs all found graphic expression. New graphic forms developed independently of established graphic design as it was understood by the profession. These new forms filled a gap between the cold formality of the Swiss style and popular taste. In spite of the increasing ease of international communication, graphic design still bore a local stamp; change still came from individual designers out of their particular circumstances.

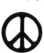

Campaign for Nuclear Disarmament
symbol 1958
[Gerald Holtom]

Cuba

The Cuban revolution of 1959 released a remarkable wave of graphic energy, particularly demonstrated in a flood of posters. They announced cultural events – films, ballet and folklore attractions; they summoned crowds to public meetings and proclaimed revolutionary achievements. Their designers, unlike those in the early Soviet period, followed no aesthetic ideology. They employed an inspired eclecticism that reflected the work of Saul Bass, Push Pin Studios and Czech and Polish posters, and their work owed nothing to technical skills of reproduction. Rather the contrary. Many of the early posters were printed by silkscreen using stencils hand-cut by the designers. Their simple techniques were an economic necessity. Photographs were line – light or shadow (without half-tones), a restriction exploited with special skill in cinema posters by Eduardo Munoz Bachs and René Azcuy. The effect of flat colour shapes with sans-serif lettering recalled the technique of Lester Beall's 1930s Rural Electrification Administration posters, and was retained for a decade by Felix Beltran, a Cuban designer who had worked in advertising in the United States.

Cuba had no commercial advertising and all publicity was controlled through a government studio, Intercomunicaciones. Posters produced

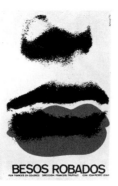

'Saving Electricity Means Saving Oil'
poster c.1969
[Felix Beltran]

Baisers Volés (Stolen Kisses)
film poster c.1970
[René Azcuy]

for export, to demonstrate solidarity with other communist countries, were distributed abroad through OSPAAAL (Organization for Solidarity with the People of Africa, Asia and Latin America). Most had banal slogans like *Hasta la Victoria Siempre* (Ever Onward to Victory) linked to a simple image; sometimes, as with Beltran, of an incongruous elegance. The Christ-like head of the guerrilla leader and former government minister Che Guevara, with its black beret and five-pointed star, became an international icon.

'Day of the Heroic Guerrilla' poster 1968
[Tony Evora]

A 1968 poster marking the 'Day of the Heroic Guerrilla' was almost alone in carrying an image which was more than an illustration of the slogan. Its red portrait of Che Guevara, the embodiment of armed struggle, expands in concentric rectangles over a map of South America, a precise graphic metaphor for the spread of revolution. The designer Tony Evora was art editor of *Lunes*, the Monday cultural supplement to the daily newspaper *Revolución*. Printed in two colours, *Lunes* was similar to Milan's earlier *Il Politecnico*, with which it shared a strategy of cultural education. Like the posters, it introduced a mass public to what was formerly an elite culture. The newspaper's own publishing house, Ediciones R, pioneered book design in Cuba and *Revolución*'s whole-page poster teaching sheets, used in the drive against illiteracy, were typical of the part played by graphic design in the efforts to transform the country.

tear-out instructional poster from newspaper *Revolución* c.1961

California, the Underground and the Alternative

The chequered background and complementary colours of Evora's Che Guevara poster echo the 'psychedelic' mid-1960s posters designed for rock concerts, particularly in San Francisco. Drugs were legal in California until 1966, and their influence on perception, mimicked by stroboscopic lighting at concerts, was simulated in graphic work by the dazzle of repeated contrasts of black and white or complementary colours. One of the most important designers of this era, Wes Wilson, claimed that he selected his colour from his visual experiences with LSD. The best known of the psychedelic group in California and the only one with an art training, Victor Moscoso had studied colour at Yale with the ex-Bauhaus teacher, Josef Albers. Moscoso combined optical vibration through colour with formalized letterforms, which he made almost unreadable by an exact equivalence of positive and negative elements: the space within and between the letters is balanced with the letters themselves, just as the adjacent colours are contrasted in an equal intensity. Wilson derived his letterforms directly from the Viennese Secessionist lettering he found in the catalogue to the 'Jugendstil and Expressionism' exhibition held at the University of California in November 1965. The medium became not the whole of the message but a large part of it: the message of these works was that they were 'underground'.

Quicksilver Messenger Service concert poster 1967 [Victor Moscoso]

Procol Harum concert poster 1969 [Lee Conklin]

'Underground' was the term used to describe the anti-establishment attitude of many of the young middle class in the 1960s who took an alternative cultural or political stance outside and opposed to conventional society. In America, it was identified with hippie culture, with the peace movement and with ecology, whose cause it promoted with an immense illustrated directory, the *Whole Earth Catalog*. This used the new do-it-yourself graphic technology which preceded desktop publishing; text was set on the IBM Selectric 'golf-ball' composer, a sophisticated typewriter (a method sometimes called 'strike-on'). It was printed by offset lithography, which had been pioneered by the New York weekly *East Village Other*. This was conceived in 1965 as 'a *visually* revolutionary paper rather than merely using offset techniques to save money'.

Internationally, underground magazines joyfully accepted the poor quality of offset printing on cheap paper. Together with overprinting text on coarse colour images, they intended 'to make sure that no-one over thirty reads it'. This style, whose informality encouraged the idea that producing a magazine required no special skill, quickly spread. It emerged in Amsterdam with *Hitweek*, the *Real Free Press* and *Hotcha!*, and in England with *Oz*, *International Times* and *Frendz*.

Common to all these magazines was the increased control shared by the people who laid them out. Words and images were positioned on the page by the designers rather than by the printers. The 'strike-on' composer, operated by the journalist or designer, could produce text in the studio. Headings could be produced with rub-down lettering such as Letraset rather than being typeset by printers. The photo-mechanical transfer (PMT) system of producing enlarged and reduced images, ready for reproduction, allowed images to be modified, refined and positioned in the studio, giving the designer direct control over the earlier stages in preparing work for printing.

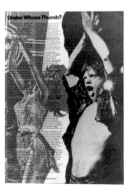

Protest: 1968 and Vietnam

In the late 1960s students and protest groups took control of the print-ing process itself in the most surprising challenge to technical advance and electronic media. They were responding to a series of events, pre-dominantly the war in Vietnam, but including the assassinations of Che Guevara and Martin Luther King in 1967 and 1968, followed in 1968 by the Paris 'events' in May and the Soviet invasion of Czechoslovakia in August. The state had television to air its views in people's homes; the students had the streets to put their case. Demonstrations, often violent, showed the depth, breadth and passion of their support, but it was their posters that produced a dramatic and indelible impression.

wall poster
Prague 1968

newspaper poster
Paris 1968

'We are in power'

'The police sticks to
the School of Fine Arts –
the School of Fine Arts
sticks [its posters] in the street'

posters
Paris 1968

During the student revolt in Paris in May 1968, posters were pro-duced by the Atelier Populaire, students of the Ecole des Beaux-Arts. Their technique was mostly silkscreen, a process whose economy was matched by an extreme graphic compression. Slogans often originated in the defiant war-cries of students confronting police on the streets. Chalked on a blackboard and refined by a committee, they were the basis for three hundred or more designs which were distributed by students and workers throughout the capital. The messages were unequivocal, the printing was urgent, sometimes in a single colour, but essentially black on white. A repeated device, to reverse a slogan in white from a black image, originated directly in the silkscreen process where the screen stencil was prepared in negative. The students exploited the sim-plicity of the graphic means (the hand-drawn lettering and brushed sil-houettes) to question the complex apparatus of printed image-making in the consumer society whose values they opposed. Neither in the medi-um nor in the message was there room for modulation of tone into pho-tographic greys, or into the distraction of colour.

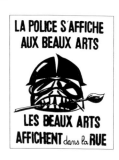

This direct type of printed graffiti was produced in poster workshops in many countries. It was a propaganda weapon, quick to respond, as in Czechoslovakia after the Soviet invasion in 1968. It was used to stimu-late protest in the face of authority by student groups, and it spoke for feminists and activists on social issues.

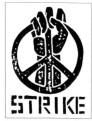

'Strike'
poster, Berkeley, California 1970

Posters too were important in calls for disarmament and peace, particularly in Vietnam. Some were the work of professional designers. In New York, agency art directors combined to produce advertisements for the Committee to Help Unsell the War, applying the same arrangement of image, headline and text which they used every day to sell products and services.

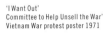

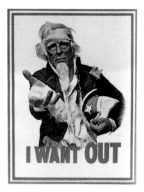

The most powerful demonstration of the effectiveness of the still image and printed text was produced in 1970 by the Art Workers Coalition in the United States. It appropriates familiar techniques from television news reporting – documentary photography and interview dialogue. A colour photograph of massacred Vietnam villagers is overprinted with an enlargement of crudely printed text, from the questioning of a witness about his orders, the laconic 'Q. And babies? A. And babies.' Not momentarily on the flickering screen but frozen on the printed sheet, the viewer absorbs the horror of the photograph to which the words give a yet more horrifying meaning.

'Q. And babies?
A. And babies'
Vietnam War protest poster 1970
[photographer R.L.Haeberle]
[designer Peter Brandt]

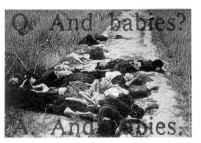

In the domestic interior, the cultural and political poster became a decorative and reassuring sign of its owner's allegiance and status. Such posters extended the boundaries of graphic design, which was no longer associated only with commercial interests. Production did not depend on the printing industry nor on the professional designer. The individual could now originate the message and control its means of production.

The Late 1960s

185

19

The 1970s and After

Graphic design had expanded during the 1960s into areas previously ruled by craft traditions, like newspaper design, and into the new media of television and video. Designers' still images, although they could be generated and controlled electronically, had to compete with, and sometimes join, the moving images of the television screen. Graphic design's role in the public services and cultural advertising had also increased. Successive Olympic Games, for example, depended on designers for publicity, programmes and comprehensive sign systems. European regions and cities struggled to attract industry and investment and government departments joined in a rush to assert their individuality and independence. In 1969 Canada had decided that the country needed more than a flag; it needed a system for its graphic identity, and in 1980 it became the first nation to have a symbol as well as a logotype.

In the 1970s graphic design became part of business, mainly used to give a company a recognizable 'image' (how the company wished itself to be seen and remembered) which was extended in annual reports (how the company wanted its activities to be seen). All enterprises and organizations, however small, felt the need for a 'logo', following Coca-Cola.

Canadian National Railways
symbol 1959
[Allan Fleming]

Canada
federal symbol (administration)
flag symbol (government)
coat of arms (legislative and judiciary)
logotype and symbol (tourism)
1970

Canadä

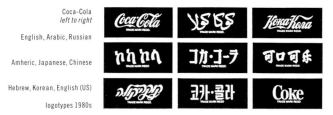

Coca-Cola
left to right

English, Arabic, Russian

Amheric, Japanese, Chinese

Hebrew, Korean, English (US)

logotypes 1980s

In marketing products and services designers were required to produce images that would identify a product or company: to do this, words and images did not have to carry a specific meaning; they simply had to be recognizable. Their context would give them a meaning, as it did in Britain with the Hadfield paint firm and its fox symbol. Graphic style often gave way to a stylishness which parodied design. Most graphic design had become part of marketing or part of the media and entertainment industry. The stereotype of graphic design was the Swiss style which derived from European modernism, with no decoration, white space, sans-serif typefaces and the use of the grid. Elaborated and refined, often misunderstood, it was used throughout the world. But the protest posters of the 1960s had shown other possibilities. Underground journals had shown the control that designers were winning over the processes of production. With the introduction of the microcomputer the designer won almost total control over the pre-print processes.

National Styles and International Influences

In a world of mass communications, the graphic style of many countries retained nevertheless a powerful national identity. In the 1980s the Polish, Czech and Hungarian tradition of drawn posters was influential in the West as well as in the Soviet Union. An awareness of what was going on in different countries was stimulated by the proliferation of graphic design magazines in the industrialized countries. 'Art directors annuals' attracted foreign subscribers, and the number of international organizations, conferences and exhibitions grew.

Japan Airlines
Alitalia / British Airways
airline liveries 1970s
[Landor Associates]

Graphic design in marketing became international, exemplified by the 'liveries' of airline companies like Alitalia, British Airways, Japan Airlines and Singapore Airlines, all designed by the San Francisco firm Landor Associates. There was an enlightened, intelligent application of modernism to the identities of multinational companies by design groups such as Chermayeff & Geismar in New York, or Pentagram in London. In this way the style itself became associated with industry and commerce, established views and respectability. There was a reaction to this, and particularly to the rigorous discipline of the Swiss approach. This critical response was typified by the new work of Total Design in Amsterdam.

It was not the rationality of the grid and the use of problem-solving techniques that were displaced; these remained at the centre of information graphics. And yet modernism – claimed by its adherents to be 'value-free', particularly since it had no historical references – had led to a dry formalism, indeed to a formula, that many designers felt they had exhausted.

Furness
Furness (road transport)
Furness (harbours)
Furness (trade)
Furness (insurance)
symbols 1969-72
[Total Design]

Alternatives to the International Style

Two alternative responses to the Modernist approach developed. The first was related to Punk, mainly in Britain; the second retained many of the elements of Swiss modernism, and became a 'new wave', especially in Holland and the United States. 'New Wave' used the new photographic and electronic technology either to 'loosen up' the old forms or, conversely, to ignore them altogether by making the graphics look crudely improvised and brash. The overall reaction was expressed in a shift to informality; rectangularity gave way to a kind of photographic and electronic Art Nouveau. With computers, designers could generate complex

The 1970s and After

187

relationships of meaning through superimpositions and 'layering' elements of text and image, instead of linking them on a horizontal and vertical grid. But the seductive effects gratuitously thrown up by the technology often led to excesses of ornament rather than expressions of meaning.

There was now a large stockpile of printed images (classical woodcuts, Victorian engravings and kitsch conceits) ready to be raided and reassembled by decorative designers. It accounted for much of Push Pin Studio's style and the later work of Herb Lubalin. Modernism itself could be recycled in grotesque pastiches like Paula Scher's Swatch advertisement of 1987.

 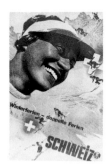

Swatch
watch advertisement 1987
[Paula Scher]

Swiss tourist poster 1934
[Herbert Matter]

Britain

The first important extension of graphic language in the early 1970s was through mass culture. Punk, in its most obvious form, was a London street style, part of the culture of drugs and pop music, rebellious and with a desire to shock. Punk 'fanzines' – magazines of music groups' fan clubs – used torn-out letters and imagery recycled from popular newspapers, typewriter text and handwriting with ready-made images, stuck together to produce an original for reproduction by lithography or photocopying. Dada had been against Art; Punk was anti-Design.

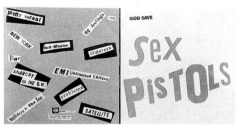

'God Save Sex Pistols'
record sleeve 1977
[Jamie Reid]

Punk found a ready response among designers disenchanted with Modernism. It emerged in similar forms in other European countries, noticeably in The Netherlands. In England, Colin Fulcher, who adopted the name Barney Bubbles, was the most original talent. After a con-

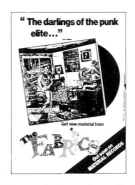

ventional apprenticeship as a design assistant, Bubbles designed record sleeves and advertisements in music magazines. His 1977 symbol for the Blockheads band is an ideogram of startling invention, perfectly expressing their aggressive wit. Bubbles was unique in his ability to find imagery for a verbal idea. His designs did not depend on obvious aesthetic effects nor did they borrow from fine art, as had the Modern Movement designers like Rand. The image was locked together with the words to make an idea; its references were only within the design itself, without connections to a broader culture. Certainly Bubbles used some of the direct unsophisticated approach of Brutalism, exposing the process of fabrication, like printing from children's printing kits with rubber letters. In fact, he exploited the direct use of the process camera in the studio, constructing his designs by a series of improvisations and manipulations of scale, crude and delicate, positive and negative.

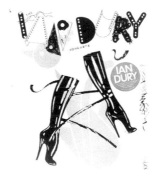

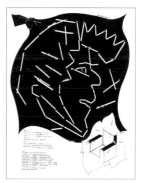

Increased control over production allowed the designer to take decisions as part of the process. Previously, with letterpress printing, the designer had given separate instructions for typesetting and picture reproduction. After the designer had prepared instructions for their assembly, changes in size and position were difficult to make. Now the designer made 'artwork' (called 'mechanicals' in the United States) 'camera ready' for the printer to make the printing plates, with the illustrations, half-tones and advertisements all in place. Using the PMT cam-

era the designer could enlarge or reduce headlines, reverse them to white on black, vary the contrast of images and improvise with last-minute amendments. This had the advantage that work was prepared (usually the same size as it was to be printed) and, instead of waiting for proofs from the printer, 'what the designer saw [apart from colour] was what the designer got'. The sizes of headlines or photographs could be changed in the studio.

Full advantage of this control was taken by David King, one of the innovating team on the *Sunday Times Magazine*. Throughout the 1970s and 1980s he designed a series of posters, books and magazines, mostly political. They may look like some Russian Constructivist work (particularly that by Rodchenko) and were assembled with similar demands of speed and economy, but were produced by completely different methods. Nineteenth-century sans-serif poster lettering, phototypeset and enlarged, was pasted up with coarse-screen photoprints, and strips of black paper cut out with a scalpel.

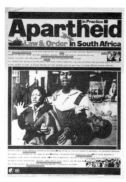 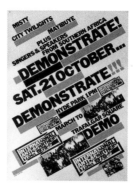

'Apartheid in Practice'
poster 1978
[David King]

'Demonstrate!'
poster 1978
[David King]

King often had parts of his work (usually in red and black, sometimes on yellow paper) double-printed 'dot-on-dot' to give an intense, brutal effect – a contrast to the dense detail of the text, which was accented by heavy underscorings in red and punctuated by black squares. The five posters *Apartheid in Practice* are typical, produced in one week of 1978. Apart from their small text set by typewriter, the usual characteristics of photolithography – reversing lettering out of solid colour or black, and overprinting – are ignored. The apparent simplicity of their production seems to belong to the Third World they describe.

Camera-ready techniques were used to produce the London weekly magazine *Time Out* from 1970. The inside pages were a more disciplined version of *Oz* and *Friends/ Frendz*, where *Time Out*'s art director, Pearce Marchbank, had worked. The logo expressed the magazine's photo-mechanical process in out-of-focus outline letters. Covers followed Lois's full-colour *Esquire* tradition of surprise, with verbal and visual puns and a Franklin Gothic headline. Some British magazines renewed themselves without being affected by changes in technology (the monthly *Management Today* for example, under the same art director over three decades).

Time Out
front cover 1975
[Pearce Marchbank]

Radio Times
magazine page 1975
[illustrator Peter Brookes]
[David Driver]

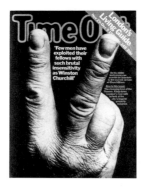

i-D magazine
covers from 1981
[art director Terry Jones]

The BBC's weekly *Radio Times*, still in the 1970s printed on the obsolescent rotary letterpress machines which had printed newspapers for a hundred years, organized the timetable of radio and television schedules with extraordinary clarity and elegance. *The Times*, which had carried typeset announcements on its front page since the eighteenth century, had replaced them with news in 1966. Its design editor Jeanette Collins introduced more illustration and brought finesse to its typographic detail worthy of Stanley Morison. *The Sunday Times*, too, under its design director Edwin Taylor and its editor Harold Evans, made all the elements – photographs, graphics, headlines and captions – play a part in the page as a complete graphic design, as Evans explained in *Pictures on a Page* (1978), a practical examination of the relationship between narrative and image.

A former art editor of *Vogue*, Terry Jones, produced *Not Another Punk Book* in 1977, itself a caricature of punk graphic techniques – torn newspaper cuttings and ready-made images and plastic lettering produced on a labelling machine. Jones went on to launch a street-style magazine, *i-D*, in 1980. It was the most energetic expression of every kind of new technology, which it used by abusing it – enormously enlarged photocopies and copies distorted by moving the paper, Polaroid instant photographs over- or under-exposed and scratched or painted on. 'We treated the computer', said Terry Jones, 'as another new, fun tool – to add to the box of graphic effects.' This was an attitude resolutely punk, to turn the limitations of new technology into positive attributes. So the matrix within which the shapes of letters were formed became an important part of the texture of the printed page.

Similar new typesetting technology, which allowed the expansion and contraction of the typeforms, was played with in *The Face*, a 'style culture' magazine launched in 1980. Its art director, Neville Brody, tamed Punk into the consumer graphic idiom of the 1980s. Where *i-D*'s words and images were displayed in an overall texture, *The Face* animated the conventional layout of consumer magazines with headlines in bizarre letterforms, sometimes computer-generated, often geometrically constructed in an Art Deco manner. On the computer screen new or existing forms could be manipulated, organized and re-organized without the discipline (or the limitations) imposed by earlier printing methods.

By the end of the 1980s, graphic design as a 'style' was an essential part of retail marketing. Some designers reacted with anxiety. Brody, with Jon Wozencroft, laid out their confusions over the role of the 'Design Industry' on a page of the newly re-designed *Guardian* newspaper. They claimed not only that 'if you approach design as problem solving all you can ever hope to communicate is the problem itself', but also that 'style is a virus'. In fact, Design as Style manifested itself in a number of styles.

above, left
The Face
magazine double page 1983
[Neville Brody]

above
i-D magazine
double page 1986
[photographer Robert Erdmann]
[art director Terry Jones]

Guardian, London
2 December 1988
[Neville Brody]

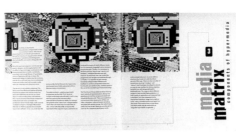

far left
Orchestral
Manoeuvres
in the Dark
record sleeve with
cut-out slots 1980
[Peter Saville]

left
Understanding
Hypermedia
book double page 1992
[Malcolm Garrett]

In the music industry, Punk (Jamie Reid's work for the Sex Pistols) survived alongside Brody's Post-punk eclecticism; Retro (all kinds of revivals); updated mainstream Modern (Peter Saville); the post-Underground Modern of the magazine *Underground;* and Electronic. Exemplified by the work of Assorted Images and Malcolm Garrett, Electronic was advanced by Garrett in his design of the book *Understanding Hypermedia*, a title that suggested a more confident graphic future.

The Netherlands

Dutch anti-authoritarian protest had an intellectual and political base in the activities of the Fluxus artists and Situationists who had used the street to stage provocative 'happenings' in the early 1960s. Their publications, and those of the subsequent Provo movement, had the Punk-like direct use of printing – the text handwritten, not typeset. This tension between freedom and repression, between anarchism and conservatism, was reflected in attitudes to design. An interesting resolution was achieved in work commissioned by the Dutch public services, where the radical Punk experiments were absorbed into a free version of modernism developed from the use of the computer.

In The Netherlands graphic design had become part of everyday life. It attracted the respect abroad which had been given to Swiss graphic design for two decades before, but not until the 1980s did it manifest itself in a particular style. In the 1960s it had borrowed much of its formal arrangements from the Swiss, as in the railways' identity by Tel Design, whose graphic design section had been founded for the project by the young designer Gert Dumbar in 1967.

The corporate style of the PTT is remarkable for its evolution. Tel and Dumbar were involved from 1968 in the design of a new identity for it that was implemented gradually and completed only in 1981. It began with the typical problem-solving approach developed in The Netherlands in the 1960s, particularly by Crouwel at Total Design. Colours were allotted to each of the four sections of PTT activity: red for mail, blue for money transfer, green for telecommunications and brown for management. The letters 'ptt', in lower case, were set in Univers which was used as the standard typeface. Reversed in white out of a solid square of colour, they became the logo, applied by the PTT's internal design department in all branches of the company, guided by a manual. Then in 1988, with impending privatization, the PTT asked Dumbar, now with his own design group, for a new house style. Studio Dumbar's response was to fragment the earlier style into a group of elements to which were added five dots. Smaller colour-coded squares were fitted into the logotype square, to which rectangles with additional lettering could be added. To cover its possible applications, Studio Dumbar produced a four-volume guide.

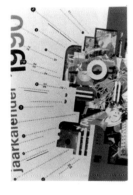

PTT
yearbook 1990
[Vorm Vijf]

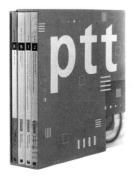

PTT
house style manual 1989
[illustrator Berry van Gerwen]
[Studio Dumbar]

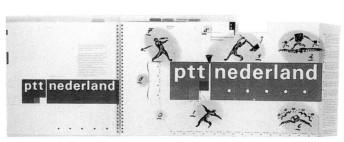

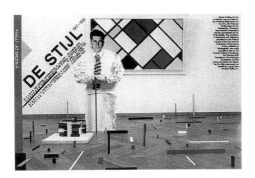

With much of its production belonging more to the artists's or photographer's studio than to the drawing board, Dumbar's design group was appropriately named. The images expose their actual two-dimensionality in exaggerated perspectives and they arrest the viewer with visual jokes. With his 1982 poster for an exhibition of De Stijl ideas in the United States, Dumbar broke the conventions of museum poster design. More than simply reproducing an art work and adding a title and detailed information, he set up a 'scene' in the museum that was photographed as the image. In front of a Van Doesburg painting on the wall he placed a dummy figure of the artist, with a photographed head. On the floor an architectural model was arranged with De Stijl-like strips of wood in the same colours as the painting. In the poster he linked the main title to the image by following the diagonals of the painting, and the rest of the type remains on the right, connected to the edge of the sheet and the flat plane of the wall. Part of the figure, in two-dimensional cut-out, relates to the flatness of the painting and the wall; part, modelled in papier-maché, becomes a bridge between the flatness and the photographic, three-dimensional space of the foreground. In this way, Dumbar breaks another convention, this time of graphic design, by introducing naturalistic perspective, which extends towards the viewer in the lower third of the poster. Here the founder of De Stijl, who had introduced one of the principal features of graphic design to the aesthetics of the Modern Movement – the graphic suppression of depth – is ironically placed in the space implied by perspective.

Many Dutch designers made similar efforts to extend their medium beyond the profession's self-imposed restrictions. Senior designers like Crouwel insisted that 'graphic design is a profession, just like being a doctor'. Others, like Jan van Toorn, insisted on a designer's commitment to exposing relationships of meaning, making each work explain its own context. Van Toorn's concern with design's social and educational role was consistently reflected in his work, which used any means he found appropriate – now Modernist techniques of montage in the manner of Zwart or Lissitzky, now the anarchic informalities of Punk.

These informal, anti-professional techniques were employed by two groups of young designers, Hard Werken (Working Hard) in Rotterdam,

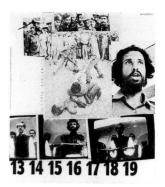

Dutch Art and Architecture Today
cover (doubling as envelope) 1974
[Jan van Toorn]

hospital signage system 1978
above identification signs
for floor levels
[Gert Dumbar/Ko Sliggers]

and Wild Plakken (Wild Sticking or Fly posting) in Amsterdam, who established themselves in the early 1980s. Their work is most remarkable for its deliberate inconsistency of style and its independence of tradition or notions of 'good taste'. There seemed as many tendencies in The Netherlands as there were designers. from the illustrational (the posters of Gielijn Escher); the photo-surrealist (Anton Beeke); the developed central Modernist typographic tradition (Karel Martens) to the many design groups, like Vorm Vijf, whose work flamboyantly demonstrated the possibilities of computer-generated graphics. In their creative wilfulness, the younger designers joined the more established: Studio Dumbar's 1989 yearbook for the PTT has the kitsch of an electronic Art Nouveau Disneyland; the work of Total Design, which Crouwel left in 1985, was invaded by the curved lines and oblique lettering that sprang from the manipulations available instantly to a designer working directly on a computer screen. Similar struggles to break with the past went on in most countries. It was the achievement of Dutch designers in the 1980s to test such a variety of radical possibilities, and a testimony to their clients' discriminating commitment.

'Holland Festival'
programme cover 1987
[Robert Nakata/
Studio Dumbar]

France

The Bauhaus elements of circle, square and triangle came to signal to the public the involvement of a graphic designer in the 1980s. They had appeared in Total Design's logo for the Dutch Ministerie van Onderwijs en Wetenschappen (Ministry of Education and Science) and they appeared again in the graphic identity for la Villette, a vast educational and cultural park at the edge of Paris, for which Total Design were asked to do the sign system. The closed competition for the general graphic identification of la Villette's site and its different attractions was won in 1984 by Grapus, a design collaborative. The group's origins were in the Atelier Populaire of 1968, where the three founders – Pierre Bernard, Gérard-Paris Clavel and François Miehe – met. In 1970 they began their production of 'social, political and cultural images'. Choosing to work where there was little money to pay for their services, they could 'fight the stiff idiom of traditional rhetoric without replacing it by the sweet poison of advertising'.

Dutch Ministry of Education
and Science
symbol and logotype 1982
[Total Design]

Ministerie van
Onderwijs en Wetenschappe

la ▼ill■tt●

La Villette
logotype 1984
[Grapus]

La Salamandre theatre
double page 1977
[Grapus]

By the end of the 1970s there were ten in the Grapus collective, working on posters and ephemera for small theatres and for the French Communist Party. The work was direct, unprofessional-looking, and playful. Much of the text was in crude handwriting; images were often childishly drawn; signs of the paintbrush, splashes and blobs, mocked the authority of photographs. This graphic slang swore, told jokes, charmed and shocked. It was manipulated by intellectuals who had studied not only communication theory but had also learned directly from one of the Polish masters of poster design, Henryk Tomaszewski. It shows Polish influence in its enjoyment of a dramatic image, silhouetted against a background, usually suggesting sky. Although there is often an intimate graphic link between word and image (or they are bound together by the coarse, improvised texture of the marks) the two remain slogan and illustration rather than combine in an integrated idea.

None of the Grapus work can be attributed to an individual designer, yet there is a consistency, not of technique, but of attitude. It was provocative. It demanded a response, sometimes a question, sometimes merely an enjoyment of the image. Grapus gave several small theatres

complete house styles, with logos, news sheets, stationery and posters. In 1977, when the La Salamandre theatre at Tourcoing produced a piece by Rimbaud, *Un Coeur sous une soutane* (*A Heart under a Cassock*), notes on the poet in the theatre's journal were presented in the same style as pages of the local paper. Grapus's poster showed a backview of the priest's head and shoulders, photographed in black and white, against the light. The image is almost in silhouette; the outline of the unmanageable, brutal haircut and of the shoulders starkly describe the stage character; the white crescent of collar identifies him. The image simply records appearance, but it has accentuated the essential features that describe a unique personality. The placing of the theatre's logotype, yellow lettering on a white-bordered black rectangle, follows the symmetry of the figure, as a label to the poster whose solemn formality is emphasized by the dark border.

Yet both the documentary character and the formality are simultaneously challenged by the colour of the actor's ears, which are tinted red, and by hand-writing all the information about the production in the bottom right corner. Such contrasts, colour against monochrome, light against dark, sharp against smudged, are part of graphic design's normal techniques, but Grapus used them from the mid-1970s to the mid-1980s as though they were newly discovered. Their posters won Grapus international awards and the expanded Grapus studio came more to resemble a conventional design group.

The growth of public understanding of graphic design in France was paralleled by the career of the Swiss 'graphiste' Jean Widmer. He had spent nearly twenty years in Paris in marketing, advertising and magazines. In 1980 he opened his own studio and established himself in the central area of graphic design – working for public organizations on sign systems, as well as publicity for cultural institutions. His symbol for the Centre Georges Pompidou in Paris was unusual at this time in being pictorial, derived from a side view of the building showing the escalator serving its five floors. For its directional signs Widmer prepared (together with Ernst Hiestand's office in Zurich) a graphic analysis of the needs of the visitors. A diagram indicated the points at which directions were

essential. It was split into three areas – *towards:* the visitors' possible starting points and means of transport; *around:* possible approaches and points of entry to the building: and *in:* circulation within the Centre itself. The special typewriter-like lettering on the signs ran vertically on colour-coded boards: taking up less space, the lettering could be large at eye level.

In the 1970s Widmer also made signs to be read at speed. The first were designed to relieve the featureless anonymity of the motorway by giving the traveller an idea of what lies beyond the margins of the road – places of historical or scenic interest, local wildlife, sports, crafts and types of farming and food. The signs were a combination of pictograms with lettering in the typeface Frutiger. For the Autoroutes du Sud, Widmer compiled a comparative study of road signing in Europe, with a plea for standardization, and made recommendations – which were not followed.

road signs 1972
[Jean Widmer]

A new cultural attraction of the 1980s in Paris was the Musée d'Orsay, a museum for nineteenth-century art established in the converted Gare d'Orsay in 1986. The competition for its graphic design was won by Widmer in partnership with the Swiss-Milanese designer Bruno Monguzzi. The museum's title was reduced to the abbreviation *M'O* in the neo-classical Walbaum typeface.

The logotype exemplifies the way in which the mainstream modern designer could construct from existing elements a solution to a problem that nicely meets functional and aesthetic criteria. The typographic idea was not new. The apostrophe had been used before in trademarks by Swiss designers, like Gerstner's for Niggli publishers in 1960. But with d'Orsay the apostrophe is the essential component: it ensures the emblem's unique identity – with the words it abbreviates and with the idea it represents. Without it, the sign degenerates into meaningless letters, signs without context. The letters also had a formal perfection; the designers took advantage of their graphic contrasts – the robust swelling curves of the 'O' and the heavy down strokes and delicate lines of the angular 'M', which they extended with a horizontal dividing line of the same weight. While the line ran between the two letters, it both established the position of the apostrophe, preventing its being misread as a

Musée d'Orsay
logotype 1986
[Bruno Monguzzi / Jean Widmer]

Niggli
publisher's logotype 1960
[Karl Gerstner]

Bellezza d'Italia
logotype c. 1957
[Franco Grignani]

'Chicago'
exhibition poster 1987
[Philippe Apeloig]

comma, and linked the letters to make them a single sign with a singular meaning. The lines appeared in the signing of the building and in the typography of all the printed material – stationery, guide books and posters – for which Walbaum was adopted as the typeface throughout. The huge posters announcing the opening of the museum added a photograph of an early aircraft flight to the logo, which kept its identity despite being dramatically cropped (the form in which it most frequently appeared).

In an atmosphere of cultural expansionism in the 1980s, exhibitions of graphic design at the Pompidou Centre helped create an informed public. 'Vive les graphistes' in 1990 celebrated the flowering of new graphic talent. Modern editorial design was represented by the re-design of several newspapers, particularly *Libération* and by the consistent wit and elegance of the monthly *Marie Claire*. The younger generation combined these Parisian characteristics with the two opposing tendencies in France – the more Polish illustrational approach typified by Grapus, and the Swiss objective attitude of designers like Widmer.

Switzerland

It was in the Basle and Zurich design schools that the Swiss style (which had begun in the 1930s and was exported as the International Style in the late 1950s) was consolidated and developed to become an underlying discipline. In the 1970s and 1980s established designers, like the teams of Odermatt and Tissi and Ernst and Ursula Hiestand, and a new generation of brilliant poster designers built on it freely. They adapted their methods to each job, without restricting themselves to Akzidenz and Helvetica, and the rectilinear layouts that had typified the style.

Akzidenz, particularly in its boldest version, was nevertheless the preferred typeface of Wolfgang Weingart, the most influential younger Swiss designer abroad. He was a German compositor engaged by Hofmann in 1968 to teach at the Basle Allgemeine Gewerbeschule. Since 1963, when his first ideas had been shown in the German trade magazine *Der Druckspiegel*, he had enjoyed a role as *enfant terrible*, enthusiastically questioning received attitudes and demonstrating his own in a considerable output of experimental work. His mouthpiece was the monthly *Typographische Monatsblätter*, whose covers (fifteen in 1972 and 1973), 'learn-covers', he called them, were designed to take the reader 'step by step through a terminology as defined by various design theoreticians and communication scientists . . . the composition ignores hand-setting dogma and challenges design ideology.'

Weingart toured the United States in 1972 and 1973. He published his lecture in 1972, entitled *How Can One Make Swiss Typography?*, which was concerned mainly with the teaching at Basle. Among other topics Weingart answered criticism of his designs. 'I think that the relatively high stimulus of such a text is adequate compensation for the low

readability'. Weingart promoted the design of Max Bill and Ruder, where 'the message, which should be communicated, is not intensified through the use of additional syntactic or semantic material'. This he described as the 'value free' manner.

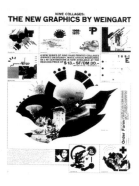

below, far left
'The new graphics by Weingart'
poster announcement 1978
[Wolfgang Weingart]

above, left
'is this typography worth supporting'
magazine cover 1976
[Wolfgang Weingart]

above
'Why and how the covers for
Typographische Monatsblätter
were produced'
magazine cover 1973
[Wolfgang Weingart]

In fact, Weingart was reversing the avant-garde direction. Artists like Schwitters and Vordemberge-Gildewart had expanded their art into design, where it was dedicated to the principle of clarity. Weingart moved graphics into the realm of personal expression, which reached an extreme in his cover design for the American academic journal *Visible Language* in 1974, where he scrawled 'No idea for this fucking cover today'. But Weingart's significance is in his early recognition of a new technology – as a threat to the craft traditions in which he was brought up as a compositor. He met this challenge with inventive gusto, exploiting phototypesetting and the use of photographic film to collage alphabet and image (see p.24)

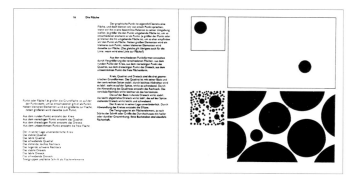

Form and Colour
book double pages 1968
[Hans Rudolf Bosshard]

A more sober contribution to formulating a basis for the development of graphic design was the textbook *Form und Farbe* by the Zurich teacher Hans Rudolf Bosshard, a statement of first principles and advanced orthodoxy. Another complete textbook on typographical teaching was produced by Hans-Rudolf Lutz, followed by his *Die Hieroglyphen von Heute* (*Hieroglyphs of Today*) in 1990. It reproduced, in a huge com-

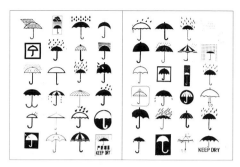

pendium, five thousand international signs and symbols found on card-board boxes. Lutz presented the signs as an existing working system, achieved without the intervention of designers.

Germany

A full-scale demonstration of the systematic approach to graphic design, seen as a method to solve communication problems, was given at the Munich Olympic Games in 1972. Every item of publicity and signs produced by Otl Aicher's team (under the chairmanship of the ever-active Stankowsi) was controlled by a geometrical grid.

Munich was one of the German cities in the 1970s that commissioned graphic designers to promote civic consciousness and a sense of efficiency by means of a house style. One such scheme, for the Rhine town of Leverkusen, designed by Rolf Müller, a former student of Aicher at Ulm, was typical. It included the design of stationery, brochures to attract tourism and industry, cultural publicity, and information on education and social services. The central element in the design was a symbol, a square tilted at 45 degrees. Like the Olympics design, it depended on the rigid controlling use of a grid and on sans-serif type.

The designers who used illustration as well as photography also seized the opportunities to do publicity offered by municipal theatres. This was a tradition in Germany nurtured by Hans Hillmann, whose film posters retained their inventiveness in the 1970s. Among the designers who used

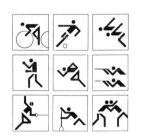

Olympic Games
symbols, Munich 1972

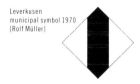

Leverkusen
municipal symbol 1970
[Rolf Müller]

Berlin
logotype allowing for slogan
and postal franking 1980s
[Anton Stankowski]

Berlin ist eine
Reise wert | **BERLIN**

S.Fischer
publisher's poster 1967
[Gunter Rambow]

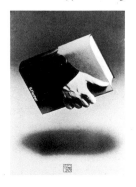

The 1970s and After

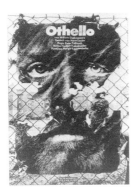

'Othello'
theatre poster 1980
[Rambow / Lienemeyer/ Van de Sand]

photography and montage were Frieder Grindler and Holger Matthies. Those whose imaginative grasp on ideas best matched their technique were the team of Rambow/Lienemeyer/Van de Sand, founded in the 1980s. Gunter Rambow, a student of Hillmann in Kassel, Gerhard Lienemeyer and Michael van de Sand exploited the hyper-realistic effects common in advertising, produced by modern cameras and lighting, but turned them into a perfectly crafted vehicle for theatrical and political ideas. A typical Rambow and Lienemeyer poster consists of a single complex image – not an obvious montage, but elements seamlessly joined, often set in deep perspective, the title of the play reduced to a label.

Advertising design in Europe largely followed New York – a large image with less than one third of the area devoted to a sharp, simple headline and small explanatory text set in columns. By the end of the 1970s, text and image were often fitted together like a magazine page. The Milka purple cow against a purple background, and below its bell the slogan 'At night I'm especially fine', was one of a series which exemplified this kind of editorializing fantasy. By contrast some advertisements depended solely on words and their typography.

'From the street to the grave
is often not more than 1mm.'
Continental tyres advertisement
GGK Dusseldorf 1979
[Gerd Hiepler / Holger Nicolai]

Milka
chocolate advertisement 1978
[photographer Beat Jost]
[art director
Maria-Christina Sennefelder]
[Young & Rubicam,Frankfurt]

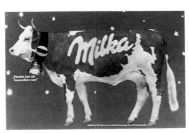

One of the innovative advertising agencies in Germany was GGK, originally the Swiss firm of Gerstner, Gredinger and Kutter. Helmut Schmidt-Rhen, at one time an art director at GGK, and of the Gerstner-designed *Capital* magazine, was responsible for the innovation of a transmutable logo (as 'Lik', for the journal *Literatur in Köln*).

Literatur in Köln
varying logotype 1974
[Helmut Schmidt-Rhen]

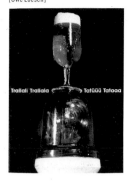

Posters in the 1970s and 1980s were given a curious lease of life by Uwe Loesch, a fellow-teacher of Schmidt-Rhen's in Dusseldorf. They exaggerated graphic devices – photographs with extreme depth of focus and range of tones, printing dark on dark and light on light, giant enlargements, posters cut out-of-square, metallic inks and fluorescent colours. His most effective poster was for an anti-drink campaign in 1979. It combined words as sound and the symmetrical juxtaposition of opposites of meaning into a single, integrated graphic idea. Against a black background, Loesch balanced a glass of beer on the dome of a blue police car light. On the left in a single white line of type is the sound of singing, 'Trallali, Trallala' extended on the right with the sound of the police siren, 'TatuuunTataaa'. In 1982, he produced his best-known eccentricity, cutting up a ten-foot-high billboard advertisement for a printing reproduction firm to make a 256-page book in A4 format. Loesch was remarkable for the unexpectedness and variety of his work, and for his explicit demonstration of graphic processes.

The mainstream of German graphic design continued in work for industry, by design groups like Mendell & Oberer and in magazines like the *Frankfurter Allgemeiner Zeitung*'s supplement, which matured the layout style for which Fleckhaus had made *Twen* famous.

Italy

The influence of the Ulm Hochschule für Gestaltung's systematic design methods was felt in Italy by the 1960s. The school's former director, Tomas Maldonado, and one of its chief theoreticians, Gui Bonsiepe, worked in Milan. One of their tasks was to oversee a co-ordinated house style for La Rinascente and its chain of associated supermarkets, Upim (1967–69), where another Ulm teacher, Tomas Gonda, had been art director. Two former Ulm students were involved in important schemes. For the Bolzano region, where place names are in both Italian and German and all information is in both languages, Giovanni Anceschi applied systems engineering to timetables which could be read at the same time as network diagrams, and to the design of multi-route tickets; Hans von Klier art directed a detailed house style for Olivetti in the early 1970s.

The involvement of designers in municipal work, particularly in transport, had been pioneered by Noorda in the signing for Milan's subway (1963-64). It was followed, most notably by the Lombardy region, begun in 1974 by DA (Centro per il Disegno Ambientale); by the Venice transport companies, designed by Giulio Cittato in 1977; and by the Aeolian Islands with the designer Mimmo Castellano.

Aeolian Islands
Resort facilities
part of pictogram system, from 1976
[Mimmo Castellano]

Aeolian Islands
'I' as in '*Isole*' (islands) - 2
'E' as in *eolie (aeolian)* + 5
= 7
symbol 1978
[Mimmo Castellano]

⊛ISOLEEOLIE

In an initiative of surprising ambition for a single tourist authority, Castellano conceived diagrammatic maps and, to cope with foreign visitors, devised sets of symbols. These were derived from a list of 250 key words which represented the concepts for which signs were needed. These were divided into 15 categories, such as communications and sporting facilities, to show what was available, its location and its standard, classified by the usual system of stars.

Italy was a country where the individual designer, rather than the group practice, flourished. The mainstream designers of the older school, such as Grignani and Albe Steiner (until his death in 1974), were still active. The strand of Modernist rigour which ran through Italian graphics remained in the work of such designers as A.G.Fronzoni and Monguzzi. Foreign distribution of the architectural magazines *Domus* and *Casabella* and, more popularly, fashion magazines like Italian *Vogue*, maintained an international interest in the rugged elegance that was the stereotype of the country's graphic design viewed from abroad.

'Inaudible Sound Fragments'
concert poster 1980
[A.G.Fronzoni]

Japan

Japan, with its own strong national graphic traditions, was nevertheless the country most open to foreign influences. Two Japanese magazines had an international outlook and distribution – *Idea*, a bi-monthly founded in 1953 by the designer Hiroshi Ohchi, and *Graphic Design*, first published in 1959, which closed with its hundredth issue in 1986. *Graphic Design*'s editor, Masaru Katzumie, had supervised the design of the symbols for the 1964 Tokyo Olympics. These invented the vocabulary of pictograms for which Aicher devised the grammar at the 1972 Munich Olympics. Katzumie used the magazine not only to reproduce historical and contemporary examples of graphic design but also as a forum for discussion. His concern for the social importance of graphic design expressed itself in his reports on the steps towards an international standardization for signing. As well as Aicher's Frankfurt airport signs in 1976, for example, he recorded the graphic analysis of the world produced in coloured charts by an ex-Ulm student, Nobuo Nakagaki.

The tradition of Japanese graphics that interested Western designers was the two-dimensional space and flat colour of woodblock prints. Japanese designers inherited a formal inventiveness and a graphic precision from their calligraphy and the geometrical symbols, the *mon*, of family héraldry. Lithography displaced woodblock printing and introduced European perspective and chiaroscuro. Between the wars Japan developed a commercial art very similar to Western advertising. By the 1950s, following New York, the Tokyo Art Directors Club was

publishing its own Annual and the Japanese Advertising Artists Club (JAAC), the chief professional body, held yearly exhibitions until it was replaced by the Japanese Graphic Designers Association in 1978. Japanese inventiveness was advertised across the world by the camera firms Canon, Nikon and Olympus and motor companies Honda, Kawasaki and Mitsubishi.

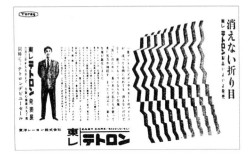

To the traditional perfection of drawing and graphic craftsmanship, the first professional Japanese designers in the 1960s added geometrical images (Yusaku Kamekura, Kazumasa Nagai, Kohei Sugiura, Ikko Tanaka). Successive generations took advantage of the new photographic and electronic equipment which was developed in Japan to originate, manipulate and reproduce printed images (Makoto Saito); they used visual tricks and optical illusions (Shigeo Fukuda), stroboscopic photography (Gan Hosoya), and electronic montages. In Western eyes an added exoticism was provided by the alternatives of horizontal or vertical directions of text reading – and an uninhibited freedom with the Roman alphabet.

Tokyo Rayon
advertisement c.1950
[Ikko Tanaka]

Japan Advertising Artists Club
symbol 1952
[Ayao Yamana]

JAGDA

Japan Graphic Designers Association
symbol 1977
[Kazuo Kashimoto]

traditional Japanese family crests

Japanese Typography
exhibition poster 1959
[Hiromu Hara]

The Russian Don Cossack Chorus
concert poster 1952
[Hiroshi Ohchi]

Tokyo had been host to the World Design Conference (WoDeCo) in 1959. It invited designers from abroad who represented the central Modernist or Constructivist tendency – Saul Bass and Bayer came from the United States, Maldonado and Aicher from Ulm, and Müller-Brockmann, Huber and Munari from Switzerland and Italy. Also in 1959 Nippon Design Center was founded, a design group established with a

Nippon Design Center
symbol 1960
[Kazumasa Nagai]

206

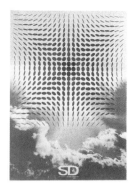

Kashima-Shuppankai
publishers poster 1967
[Kazumasa Nagai]

Olympic Games
poster 1964
[Yusaku Kamekura]

consortium of large companies that also provided graduate training for newly qualified designers. One of its three founder members was Kamekura, designer of the symbol and a series of photographic posters for the 1964 Tokyo Olympics. The most popular and best known of these showed a wedge of athletes frozen into a still life as they surge from the starting blocks above the symmetrically placed symbol of the Games. The black background abstracts the figures from three dimensions, exactly the device used by Cappiello (see p.13).

Both Kamekura and Katzumie were involved in 1965 with an exhibition to promote younger Japanese designers of whom more than a thousand graduated from art schools each year. This 'Persona' exhibition's choice of four foreign designers showed a more eclectic interest than 'WoDeCo': Swiss design was represented by Gerstner, Polish posters by Lenica, American modern by Dorfsman of CBS. 'Persona' helped redirect the career of one of the many designers who passed through Nippon Design Center, Tadanori Yokoo, who summed up his generation's impatience: 'Modernist design, linked as it has become to modern industry, has made a contribution to our materialistic civilization. But, conversely, it is now trying to rid us of our souls'.

Yokoo became a rebel and a celebrity, using his graphic work to pay homage to other celebrities, alive and dead, from the sublime to the banal.

John Silver Part Two
theatre poster 1967
[Tadanori Yokoo]

Suntory Brandy
poster 1979
[Tadanori Yokoo]

In his prodigious output of posters in the 1960s and 1970s, for cultural events and alcoholic drinks, he assembled images from Western art, engravings and tracings of photographs, traditional Japanese as well as Islamic decoration, and psychedelic effects on backgrounds of graduated hues which recalled earlier woodblock printing. Yokoo became increasingly reliant on printers and new reproduction equipment in order to repeat motifs in gradually diminishing scales to give an effect of infinite depth.

exhibition poster 1975
[Shigeo Fukuda]

far left
'Look 1'
exhibition poster 1984
[Shigeo Fukuda]

'Pyramid Zone'
department store poster 1985
[Takayuki Soeda]

Much Japanese graphic work, particularly posters, used images whose relationship to the product being advertised was often distant. Like Western posters at the turn of the century (see Chapter 1), it was the graphic idea alone that drew attention to the name of the advertiser. In this way, department stores like Parco and Seibu and the drinks firm Suntory were sponsors of the most individualistic and advanced design.

far left
'Project 7000 –
A Flood of Sound'
Pioneer Electronics
advertisement 1979
[Gan Hosoya]

left
'Yoshie Inaba
Parfum'
poster 1985
[Kaoru Watanabe]

International marketing design companies, no less than multinational corporations, were often preferred to local designers. Landor was commissioned by Japan Airlines for its identity; the newly privatized Japan Railway was given a bland Western-style corporate logo designed by Nippon Design Center in 1987.

Japanese graphic invention appeared over the whole field of printed design: in advertising, in fashion magazines and specialist journals and particularly in countless trademarks, at first following the traditional black-and-white simplicity of the *mon*, later manipulating and taking advantage of computer imagery.

Taiyo Machine
Industry Company
symbol
[Yusaku Kamekuro]

Suruga Bank
symbol 1965
[Kazumasa Nagai]

'Waltz'
building logotype,
Tokorozawa 1986
[Shin Matsunaga]

Technological innovation inspired new images. At the same time, it brought a revolution in book production. The publishers Kodansha introduced an 'editorial editing system' for its *Encyclopaedia of Medical Science* published in 1982-83. The production team's work, using automatic drawing machines, and plotters linked by optical fibres by a central computer, was co-ordinated by systems which specified such requirements as airbrushing density and colour. These techniques of graphic management placed Japan at the head of the new technological avant-garde, where computers are part of the design team.

The United States

While America was exporting mainstream modern design to service the international corporations, it was still importing design ideas, particularly from the European avant-garde. In some ways, there was a convergence of the techniques of East and West. Among the Modernist designers working for large corporations from the 1970s (who were also heroes of the Japanese) were Saul Bass, Paul Rand, and the New York consultancy of Chermayeff & Geismar. Bass's trademarks for Quaker Oats and Girl Scouts, as abstractions, have the positive/negative relationships of the *mon*, and in 1984 he employed the same photographic techniques as the Japanese in his poster for the Los Angeles Olympics.

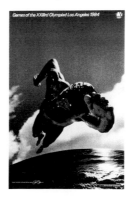

Paul Rand, who designed one of the first covers for *Idea* in 1955, was still winning awards for his company identities (IBM won the AIGA Design Leadership Award in 1980, Cummins Engine Company in 1983). They were in the mainstream Modern manner shared by Chermayeff & Geismar, who had given Mobil a new house style in the 1960s. The advertisements of the 1970s and 1980s for the television programmes sponsored by Mobil, designed by Ivan Chermayeff, refer to European models for their *papiers collés* and their typefaces. Indeed, in Rand's book of essays, *A Designer's Art* (1985), all the modern references are to European culture, to Picasso, Matisse, Miró. American vernacular graphics – design without designers (the Coca-Cola sign, Walt Disney's animation, comics) – are conspicuously ignored.

Attention to the everyday graphic language surrounding us appeared in *Learning from Las Vegas* (1972), a polemic by the architects Robert Venturi and Denise Scott Brown. This large-format book was as important for its ideas as for its design and production techniques. Typeset by IBM typewriter in Univers, elegantly laid out by the MIT Press designer Muriel Cooper, its flexible grid allowed the arguments to be made visually by extreme contrasts of density, in refined but expressive European accents.

Cummins
engine parts pack
corporate identity 1983
[Paul Rand]

Las Vegas airport
directional sign 1976
[John Follis and Associates]

Learning from Las Vegas
book double page 1972
[Muriel Cooper]

Signs were a Post-Modernist concern. Venturi and others discussed buildings as signs or composed of signs, and as part of a larger 'communication system' which included commercial street signs ('Billboards are almost all right'). Paradoxically, this was at a time when the Highways Commission was undertaking a review of signs with the help of the AIGA.

The signs at Las Vegas International airport were certainly international, designed by the John Follis office in the Schiphol tradition. Instead of Helvetica, though, they used the typeface Avant Garde. The letters had a functional appearance (like the Futura that Chermayeff & Geismar re-vamped for Mobil). They were geometrical, but designed to be decorative, starting life in 1968 as a magazine logo by Lubalin and Tom Carnase. Since the 1960s Lubalin had moved closer to a recognizably American style, revivalist and eclectic – the style identified with Push Pin Studio, particularly Milton Glaser.

Mobil
logotype 1965
[Chermayeff & Geismar]

Avant Garde
capital letters design 1970s
[Herb Lubalin]

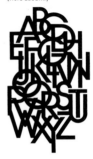

U&lc
magazine cover 1980
[Herb Lubalin]

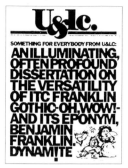

The proliferation of typeface designs on digital data discs led by the 1980s to the availability on a single system of more than one thousand designs. Linotype, for example, had five versions of Baskerville which, with different weights and italics, amounted to twenty-six in all. The relative cheapness of the system and the ease with which new typefaces could be generated by manipulating existing designs by computer allowed designers access to exotic designs which had previously been available only as photo-lettering or transfer lettering.

In 1970, Lubalin had co-founded with Aaron Burns the International Typeface Corporation. To advertise their designs, ITC launched a large-format tabloid journal, *U&lc*, unmistakeably American from its logo to its layout. Under Lubalin's art direction it was more like a women's weekly than a technical news-sheet. In fact, during the 1970s, many magazines changed their typefaces for the heading of each article (like the *New York* weekly art-directed by Milton Glaser), and came more and more to resemble ITC publicity.

Glaser was the American designer most admired abroad. His eclectic interests were shown at the Pompidou Centre's one-man exhibition: he worked comfortably in narrative illustration and Victorian-style typography, and sometimes, brilliantly, in a modernist idiom of geometry and sans-serif type. He redesigned *Paris Match* in 1972, in a smaller format, at the same time nearly doubling the size of Widmer's exquisite *Jardin des Modes*.

Art-school students went to Europe, many to the Basle Gewerbeschule. If they had come for the bland recipes of Armin Hofmann, they came away with Weingart's enthusiasm for breaking rules – for typographic expressionism. This helped to create a 'new wave', in which electronic technology was used to generate and manipulate type and imagery, and the microcomputer became a design tool. The wave swept up many of Modernism's formal elements (typeset 'rules' and sans-serif types) and emptied them out on the paper in curves, at odd angles and in fading perspective. The tide flowed most strongly in California, but also at the Cranbrook Academy of Art on the outskirts of Detroit (where Eames had taught in the 1940s), at MIT and in New York.

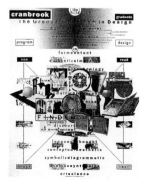

'Cranbrook:
The Graduate Progam
in Design'
poster 1989
[Katherine McCoy]

The 1970s and After

The new Californian graphics were chiefly identified with one of Weingart's students, April Greiman. Her early work of the late 1970s introduced two features of 'new wave'. First were what was often described as 'cocktail graphics' – type and small images with typeset oddments dispersed over the whole area of the design, taking spaced type to extremes. Second were colour collages made with the photographer Jayme Odgers. Their spatial play, the overlapping of images put into perspective, anticipated her work with computers. Her developing relationship with 'all the technology I'd been throwing myself at', from colour photocopiers to all kinds of computer systems, was unfolded as an issue of *Design Quarterly*, published by the Walker Art Center in Minneapolis in 1986. This was produced as a fold-out poster (see p.23). On one side was a digitized photograph of a naked Greiman and on the other an account of her complex technical procedures. Her methods are discussed in detail in her 1990 book, *Hybrid Imagery*, where she emphasizes the use of ready-made visual material, stored on data disc or on videotape, which can be repeated and re-worked (the NASA earth-from-space photograph is a favourite). She accepted chance effects and the low resolution of text and image; without focus of image or idea, the 'layering' of images was so complex and apparently random as to verge on unreadability, but, as Greiman has explained, 'if the client walks through the door, he's bought into the aesthetic'.

'Vertigo'
clothing and gifts store logotype 1982
[April Greiman]

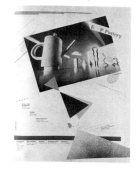

'E P Pottery'
advertisement 1979
[April Greiman / Jayme Odgers]

California Institute of the Arts
prospectus folder 1986
[April Greiman / Jayme Odgers]

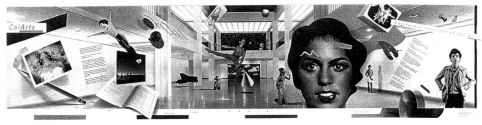

Greiman's aesthetic had developed direct from Weingart, whose lecture tour of the States in 1972 had been arranged by Dan Friedman, a typographic designer teaching at Yale, where the direct influence of Basle had been marked since Armin Hofmann had been a visiting lecturer in the mid-1950s. Friedman, an ex-Basle, ex-Ulm designer, taught a kind of expressive, eccentric Modernist typography. In commercial practice, such an attitude was muted; Friedman's work for Citibank in New York joined the more conventional approach to corporate identity as it had been established by Rand, Chermayeff & Geismar and Massimo Vignelli, and the new, commercial anti-design inelegance of Tibor Kalman at M&Co. Other designers whose demonstrably Swiss-American attitudes were absorbed into corporate design include the Swiss Willi Kunz, both student and teacher in Basle, who brought a more disciplined Late Modernism to New York; and Wilburn Bonnell and Woody Pirtle, with a more home-grown variety.

The same Late-Modernist tradition could be seen in the training at

New York / Paris
Graduate Study Program
poster 1988
[Willi Kunz]

Fetish
magazine cover 1980
[David Kosstrin and Jane Sterling]

Cranbrook since 1972 under Katherine McCoy. Students, taken through the steps of Swiss typography, then subjected the lettering of a food label to a grid structure in what was known as the 'vernacular message' project. This was the direction Hans-Rudolf Lutz had taken in his *Typographische Monatsblätter* covers in 1977, which were carried out in the style of different popular magazines and comics to demonstrate that the context of information affects the message. Although students were encouraged to make personal graphic comments on their work, a distinct style of Dumbar-like Detroit-Dutch emerged, which was disseminated in New York by Doublespace, a design firm started by the Cranbrook graduates David Sterling and Jane Kosstrin. Doublespace produced *Fetish*, a magazine for collectors of kitsch, who designed publicity for progressive dance and music performances, using collage and overlapping and layering techniques and deep perspective, like Greiman. The Cranbrook manner was continued by Lucille Tenazas at the California College of Arts and Crafts (CCAC).

'Recent Graphic Design
from the Netherlands'
poster 1987
[Lucille Tenazas]

Apart from Greiman, the most significant Californian contribution was *Émigré*, a large-format magazine launched in 1982 by a Dutch immigrant, Rudy VanderLans, and his wife Zuzana Licko. Typeset with a Macintosh computer in types that Licko designed so that they 'would look good on a coarse resolution printer', the magazine published all kinds of graphic design. As a designer, VanderLans could give his role as editor a much more comprehensive scope: the layout could be used directly by the editor to shape the content and to relate the parts in ways which, before the microcomputer, relied on written instructions rather than interaction with an electronic display.

Émigré
above
cover 1990
right
magazine double page 1992
[Zuzana Licko / Rudy VanderLans]

Electronic visual editing and the arrival of presses printing reels of paper in full colour helped to change editorial design – not only in magazines but also in newspapers, which came to look more like magazines. Readers and advertisers were presented with a medium that, it was hoped, would match the visual stimulus of television. Colour photographs, charts, maps and diagrams accompanied a variety of headline typefaces; columns of text were sometimes set ranged left with a ragged-right edge. These were the ingedients of *USA Today*, launched in 1982, by the end of the decade the largest-selling daily in the country.

During the 1980s designers in America became more aware of the need for theory and history to back their own practice. Professional journals like the monthly *Print* introduced historical articles, and *Industrial Design* provided a critical view of graphic design, as did the more academic *Design Issues* and *Visible Language*, launched as the quarterly *Journal of Typographic Research* in 1967, which covered technical and historical aspects of visual communication. Specialist books on theory and history included Donis A. Dondis's *Primer of Visual Literacy* (1975), Edward R. Tufte's *The Visual Display of Quantitative Information* (1983) and Philip Meggs's *History of Graphic Design* (1987). Cranbrook introduced critical theory into its course mainly of French structuralists (the 'reading list was pages and pages long', said an *Emigré* interviewee).

An ambitious attempt to bring together various disciplines with graphic design was initiated in the Visible Language Workshop at MIT (1988) led by Muriel Cooper. It 'became the experimental bridge between the computer and four hundred years of printing' and looked forward to the extension of graphic design into animation, video and new electronic media.

Information Design was significantly advanced, and itself became a specialist enterprise, through the efforts of Richard Saul Wurman. In 1981 Wurman, previously an architect, set up Access Press, which produced guidebooks and guides to 'how it works'; later, his San Francisco office, called The Understanding Business, began with a *Smart Yellow Pages* in 1988. They showed an uncommon concern for the user, relying on graphics to build on existing knowledge. Wurman's essay for *Design Quarterly* in 1989, titled 'Hats', defined information as consisting of 'the visual hat racks (maps, diagrams, charts, lists, time lines) that help us to understand how our world is organized'.

Wurman's mapping of big cities around the world tried to make sense of urban muddle. One of his illustrations in 'Hats' is the 1931 map of the London Underground system, the prototype for transport system guides – such as the New York subway map designed by Massimo Vignelli in the 1960s.

Vignelli's career exemplifies the growth of the large entrepreneurial designer from the 1960s to the 1990s. His practice represents the triumph of a style that was international, but rooted in north Italy and Switzerland. In America, Vignelli's Modernist manner (heavy horizontal rules, condensed bold capitals, Helvetica or Bodoni), which he had

Football / Access
book double page 1983
[Richard Saul Wurman]

New York City Transit Authority
subway map 1972, revised 1978
[Massimo Vignelli]

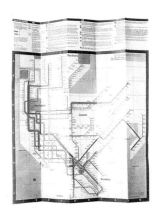

Skyline
architectural magazine cover 1980
[Massimo Vignelli]

United States
National Parks Services Program
visitor's folder 1977
[Massimo Vignelli]

used for the Piccolo Teatro di Milano in 1965, was an efficient formula applied to marketing, publishing, Corporate Identity and Information Design. It served Knoll furniture in New York, as it had served countless companies in Italy.

Vignelli's professional life had begun at a pivotal time and place in graphic design's history: Milan in the 1950s. It was here that the central tradition of International Modernism had been nurtured and developed; brought from the Bauhaus by Schawinsky and from Switzerland by Max Huber. Less a style than an attitude, it dealt with each of the categories of graphic design. Modernism provided Olivetti with its graphics of *identification* (its logo), *information* (its leaflets and manuals) and *presentation and promotion* (its advertisements and posters). Since the 1970s there has been a reaction against Modernist graphic design. It is seen to belong to an era of ideologies, its objectivity has been questioned and its discipline regarded as belonging to pre-electronic technology. Throughout the century, new media have brought new forms. Each new technique has given the designer increased control over the graphic process, which through electronics has come to include not only colour but also movement.Graphic design, as it is described in this book, may have a diminished role in visual communication. But the uses of graphic design will remain, and so will the need for the alphabet and the use of the image.

&
digitized 'three-dimensional'
computerized letterform 1992
[Nick Clarke]

Bibliography and Sources

The following is a guide to publications that have been consulted by the author,
and also to selected further reading.
It includes only material published since 1945 (excepting that from which illustrations have been reproduced).
Readers are referred to *Art Index* for earlier works.
Some foreign titles are available in English translation;
English editions are cited where these have been available to the author.

General

Amstutz, W. *Who's Who in Graphic Art*, 1st edn, Zurich 1962
Art & Pub (Art & Publicité), Centre Georges Pompidou, Paris 1990
Booth-Clibborn, E. *The Language of Graphics*, London and Tokyo 1970
Craig, J. and Barton, B. *Thirty Centuries of Graphic Design*, New York and Oxford 1987
Dormer, P. *The Meanings of Modern Design: Towards the Twenty-First Century*, London 1990
Forty, A. *Objects of Desire: Design and Society 1750-1980*, London 1986
Gentleman, D. *Design in Miniature*, London 1972
Gerstner, K. and Kutter, M. *Die neue Graphik*, Teufen, 1959
Gottschall, E.M. *Typographic Communications Today*, Cambridge, Mass. and London 1989
Graphic Designers in Europe, 4 vols, London and New York 1971-73
Facetti, G. and Fletcher, A. *Identity Kits*, London 1967
Havinden, A. *Advertising and the Artist*, London 1956
Heller, S. and Chwast, S. *Graphic Style: from Victorian to Post-Modern*, New York and London 1988
Henrion, F.H.K. *Top Graphic Design*, Zurich 1983
– (ed.) *AGI Annals*, Tokyo and Zurich 1989
Hölscher, F. *Gebrauchsgraphik-Fibel*, Munich 1954
Kery, P.F. *Art Deco Graphics*, New York and London 1986
King, J. *The Flowering of Art Nouveau Graphics*, London 1990
Livingston, A. and I. *The Thames and Hudson Encyclopaedia of Graphic Design and Designers*, London 1993
Le Graphisme et l'art (special issue *Art d'aujourd'hui*), Paris 1952
Lois, G. *The Art of Advertising*, New York 1977
Margolin, V. (ed.) *Design Discourse: History / Theory / Criticism*, Chicago and London 1989
McQuiston, L. *Women in Design: A Contemporary View*, London 1988
Meggs, P.B. *A History of Graphic Design*, New York and Harmondsworth 1983
Müller-Brockmann, J. *A History of Visual Communication*, Teufen and New York 1971
Neumann, E. *Functional Graphic Design in the 20's*, New York 1967

Poynor, R. *The Graphic Edge*, London 1993
Thompson, P. and Davenport, P. *The Dictionary of Visual Language*, London 1980
Walker, J.A. *Design History and the History of Design*, London 1989

Signs, Symbols and Identity

Blake, J.E. (ed.) *A Management Guide to Corporate Identity*, London 1971
Bühler-Oppenheim, K. *Signs, Brands, Marks*, Teufen 1971
Child, H. *Heraldic Design*, London 1965
Diethelm, W. *Signet, Signal, Symbol*, 3rd edn, Zurich 1976
Frutiger, A. *Signs and Symbols: Their Design and Meaning*, London 1989
Henrion, F.H.K. and Parkin, A. *Design Coordination and Corporate Image*, London and New York 1967
Herdeg, W. *Graphis Diagrams*, Zurich 1976
Hornung, C.P. *Handbook of Designs and Devices*, New York 1946
Humbert, C. *Label Design*, Tübingen 1972
Images d'utilité publique, Centre Georges Pompidou, Paris 1988
Ishihara, Y. *American Trademarks and Logotypes* (special issue *Idea*), Tokyo 1976
Jacobson, E. (ed.) *Trademark Design (Seven Designers Look at . . .)*, Chicago 1952
Jung, C.G. *Man and his Symbols*, London 1964
Koch, R. *The Book of Signs*, London 1930
Kuwayama, Y. *Trademarks and Symbols of the World*, Tokyo 1988
Leitherer, E. and Wichmann, H. *Reiz und Hülle: Gestaltete Warenverpackungen des 19. und 20. Jahrhunderts*, Basle, Boston and Stuttgart 1987
Lutz, H-R. *Die Hieroglyphen von heute*, Zurich 1990
Meadows, C.A. *Trade Signs and Their Origin*, London 1957
Olins, W. *The Wolff Olins Guide to Corporate Identity*, London 1990
Opie, R. *The Art of the Label*, London 1987
Palazzini, F.S. *Coca-Cola Superstar*, London 1986
Pedersen, B.M. *Graphis Annual Reports I*, Zurich 1988
– *Graphis Corporate Identity I*, Zurich 1989

Ricci, F.M. and Ferrari, C. *Top Symbols and Trademarks of the World*, Milan 1973
Rosen, B. *The Corporate Search for Visual Identity*, New York 1970
Sacharow, S. *Symbols of Trade*, New York 1982
The Image of a Company: Manual for Corporate Identity, Design Council, London 1990
Whittick, A. *Symbols: Signs and their Meaning and Uses in Design*, 2nd edn, London 1971
Wildbur, P. *Trademarks: A Handbook of International Designs*, London 1966

Visual Communication, Information Design Theory, Graphic Techniques and Technology

Ades, D. *Photomontage*, London 1976
Baroni, D. *Art Graphique Design*, French edn, Paris 1987
Bettinghaus, E.P. *Persuasive Communication*, New York and London 1968
Cherry, C. *On Human Communication*, New York 1959
Cotton, B. and Oliver, R. *Understanding Hypermedia*, London 1992
Dondis, D.A. *A Primer of Visual Literacy*, Cambridge, Mass. and London 1973
Garland, K. *Graphics Handbook*, London 1966
– *Illustrated Graphics Glossary*, London 1980
– *Graphics, Design and Printing Terms*, London 1989
Gibson, J. *The Perception of the Visual World*, Boston 1950
Herdeg, W. (ed.) *Graphis Diagrams*, Zurich 1976
Hind, A.M. *An Introduction to a History of Woodcut*, 2nd edn, New York and London 1963
Igarashi, T. (ed.) *Designers on Mac*, Tokyo and London 1994
Ivins, W.M. Jr. *Prints and Visual Communication*, Cambridge, Mass. 1953 (reprint New York 1969)
Jean, G. *Writing, The Story of Alphabets and Scripts*, English edn, London 1992
Mayor, A.H. *Prints and People*, Princeton, New Jersey and Guildford, England 1971
Merritt, D. *Television Graphics*, London 1987

Neurath, O. *International Picture Language* (1936), facsimile reprint, Reading 1980
Peignot, J. *De l'Écriture à la typographie*, Paris 1967
Stankowski, A. and Duschek, K. *Visuelle Kommunikation*, Berlin 1989
Steinberg, S.H. *Five Hundred Years of Printing*, 2nd edn, Harmondsworth 1961
Thompson, P. and Davenport, P. *The Dictionary of Visual Language*, London 1980
Twyman, M. *Printing 1770-1970*, London 1970
– (ed.) *Graphic Communication through Isotype*, Reading 1975
Wildbur, P. *Information Graphics*, London 1988
Williamson, J. *Decoding Advertisements*, London and Boston 1978
Zeitlyn, J. *Print: How You Can Do It Yourself!*, 2nd edn, London 1992

Type, Typography
Book and Editorial Design

Aicher, O. *Typographie*, Berlin 1988
Blackwell, L. *Twentieth-Century Type*, London 1992
Bosshard, H.R. *Form und Farbe*, Zurich 1968
Day, K. *Book Typography 1815-1965 in Europe and the United States of America*, Chicago and London 1966
Carter, S. *Twentieth-Century Type Designers*, London 1987
Eason, R. and Rookledge, S. *Rookledge's International Handbook of Type Designers*, Carshalton Beeches 1991
Evans, H. *Editing and Design* (5 vols.), 4: *Pictures on a Page*; 5: *Newspaper Design*, London 1978
Gill, E. *An Essay on Typography*, London 1931
Gottschall, E.M. (ed.) *Advertising Directions 4: Trends in Visual Advertising*, New York 1964
Hochuli, J. *Book Design in Switzerland*, Zurich 1993
Hurlburt, A. *The Grid*, New York 1978
Hutt, A. *Newspaper Design*, London 1960
– *The Changing Newspaper*, London 1973
L'Image des mots, Centre Georges Pompidou, Paris 1985
International Center for the Typographic Arts, *Typomundus 20*, New York, London and Ravensburg 1966
Jaspert, W.P., Berry, W.T., Johnson, A.F. *The Encyclopaedia of Type Faces*, Poole, 4th edn, 1970
Kapr, A. and Schiller, W. *Gestalt und Funktion der Typografie*, Leipzig 1977
Kepes, G. and others, *Graphic Forms: The Arts as Related to the Book*, Cambridge, Mass. and Oxford 1949
Kery, P.F. *Great Magazine Covers of the World*, New York 1982

Kinross, R. *Modern Typography*, London 1992
Lang, L. *Konstruktivismus und Buchkunst*, Leipzig 1990
Lee, M. (ed.) *Books for our Time*, New York 1951
– *Bookmaking*, New York 1965
Lewis, J. *The Twentieth-Century Book*, 2nd edn, New York and London 1984
Lutz, H-R. *Ausbildung in typographischer Gestaltung*, Zurich 1987
McLean, R. *Magazine Design*, London, New York and Toronto 1969
– *The Thames and Hudson Manual of Typography*, London 1980
Massin (R.) *Letter and Image*, London 1970
– *L'ABC du métier*, Paris 1988
– *La Mise en page*, Paris 1991
Owen, W. *Magazine Design*, London 1991
Poynor, R. and Booth-Clibborn, E. *Typography Now: The Next Wave*, London 1991
Rosner, C. *The Growth of the Book Jacket*, London 1954
Ruder, E. *Typography: A Manual of Design*, Teufen 1967
Rüegg, R. and Frölich, G. *Basic Typography*, Zurich 1972
Schmid, H. *Typography Today* (special issue *Idea*), Tokyo 1980
Simon, O. *Introduction to Typography*, 2nd edn, London 1963
Spencer, H. *Design in Business Printing*, London 1952
– *Pioneers of Modern Typography*, revised edn, London 1982
– *The Liberated Page*, London 1987
Spiekermann, E. *Rhyme and Reason: A Typographic Novel*, Berlin 1987
Spiekermann, E. and Ginger, E.M. *Stop Stealing Sheep and Find Out How Type Works*, California 1993
Sutton, J. and Bartram, A. *An Atlas of Typeforms*, London 1968
Typomundus 20, New York 1966
Tschichold, J. (ed.) *Elementare Typographie*, reprint of special issue of *Typographische Mitteilungen* (1925), Mainz 1986
– *Die neue Typographie*, 2nd edn, Berlin 1987
– *Treasury of Alphabets and Lettering*, English edn, Ware 1985
Weidemann, K. (ed.) *Book Jackets and Record Sleeves*, Stuttgart 1969
Williamson, H. *Methods of Book Design*, Oxford 1983
Zapf, H. *Manuale Typographicum*, Cambridge, Mass. 1980

Posters
[Chapter 1]
See also individual countries

Ades, D. *The 20th-Century Poster*, New York 1984
L'Affiche anglaise: les années '90, Musée des Arts Décoratifs, Paris 1972

Cate, P.D. and Hitchings, S.H. *The Color Revolution: Color Lithography in France 1890-1900*, Santa Barbara and Salt Lake City 1978
Cirker, H. and B. (eds.) *The Golden Age of the Poster*, New York, Toronto and London 1971
Constantine, M. *Word and Image: Posters from the Collection of the Museum of Modern Art*, New York 1968
Cooper, A. *Making a Poster*, 2nd revised edn, London and New York 1945.
Gallo, M. *The Poster in History*, London 1974
Hillier, B. *Posters*, London 1969
Kamekura, Y., Tanaka, I. and Sato, K. (eds.) *World Graphic Design Now I: Posters*, Tokyo 1988
Kämpfer, F. *Der Rote Keil: Das politische Plakat - Theorie und Geschichte*, Berlin 1985
Malhotra, R. and others, *Das frühe Plakat in Europa und den USA*, 3 vols, Berlin 1973-1980
Malhotra, R. *Politische Plakate 1914-1945*, Hamburg 1988
Meister der Plakatkunst, Kunstgewerbemuseum, Zurich 1959
Müller-Brockmann, J. *A History of the Poster*, Zurich 1971
Müller-Brockmann, J. and Wohmann, K. *Fotoplakate*, Aarau 1989
Popitz, K. *Plakate der zwanziger Jahre*, Berlin 1977
Rennert, J. *Posters of the Belle Epoque*, New York 1990
Rickards, M. *The Rise and Fall of the Poster*, Newton Abbott 1973
– *The Public Notice: An Illustrated History*, Newton Abbott 1973
The Poster, Takashimaya Art Gallery, Nihonbashi, Japan 1985
Weill, A. *The Poster*, London 1985
Wrede, S. *The Modern Poster*, New York 1988

War, Propaganda and Politics
[Chapters 3, 12 and 18]

Boehm E. *Behind Enemy Lines: WW II Allied/Axis Propaganda*, Secaucus 1989
Carteles de la guerra civil española, Madrid 1981
Bohrmann, H. (ed.) *Politische Plakate*, Dortmund 1984
Cantwell, J.D. *Images of War: British Posters 1939-45*, London 1989
Darracott, J. and Loftus, B. *First World War Posters*, 2nd edn, London 1981
Darracott, J. and Loftus B. *Second World War Posters*, London 1972
Davidson, S. *Images de la révolte 1965-1975*, Paris 1982
Nelson, D. *The Posters that Won the War: The Production, Recruitment and War Bond Posters of WWII*, Osceola, Wisconsin 1991
No Pasaran!: Photographs and Posters of the Spanish Civil War, Arnolfini, Bristol 1986

Philippe, R. *Political Graphics: Art as a Weapon,* English edn, Oxford 1982
Rawls, W. *Wake up, America!: World War I and the American Poster,* New York 1988
Rhodes, A. *Propaganda: the Art of Persuasion World War II,* New York and London 1976
Rickards, M. *Posters of the First World War,* London 1968
Rohan, M. *Paris '68: Graffiti, Posters of May 1968,* London 1988
Tisa, J. (ed.) *The Palette and the Flame: Posters of the Spanish Civil War,* New York 1979
Yanker, G. *Prop Art: Over 1000 Contemporary Political Posters,* London 1972

Austria
[Chapter 2]

Baroni, D. and D'Auria, A. *Kolo Moser: Grafico e designer,* Milan 1984
Fenz, W. *Koloman Moser: Graphik Kunstgewerbe Malerei,* Salzburg and Vienna 1984
Kallir, J. *Viennese Design and the Wiener Werkstätte,* London and New York 1986
Kossatz, H-H. *Ornamental Posters of the Vienna Secession,* London 1974
Larisch, R. von, *Über Zierschriften im Dienste der Kunst,* Munich 1899
– *Unterricht in Ornamentale Schrift,* Vienna 1905
Le Arti a Vienna: dalla Sessessione alla caduta del'impero asburgico, Palazzo Grassi, Venice 1984
Pabst, M. *Wiener Grafik um 1900,* Munich 1984
Schweiger, W.J. *Aufbruch und Erfüllung: Gebrauchsgraphik der Wiener Moderne 1897-1918,* Vienna and Munich 1988
Vergo, P. *Art in Vienna 1898-1918,* London and New York 1975
Vienne 1880-1938: L'Apocalypse joyeuse, Centre Georges Pompidou, Paris 1986
Waissenberger, R. *Vienna 1890-1920,* New York 1984

Italy
[Chapters 4,15,19]

Anceschi, G. and Calabrese, O. *Il campo della grafica italiana (6 Rassegna),* Bologna 1979
Cerri, P. (ed.) *Campo Grafico 1933-1939* Milan 1983
Dorfles, G. (ed.) *Albe Steiner: comunicazione visiva,* Florence 1977
Giugiaro, G. and Munari, B.(eds.) *Made in Italia: selezione dei marchi italiani,* Monte San Pietro, 1988
– Freddi, D.A. and L. *Mostra della rivoluzione fascista,* Rome 1933
Lista, G. *Le Livre futuriste,* Modena 1984
– *L'Art postal futuriste,* Paris 1979

Litta, S.G. *30 anni di pubblicità in Italia,* Milan 1984
Max Huber: progetti grafici 1936-1981, Milan 1982
Monguzzi, B. *Lo Studio Boggeri 1933-1981,* Milan 1981
Priarome, G. *Grafica pubblicitaria in Italia negli anni trenta,* Florence 1989
Rye, J. *Futurism,* London 1972
Salaris, C. *Il Futurismo e la pubblicità,* Milan 1986
Scudiero, M. *Futurismi postali: Balla, Depero e la comunicazione postale futurista,* Rovereto 1986
Scudiero, M. and Leiber, D. *Depero futurista and New York,* Rovereto 1986
Sparti, P. *L'Italia che cambia: attraversa i manifesti della raccolta Salce,* Florence 1988
Steiner, A. and others, *Due dimensioni,* Milan 1964
Waibl, H. *Alle radici della comunicazione visiva italiana,* Como 1988

Russia and the Soviet Union
[Chapter 5]

Alexander Rodchenko 1891-1956, Museum of Modern Art, Oxford 1979
Anikst, M. *Soviet Commercial Design of the Twenties,* London 1987
Bojko, S. *New Graphic Design in Revolutionary Russia,* London and New York 1972
Compton, S.P. *Russian Futurist Books 1912-16,* London 1978
Constantine M. and Fern A. *Revolutionary Soviet Film Posters,* Baltimore and London 1974
El Lissitzky, Galerie Gmurzynska, Cologne 1976
El Lissitzky 1990-1941: Architect, Painter, Photographer, Typographer, Municipal Van Abbemuseum, Eindhoven 1990
Elliott, D. *New Worlds: Russian Art and Society 1900-1937,* London 1986
Gassner H. and Nachtigäller, R.*Gustav Klucis [Klutsis] Retrospektive,* Stuttgart 1991
Gray, C. *The Russian Experiment in Art 1863-1922,* revised edn, London 1986
Kunst und Propaganda, Museum für Gestaltung, Zurich 1989
La tipografia russa 1890-1930, Palazza Vitelli, Città di Castello, 1990
Lavrentiev, A. *Varvara Stepanova: A Constructivist Life,* London 1988
Leclanche-Boulé, C. *Typographies et photomontages constructivistes en URSS,* Paris 1984
Lissitzky-Küppers, S. *El Lissitzky: Life, Letters, Texts,* London 1968
Lodder, C. *Russian Constructivism,* New Haven and London 1983
Lyakhov, V. *Soviet Advertising Poster 1917-1932,* Moscow 1972
Maiakovski: 20 ans de travail, Centre Georges Pompidou, Paris 1975
Majakovskij Mejerchol'd Stanislavskij, Castello Sforzesco, Milan 1975

Paris-Moscou 1900-1930, Centre Georges Pompidou, Paris 1979
Telingater, exhibition catalogue, Paris 1978
The Soviet Political Poster, Moscow 1984
White, S. *The Bolshevik Poster,* New Haven and London 1988
Williams, R.C. *Artists in Revolution: Portraits of the Russian Avant-Garde 1905-1925,* Bloomington, Indiana and London 1977

Germany
[Chapters 6,17,19]

Arnold, F. (ed.) *Anschläge: Deutsche Plakate als Dokumente der Zeit 1900-1960,* Ebenhausen 1963
Bayer, H. Gropius W. and Gropius, I. *Bauhaus 1919-1928,* Boston 1959
Buddensieg, T. (ed.) *Industrie Kultur: Peter Behrens und die AEG 1907-1914,* Berlin 1981
Chantzit, G.F. *Herbert Bayer Collections and Archives at the Denver Art Museum,* Seattle and London 1988
Coutts-Smith, K. *Dada,* London 1970
Revolution und Realismus: Revolutionäre Kunst in Deutschland 1917 bis 1933, Staatliche Museen, Berlin 1979
Der Malik-Verlag 1916-1947, Deutsche Akademie der Künste, Berlin 1967
Die Zwanziger Jahre in Hannover 1916-1933, Kunstverein, Hannover 1962
Die Zwanziger Jahre in München, Münchner Stadtmuseum, Munich 1979
Droste, M. *Bauhaus 1919-1933,* Berlin and Cologne 1990
– *Herbert Bayer: das künstlerische Werk 1918-1938,* Berlin 1982
Fleischmann, G. *Bauhaus Drucksachen Typografie Reklame,* Dusseldorf 1984
– *Walter Dexel: Neue Reklame,* Dusseldorf 1987
– *Joost Schmidt: Lehre und Arbeit am Bauhaus 1919-1932,* Dusseldorf 1984
George Grosz/John Heartfield, Württembergischer Kunstverein, Stuttgart 1969
Herzfelde, W. *John Heartfield: Leben und Werk,* Dresden 1971
Hirdina, H. *Neues Bauen Neues Gestalten: die neue Stadt,* Dresden 1984
Kermer, W. *Willi Baumeister Typographie und Reklamegestaltung,* Stuttgart 1989
Kostelanetz, R. *Moholy-Nagy,* New York 1970 and London 1971
L.Moholy-Nagy, Institute of Contemporary Arts, London 1980
Lammers, J. and Unverfehrt, G. *Vom Jugendstil zum Bauhaus : Deutsche Buchkunst 1895-1930,* Münster and Göttingen 1981
Moholy-Nagy, S. *Moholy-Nagy: Experiment in Totality,* Cambridge, Mass. and London, 2nd edn, 1969
Naylor, G. *The Bauhaus Reassessed,* London 1985

Neue Sachlichkeit and German Realism of the Twenties, Hayward Gallery, London 1979
Pachnicke, P. and Honnef, K. *John Heartfield*, Cologne 1991
Paris-Berlin 1900-1933, Centre Georges Pompidou, Paris 1978
Politische Plakate der Weimarer Republik 1918-1933, Hessisches Landesmuseum, Darmstadt 1980
Rademacher, H. *Das deutsche Plakat von den Anfängen bis zur Gegenwart*, Dresden 1965
Richter, H. *Dada: Art and Anti-Art*, London 1965
Tschichold - see Switzerland
'Typographie kann unter Umständen Kunst sein' (3 vols), 1: *Kurt Schwitters: Typographie und Werbegestaltung*; 2: *Ring 'neue werbegestalter': Die Amsterdamer Ausstellung 1931*; 3: *Vordemberge-Gildewart: Typographie und Werbegestaltung*, Landesmuseum, Wiesbaden 1990
Uwe Loesch, Zeichenzitate / Sign Citations: Plakate von 1968 bis 1986, Dusseldorf 1986
Westphal, U. *Werbung im dritten Reich*, Berlin 1989
Wichmann, H. *Graphic Design Mendell and Oberer*, Basle and Boston 1987
Willett, J. *The New Sobriety 1917-1933: Art and Politics in the Weimar Period*, London 1978
Windsor, A. *Peter Behrens: Architect and Designer*, London 1981
Wingler, H.M. *The Bauhaus: Weimar Dessau Berlin Chicago*, 2nd edn, Cambridge, Mass. 1976

Central Europe
[Chapters 1,6,17]

Bojko, S. *The Polish Poster Today*, Warsaw 1972
Constructivism in Poland 1923 to 1936, Kettle's Yard Gallery, Cambridge
Czech Modernism 1900-1945, Museum of Fine Arts, Houston 1989
Devetsil: Czech Avant-Garde Art, Architecture and Design of the 1920s and 30s, Museum of Modern Art, Oxford 1990
Kowalski, T. *The Polish Film Poster*, Warsaw 1957
Présences polonaises: Witkiewicz/ Constructivism /Les Contemporains, Centre Georges Pompidou, Paris 1983
100 +1 Jahre ungarische Plakatkunst, exhibition catalogue, Dortmund 1987

The Netherlands
[Chapters 7,17,19]

Baljeu, J. *Theo van Doesburg*, London 1974
Brattinga, P. and Dooijes, D. *A History of the Dutch Poster 1890-1960*, Amsterdam 1968

Broos, K. and Hefting, P. *Dutch Graphic Design*, London 1993
Broos, K. *Design: Total Design*, Utrecht 1983
– (ed.) *Piet Zwart*, Haags Gemeentemuseum, The Hague 1971
Franciscono, M. *The Modern Dutch Poster*, Cambridge, Mass. and London 1987
Friedman, M. (ed.) *De Stijl 1917-1931: Visions of Utopia*, Oxford 1982
Hendrik Nicolaas Werkman 1882-1945: 'druksel' prints and general printed matter, Stedelijk Museum, 1977
Hubben, H. *Design: Total Design*, Wormer 1989
Koch, K. *W. H. Gispen 1890-1981*, Rotterdam 1988
Maan, D. and Van der Ree, J. *Typo-foto: elementaire typografie in Nederland*, Utrecht and Antwerp 1990
Monguzzi, B. *Piet Zwart: L'opera tipografica 1923-33 (30 Rassegna)*, Bologna 1987
Müller, F. (ed.) *Piet Zwart*, Teufen, Switzerland 1966
Petersen, A. and Brattinga, P. *Sandberg: A Documentary*, Amsterdam 1975
Purvis, A.W. *Dutch Graphic Design, 1918-1945*, New York 1992
Staal, G. and Wolters, H. *Holland in Vorm: Dutch Design 1945-1987*, The Hague 1987
Theo van Doesburg 1883-1931, Kunsthalle Nürnberg, Nuremburg 1969

France
[Chapters 9,16,19]

Adriani, G. *Toulouse-Lautrec: The Complete Graphic Works*, London 1988
Arwas, V. *Berthon and Grasset*, London 1978
Atelier Populaire: Paris, May 1968, London 1969
Broido, L. *The Posters of Jules Chéret*, New York 1980
Brown, R.K. and Reinhold, S. *The Poster Art of A. M. Cassandre*, New York 1979
Cappiello 1875-1942, Grand Palais, Paris 1981
Cauzard, D., Perret, J. and Ronin, Y. *Images de marques - marques d'images*, Paris 1988
Faucheux, P. *Écrire l'espace*, Paris 1978
Fields, A. *George Auriol*, Leyton, Utah 1985
Grapus 85, Städtische Galerie, Erlangen 1985
Jean Widmer, Villeurbanne, 1991
L'Encyclopédie Diderot et D'Alembert, (Imprimerie, Reliure) reprinted Paris 1988
Massin, *L'ABC du métier*, Paris 1988
Mouron, H. *Cassandre*, Munich and London 1985
Quand l'affiche faisait de la réclame! L'affiche française de 1920 à 1940,

Musée National des Arts et Traditions Populaires, Paris 1992
Rohan, M. *Paris '68*, London 1988
Savignac (R.) *Savignac: affichiste*, Paris 1975
Tolmer, A. *Mise en Page: The Theory and Practice of Lay-out*, London 1931
Vive les graphistes!: petit inventaire du graphisme français, Centre Georges Pompidou, Paris 1990
Weill, A. *L'Affiche française*, Paris 1982

Switzerland
[Chapters 8,14,19]

Art concret suisse: mémoire et progrès, Musée des Beaux-Arts, Dijon 1982
Burkhard Mangold 1873-1950, Museum für Gestaltung, Zurich 1984
Emil Cardinaux 1877-1936 Museum für Gestaltung, Zurich 1985
Ferdinand Hodler und das schweizer Künstlerplakat 1890-1920, Museum für Gestaltung, Zurich 1984
Gerstner, K. *Kalte Kunst? zum Standort der heutigen Malerei*, Teufen 1957
– *Designing Programmes*, London and New York, enlarged edn, 1968
– *Kompendium für Alphabeten: Eine Systematik der Shrift*, Teufen 1972 (English edn, *Compendium for Literates*, Cambridge and Mass. 1972)
Grafik (special issue *Werk*) Zurich 1955
Hofmann, A. *Graphic Design Manual*, New York 1965
Klemke, W. *Jan Tschichold: Leben und Werk des Typographen*, Dresden 1977
McLean, R. *Jan Tschichold: Typographer*, London 1975
Neuburg, H. *Hans Neuburg: 50 anni di grafica costruttiva*
– *Graphic Design in Swiss Industry*, Zurich 1965
Müller-Brockmann, J. and S. *The Graphic Designer and his Design Problems*, Teufen 1961
Niklaus Stoecklin 1896-1982, Gewerbemuseum, Basle 1986
Otto Baumberger 1889-1961, Museum für Gestaltung, Zurich 1988
Tschichold, J. *Asymmetric Typography*, London, Toronto and New York 1967 (original German *Typographische Gestaltung*, Basle 1935)
– *Die neue Typographie*, Berlin 1987 (original German edn, 1928)
Werbestil (publicity style) 1930-1940, Museum für Gestaltung, Zurich 1981
Werk (special graphics issue) Zurich, November 1955
Wichmann, H. *Armin Hofmann: His Work, Quest and Philosophy*, Basle 1989

Britain
[Chapters 1,2,3,10,12,17,18,19]

Archer, L.B. *Systematic Method for Designers* (reprint from *Design*), London 1964
Barker, N. *Stanley Morison*, London 1971

Biggs, A. *William Morris: Selected Writings and Designs*, Harmondsworth 1962
Blake, A. *Milner Gray*, London 1986
– *Misha Black*, London 1984
Brattinga, P. and Watano, S. (eds.) *British Visual Communication Design 1900–1985* (special issue *Idea*), Tokyo
British Art and Design 1900–1960, Victoria and Albert Museum, London 1983
Brewer, R. *Eric Gill: The Man who Loved Letters*, London 1973
Callen, A. *Angel in the Studio: Women in the Arts and Crafts Movement 1870–1914*, London 1979
Campbell, C. *The Beggarstaff Posters*, London 1990
E. McKnight Kauffer, Victoria and Albert Museum, 1955
Fifty Penguin Years, Harmondsworth 1985
Fletcher A., Forbes, C., and Gill, B. *Graphic Design: Visual Comparisons*, London 1963
Games, A. *Over My Shoulder*, London 1960
Green, O. *Underground Art*, London 1990
Haworth-Booth, M.E. *E. Mc Knight Kauffer: A Designer and his Public*, London
Hewitt, J. (ed.) *Poster Art of the 20s and 30s from the Collection of Manchester Polytechnic*, Manchester 1978
High Art and Low Life, 'The Studio' and the fin de siècle (centenary number *Studio International*), London 1993
Hopkinson, T. *Picture Post 1938–50*, Harmondsworth 1970
Johnston, P. *Edward Johnston*, London 1959
Jones, H. *Stanley Morison Displayed*, London 1976
Jones, T. *Wink Instant Design: A Manual of Graphic Techniques*, London 1980
Kaplan, W. (ed.) *Encyclopedia of Arts and Crafts: The International Arts Movement 1850–1920*, London 1989
Ken Garland and Associates 1960–82, London 1982
Lambert, F . (ed.) *Graphic Design Britain 70*, London and New York 1970
Levey, M.F. *London Transport Posters*, Oxford 1976
Mendenhall, J. *British Trademarks of the 1920s & 30s*, San Francisco 1989
Moran, J. *Stanley Morison: His Typographic Achievement*, London 1971
Minale, Tattersfield, Provinciali Limited, London 1967
Pentagram: The Work of Five Designers, London 1972
Peterson, W.S. (ed.) *The Ideal Book: Essays . . . by William Morris*, Berkeley, L.A. and London 1982
– *The Kelmscott Press*, Oxford and Berkeley 1991
Naylor, G. *The Arts and Crafts Movement*, London 1971

The Practice of Design (introduction by Herbert Read), London 1946
Spencer, I. *Walter Crane*, London 1975
Vorticism and its Allies, Hayward Gallery, London 1974
Weintraub, S. *Beardsley*, revised edn, Harmondsworth 1972
Wozencroft, J. *The Graphic Language of Neville Brody*, London 1988

United States
[Chapters 1,3,11,12,13,18,19]

AIGA Graphic Design USA, New York (from 1980: yearly)
Aldersey-Williams, H., Wild, L. and others, *Cranbrook Design: the new discourse*, Bloomfield Hill, Michigan 1990
Aldersey-Williams, H. *New American Design*, New York 1988
Allner, W.H. *Posters*, New York 1952
Brand, S. *The Media Lab: Inventing the future at MIT*, New York 1987, London 1988
Breitenbach, E. and Cogswell, M. *The American Poster*, New York 1967
Burns, A. *Typography*, New York 1961
Burtin, W. *Visual Aspects of Science*, New York 1960
Carr, R., Case, B., and Dellar, F. *The Hip, Hipsters, Jazz and the Beat Generation*, London 1986
Carter, R. *American Typography Today*, New York 1989
DeNoon, C. *Posters of the WPA*, Los Angeles 1987
Dobrow, L. *When Advertising Tried Harder: The Sixties*, New York 1984
Friedman, M. (ed.) *Graphic Design in America: A Visual Language History*, Minneapolis and New York 1989
Glaser, M. *Milton Glaser: Graphic Design*, New York 1973
Gottschall, E.M. *Typographic Directions (Advertising Directions 4)*, New York 1964
Graphic Designers in the USA (4 vols), New York 1972
Greiman, A. *Hybrid Imagery: The Fusion of Technology and Graphic Design*, London 1990
Grundberg, A. *Brodovitch*, New York and London 1989
Hess, D. and Muller, M. *Dorfsman and CBS*, New York 1987
Hornung, C.P. *Will Bradley: His Graphic Art*, New York 1974
Ishihara, Y. *American Trademarks and Logotypes* (special issue *Idea*), Tokyo 1976
Kepes, G. *Language of Vision*, Chicago 1944
Kiehl, D. W. *American Art Posters of the 1890s*, New York 1987
Loewy, R. *Never Leave Well Enough Alone*, New York 1951
Lönberg-Holm, K. and Sutnar, L. *Catalog Design Progress*, New York 1950

Moholy-Nagy, L. *Vision in Motion*, Chicago 1947
Marchand, R. *Advertising the American Dream: 1920–1940*, Berkeley, Los Angeles and London 1986
Margolin, V., Brichta, I. and Brichta, V. *The Promise and the Product: 200 Years of American Advertising Posters*, New York and London 1979
Modern Art in Advertising (Container Corporation of America), Chicago, 1946
McLuhan, M. *Understanding Media: the Extensions of Man*, London 1964
McLuhan, M. and Fiore, Q. *The Medium is the Massage*, New York and London 1967
– *War and Peace in the Global Village*, New York, London and Toronto 1968
Neuhart, J. and M. and Eames, R. *Eames Design*, New York 1989
Pacific Wave: California Graphic Design, Museum Fortuny, Venice 1987
Rand, P. *Thoughts on Design*, New York 1947; revised edn, London and New York 1970
– *A Designer's Art*, New Haven and London 1985
Remington, R.R. and Hodik, B.J. *Nine Pioneers in American Graphic Design*, Cambridge, Mass. and London 1989
Saul Bass and Associates (special issue *Idea*), Tokyo, c.1979
Snyder, G. and Peckolick, A. *Herb Lubalin*, New York 1985
The American Psychedelic Poster, Stadthaus Galerie, Münster, Germany 1988
Thompson, B. *The Art of Graphic Design*, New Haven and London 1988
Wolf, H. *Visual Thinking*, New York 1988

Japan
[Chapters 12,19]

Japanese Affiches / Modern Posters of Japan, Hessenhuis, Antwerp 1989
Katsumie, M. *The Graphic Design of Yusaku Kamekura*
Kristahn, H-J. and Mellinghoff, F. *Japanische Plakate*, Tokyo and Berlin 1983
L'Affiche japonaise: des origines à nos jours, Paris 1980
Maeda, M. *Signs and Symbols of Japan*, Tokyo, New York and San Francisco 1975
Nagai, K., Sato, K. and Toda, M. *Graphics Japan*, Tokyo 1987
Tanikawa, K. *100 Posters of Tadanori Yokoo*, Tokyo and London 1978
Thornton, R.S. *Japanese Graphic Design*, London 1991

Index

Designers, design groups, studios, agencies and significant clients.
Where designers' dates are not known,
the country and period in which their work was most prominent are given.
Page numbers in *italic* indicate illustrations.
References normally appear in the text on the same page.

Further Sources

Art directors' clubs and designers'
associations in most countries publish
annuals. Selected work also appears in
yearbooks (such as *Modern Publicity*,
London, and *Graphis Annual*, Zurich).

Original material

Many museums, particularly of design,
decorative and applied arts, have col-
lections of graphic work. Intended to
be ephemeral, the paper is often
brittle, yellowed, and the colour
unevenly faded.

It is difficult to examine work more
than a few decades old, especially
by the most prominent designers,
which can have a high market value.
Antiquarian booksellers and auction
houses provide occasional access to
material (though details of work in
their catalogues are not necessarily
reliable).